HORST A. FRIEDRICHS
STUART HUSBAND

Bookstores

A Celebration of Independent Booksellers

WITH A FOREWORD BY
NORA KRUG

PRESTEL

MUNICH LONDON NEW YORK

Contents

Paper Towns

NORA KRUG

Imagine the sense of excitement a traveller must have felt some 450 years ago when entering Christophe Plantin's print shop in Antwerp, viewing the books he had on offer. Imagine leafing through the pages of *Theatrum Orbis Terrarum* (the first true modern atlas, 1570), and *Dictionarium Tetraglotton* (a dictionary in Greek, Latin, French and Flemish, 1562), and *La Institutione di una Fanciulla Nata Nobilmente* (a manual on the education of young girls, 1555), or closely examining his illustrated bibles, travel stories and song books, sold there and distributed at the Frankfurt Book Fair (the first of which took place in 1454), to places as far away as China, India and the Spanish colonies, expanding the minds of our reading ancestors. Plantin himself strongly believed in the educational and humanist value of literature. Suspecting him of printing materials of heretic and anti-Spanish content, the Spanish ordered the raiding of his workshop in 1561, but Plantin had the foresight to sell all of his radical books in advance of the raid – only to buy them back once normalcy returned. In 1576, Spanish mercenaries looted and torched Antwerp, but by paying them an enormous ransom, Plantin was able to save his books.

Readers today don't have to travel for weeks by boat or horse-drawn coach to purchase a book. Production modes and distribution methods have changed, but the same excitement greets the contemporary reader when entering a bookstore that reflects the idiosyncratic perspective of its owner. Entering an independent bookstore feels like setting foot in a strange town. You find yourself promenading paper boulevards, passing lively town squares, then turning corners and wandering down secret alleyways, perhaps hoping to lose yourself in a quiet dead end – to take refuge from the world outside, or even from yourself. The books on the shelves are like the people you'd encounter along the way, the covers are their faces, the sentences their thoughts. You pick them off their shelves, weigh them in your hands, you open them up and begin a conversation. Some speak easily, some with hesitation. Some have manners, others don't. Some you couldn't agree with more, others contradict your every word. Some are reassuring and comforting, others confuse and frighten you. All of them sharpen your senses, and when you leave the store (hopefully with a purchased book in your bag), you find that you are richer: in images and words, in thoughts and feelings.

Books are more than just cultural artefacts. They are manifestations of who we are. They are proof that we exist, and they make a commitment to remembering that we have lived once we are gone. They give us the illusion that not everything is ephemeral, that there has to be a reason for why we are here, that our struggles aren't futile. Because books show us who we are, they satisfy our desire to culturally belong. And by telling us who we might become, they allow us to question all we take for granted, test our ethical conscience, gain distance to the world in order to challenge our relationship with it, and question our commitment to it.

Books are therefore under threat when the edges of democracy begin to crumble. Totalitarian regimes control printing, publishing and distribution, stifling the possibility for critical thinking, which can, in turn, breed intolerance and acts of violence. In democratic societies, too, the political power of books can make them vulnerable. Book burnings aren't only a thing of the past: in the fall of 2019, students at a university in the United States burned a novel on campus by an author who had visited the college to engage in a dialogue about diversity and white privilege. Books defend our human dignity, and therefore we have to protect them – just as Christophe Plantin did four and a half centuries ago.

Independent bookstores are free from state-mandated, or even just mainstream taste. They provide access to books that make us think and challenge our conventional viewpoints, which is precisely why they are important. They underline the necessity of diverse opinions, they give voice to authors otherwise left unheard, they provide a sense of community and a platform for radical ideas. They are sites and sanctuaries for democratic thinking.

After a period of decline, there has been an increase in independent bookstores in some countries. But their survival continues to be challenged. If people used to have to travel by horse-drawn coach for days on end just to purchase a book, then we can support the well-being of our local bookstore by, among other ways, walking to the shop to pick one up, instead of going online. And perhaps, while we wait in line, we can give the resident cat a good scratch behind its ear.

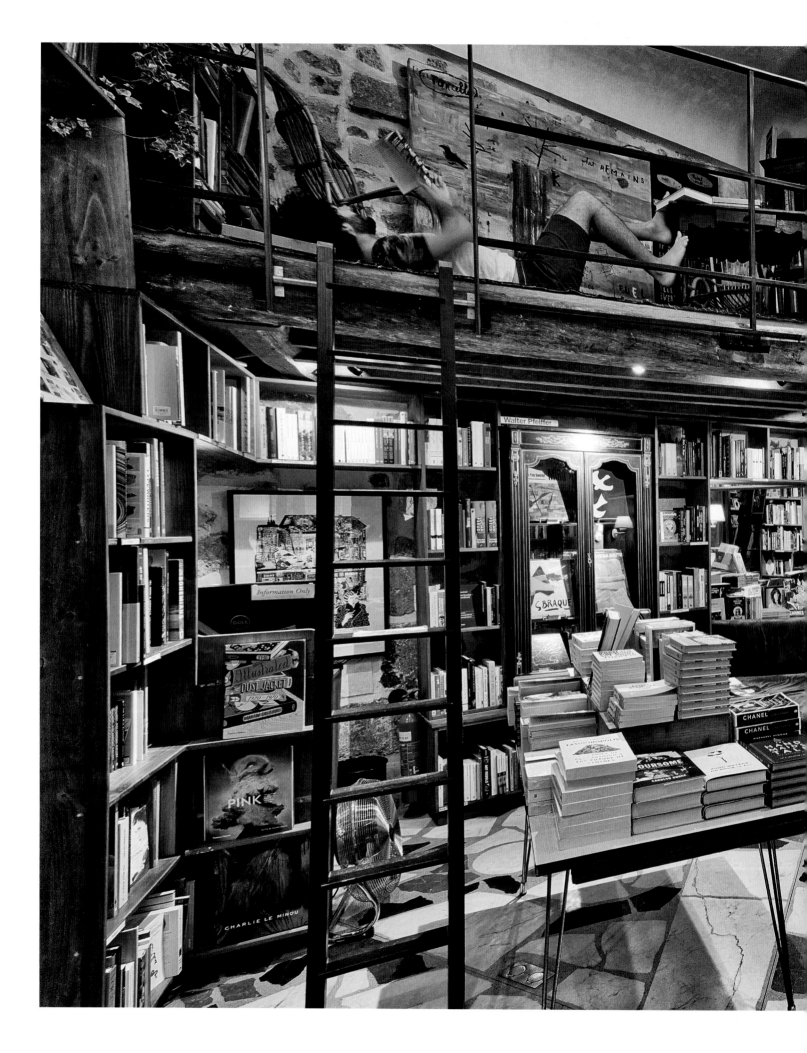

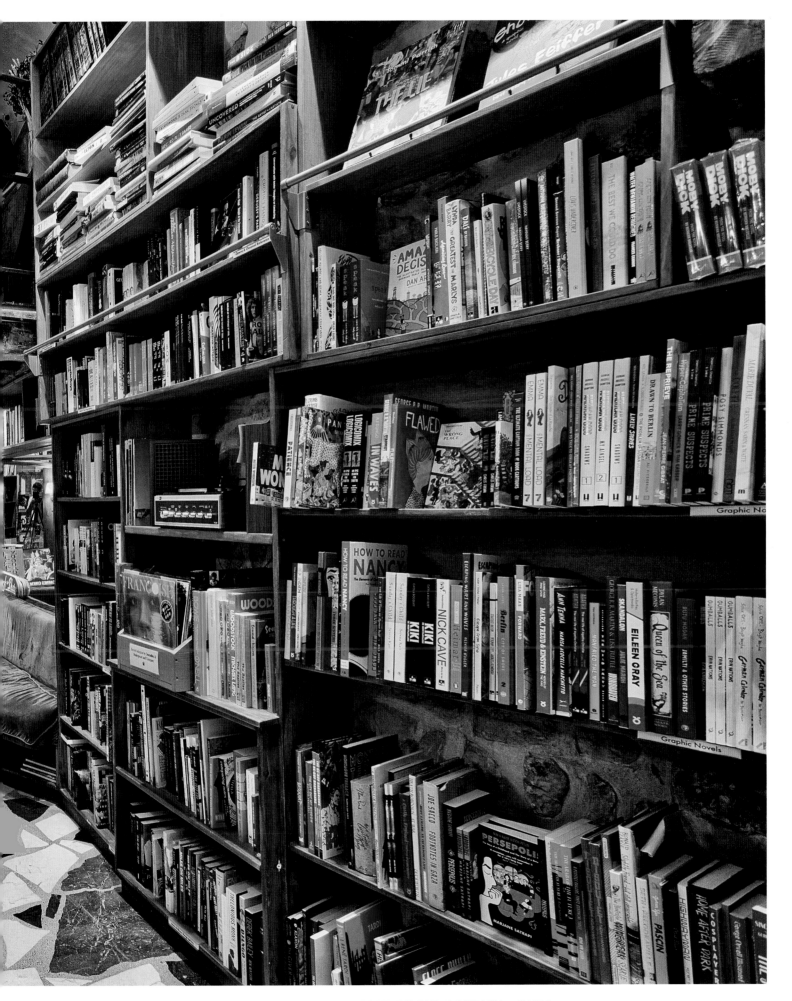

SHAKESPEARE AND COMPANY — PARIS

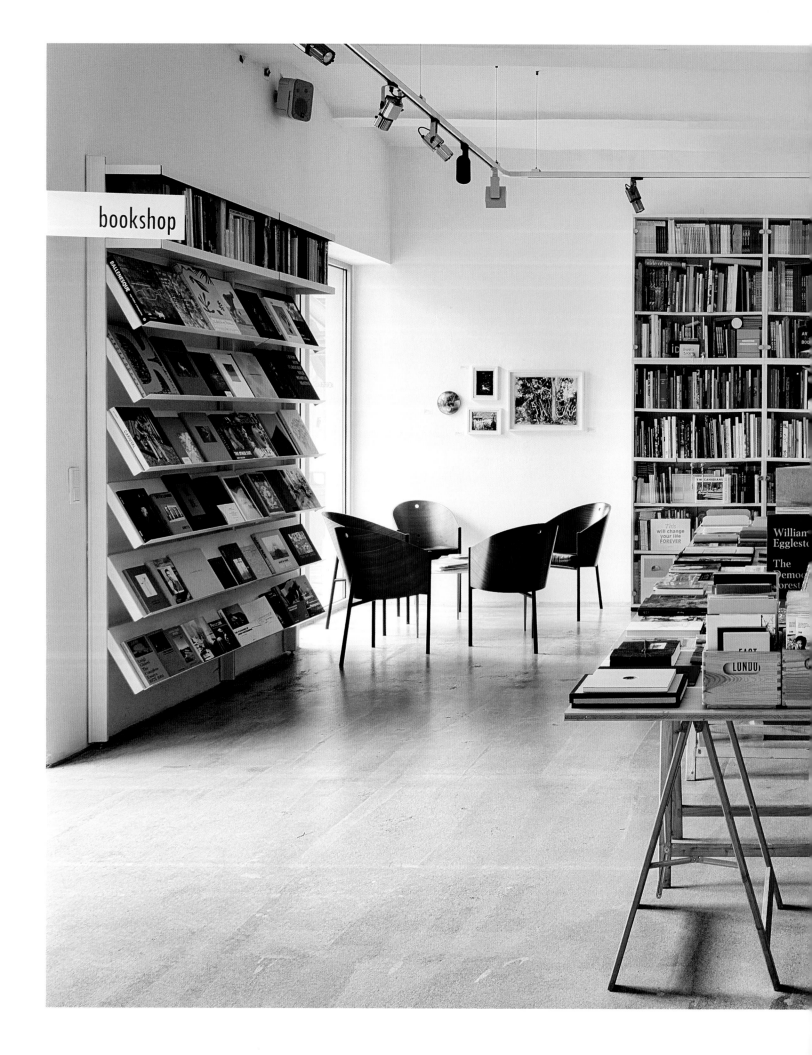

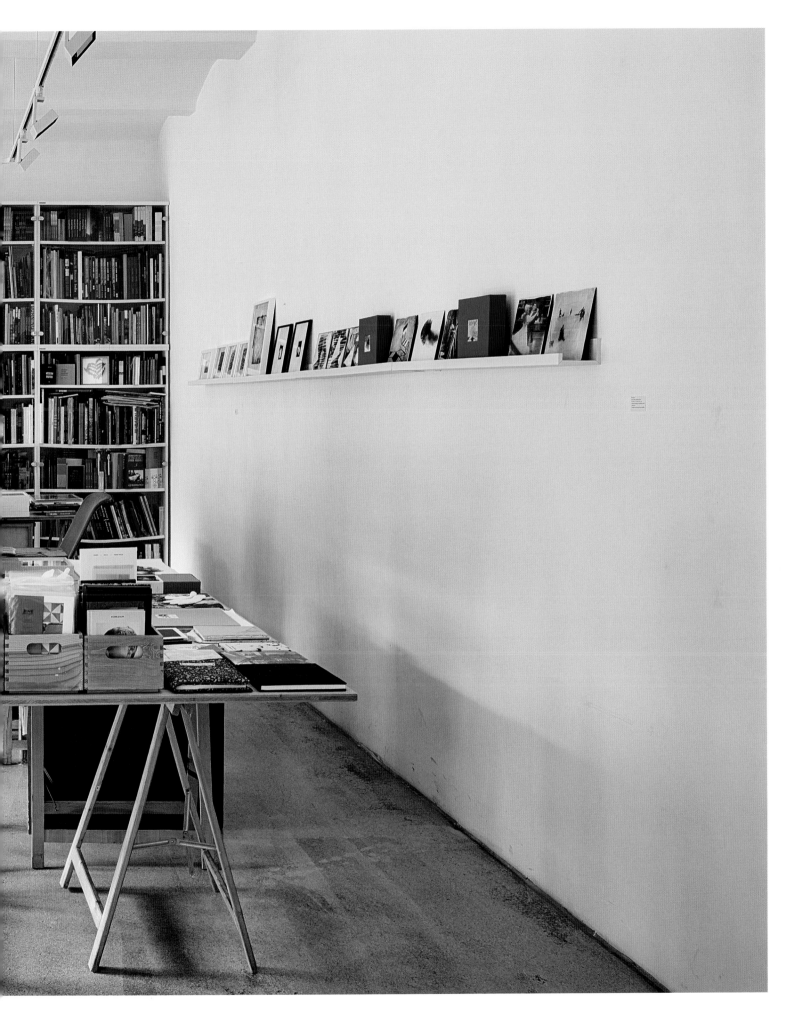

ANZENBERGERGALLERY — VIENNA

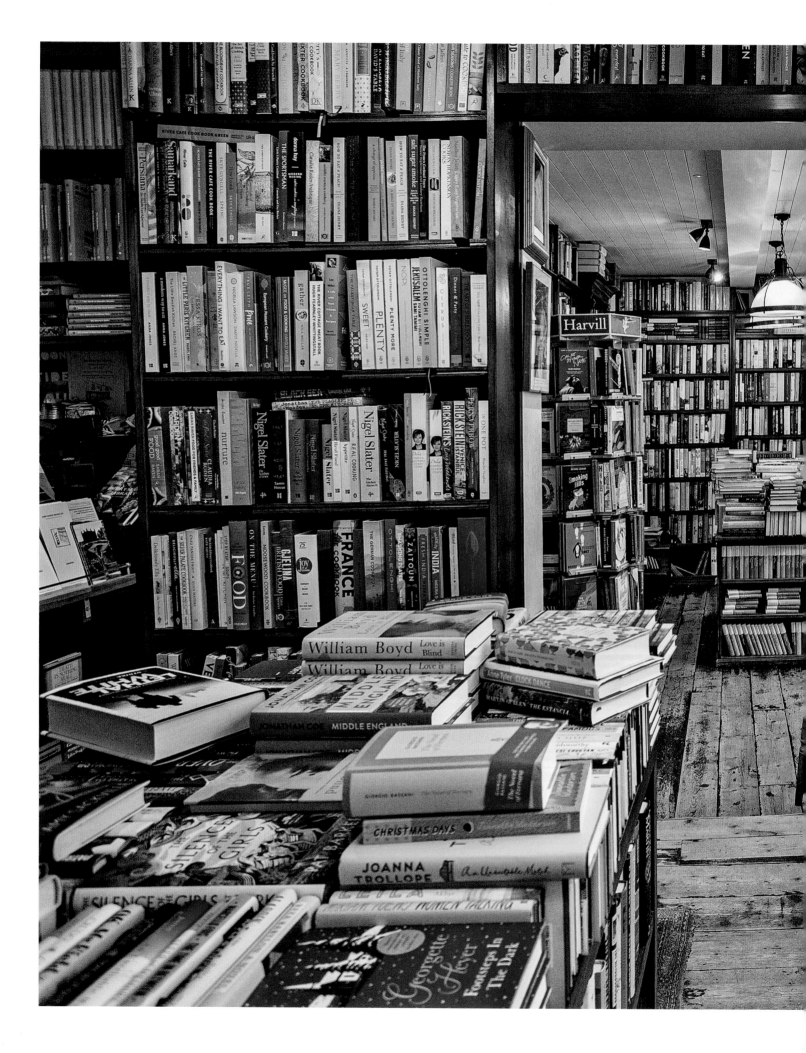

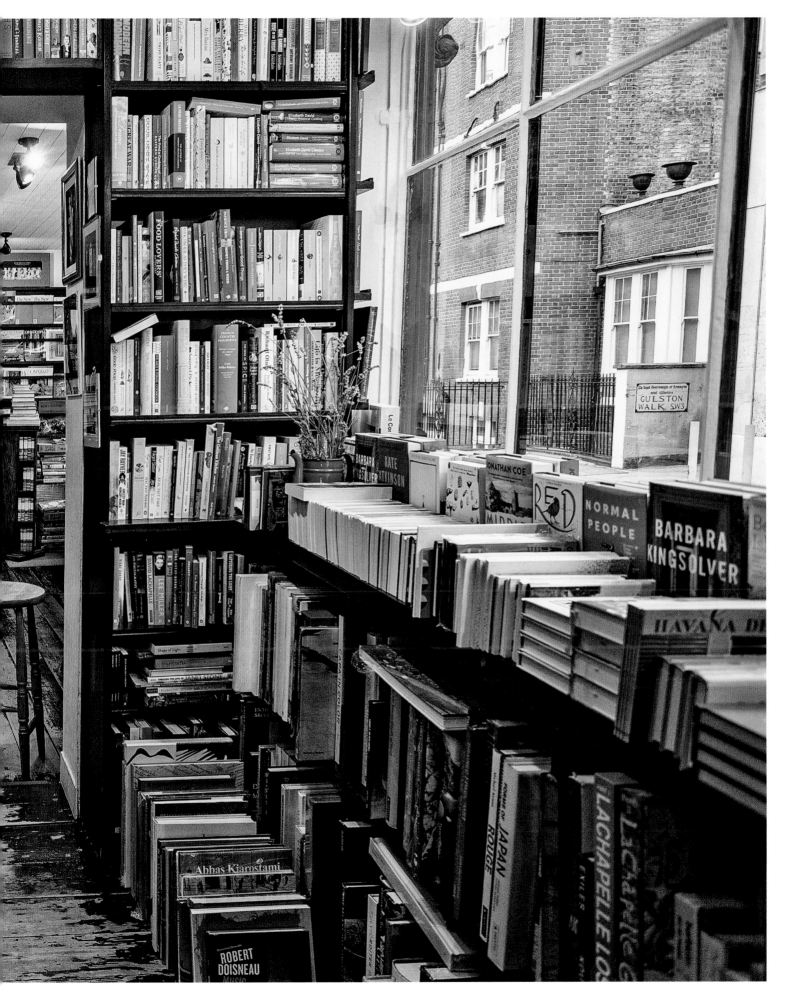

JOHN SANDOE BOOKS – LONDON

The Strand

NANCY BASS WYDEN

If our name is synonymous with that of New York City, I think that being in business for almost a century has something to do with it. It's always been my family's mission to put good books in the hands of readers. My grandfather started The Strand in the 1920s with $600 and his own book collection. He slept on a cot in the basement when times got really tough. He bought the eleven-storey building we're in now to safeguard the business. It's just been given city landmark status, which I'm appealing against – it drives up the costs of everything, which we don't need – but I'm happy to regard The Strand as a landmark in its own right.

My earliest memory of the place? I'd come in here with my mom and my brother, and they'd kind of turn me loose. I remember seeing what seemed like an ocean of books, and imbibing the fabulous chocolatey, musky smell they gave off. I'd run to the kid's section, sweep my fingers along the spines, and be told I could choose any book that was there. I remember my delight in feeling like I was the queen of the stacks. And seeing my dad and granddad working here too, they felt like giants. I guess books were my candy.

You know, the death of bookstores has probably been prophesied ever since bookstores began. We started on Book Row, where you had six blocks containing forty-eight bookstores in competition. One was even called The Cheapest Bookstore in The World. So it was a struggle to survive back then; then paperbacks were supposed to put us out of business, then the movies, then TV, then the big box stores, then the internet, then e-books. We've always been under assault by something, but it just keeps you on your toes. People still love the space of a bookstore as a place to dream, to "Get Lost in the Stacks", as our slogan has it, where getting lost is a positive thing. You see customers stop as they come in, take a deep breath, prepare to decompress a little from the city, maybe go back in time a little bit. And we try to hire employees that love

books – you have to pass a literary test before you're taken on, which, believe me, is not easy – and who want to share their enthusiasms. Almost everyone's a literary major. Ben McFall, our head of fiction who's been here since the 1970s, was called the "Oracle of The Strand" by the *New York Times*. People are always coming to him for suggestions on what to read next.

David Bowie, who was a regular here, said, "You always find the book you didn't know you wanted at The Strand." We have eighteen miles of books - from the bargain carts outside, which are like our gateway drug, to the rare book room like an old, magical attic upstairs – and we also have access to amazing estates in and around New York, who think of us as the best repository for their collections, as well as creating home libraries for people. I did a library for Moby and he said it felt like Christmas because I picked out things he'd never encountered but really appreciated. What do I love doing most here? The sort of extracurricular stuff. I started the event program, and we now hold 400 signings and talks a year; we run a kids' story time where we get people costumed up as the book's characters to narrate; we have our own leather bookmarks, a candle line, a tea line, bags and socks, anything that's really just fun to try.

My favourite section? I love rare books, but my favourite to read is memoirs and biographies. Right now I'm in the middle of the Truman Capote biography by Gerald Clarke. Oh my gosh, it's brilliant. I'm still passionate about books and reading. I love it when customers tell me this is their most cherished place in New York City, or to hear from authors like Gary Shteyngart that we inspired them to become writers. Patti Smith and Mary Gaitskill both worked here. In fact, Patti Smith's sister also worked here and met her husband here, and they're still married. I think there are more than a few Strand babies running around out there, getting lost in the stacks, just like I did.

NANCY BASS WYDEN — THE STRAND — NEW YORK CITY

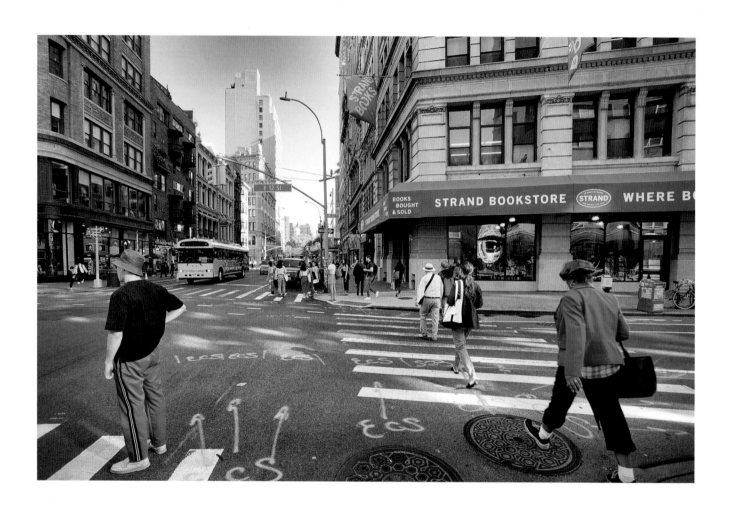

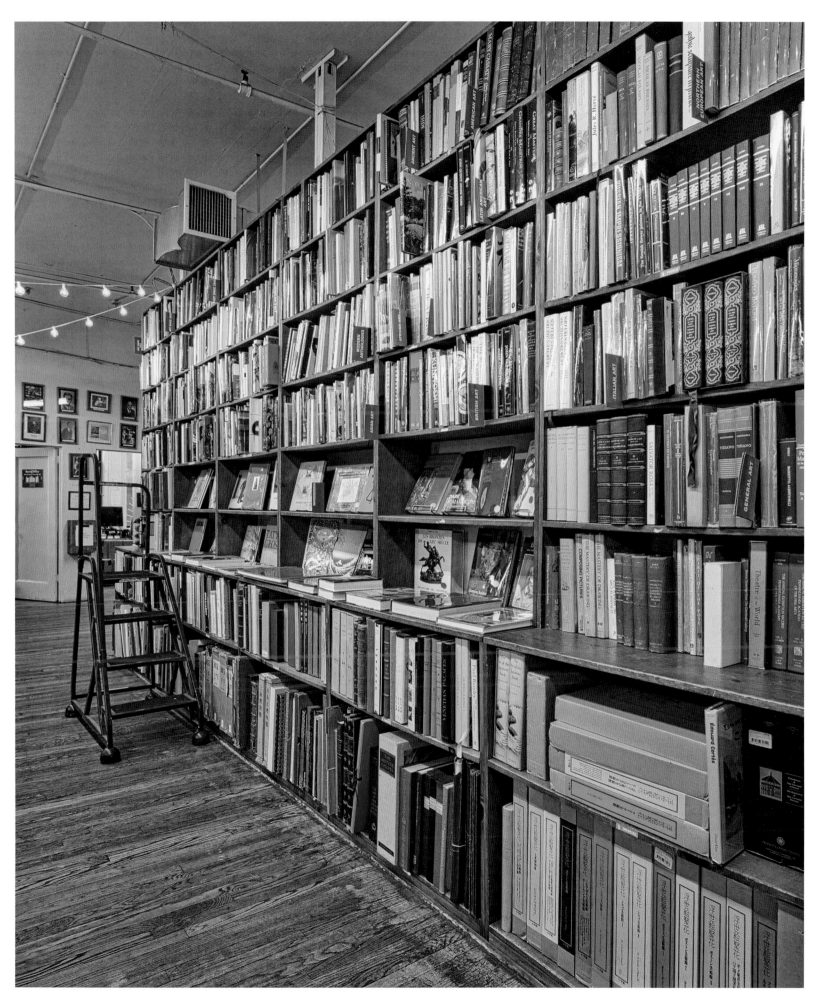

THE STRAND — NEW YORK CITY

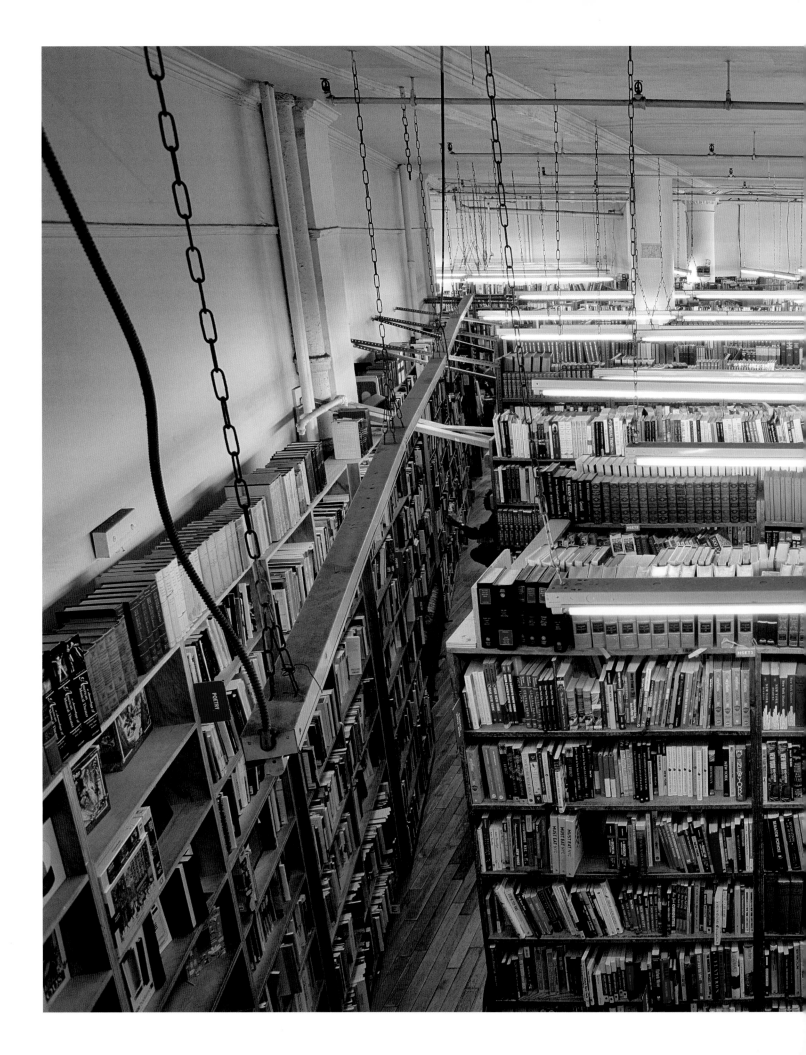

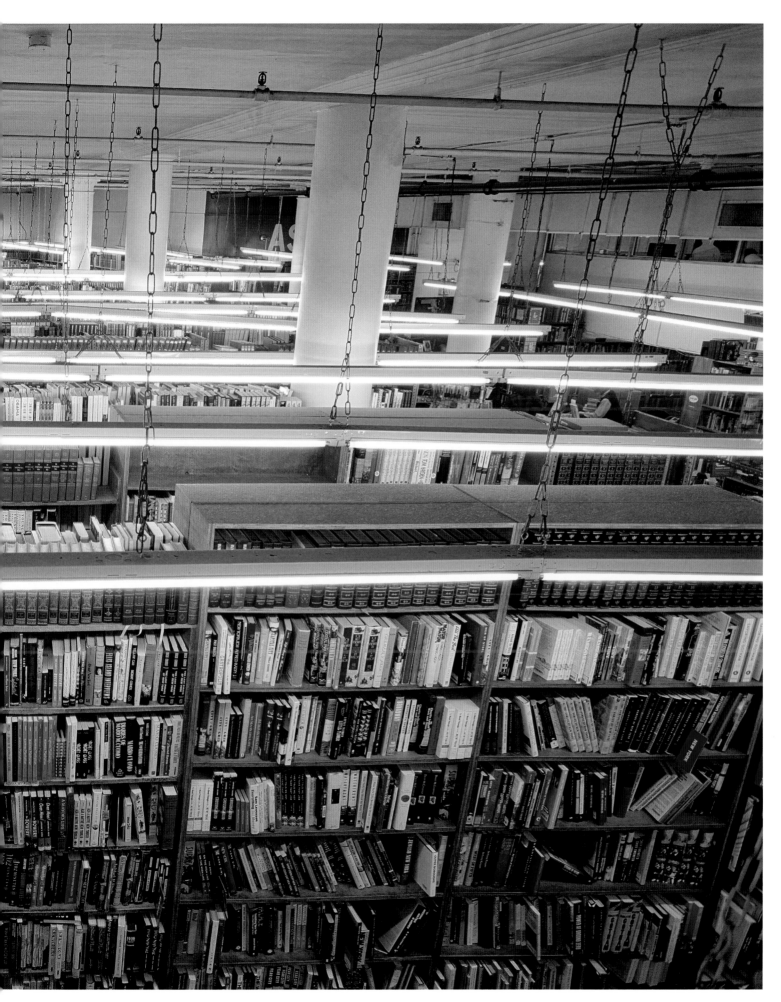

THE STRAND — NEW YORK CITY

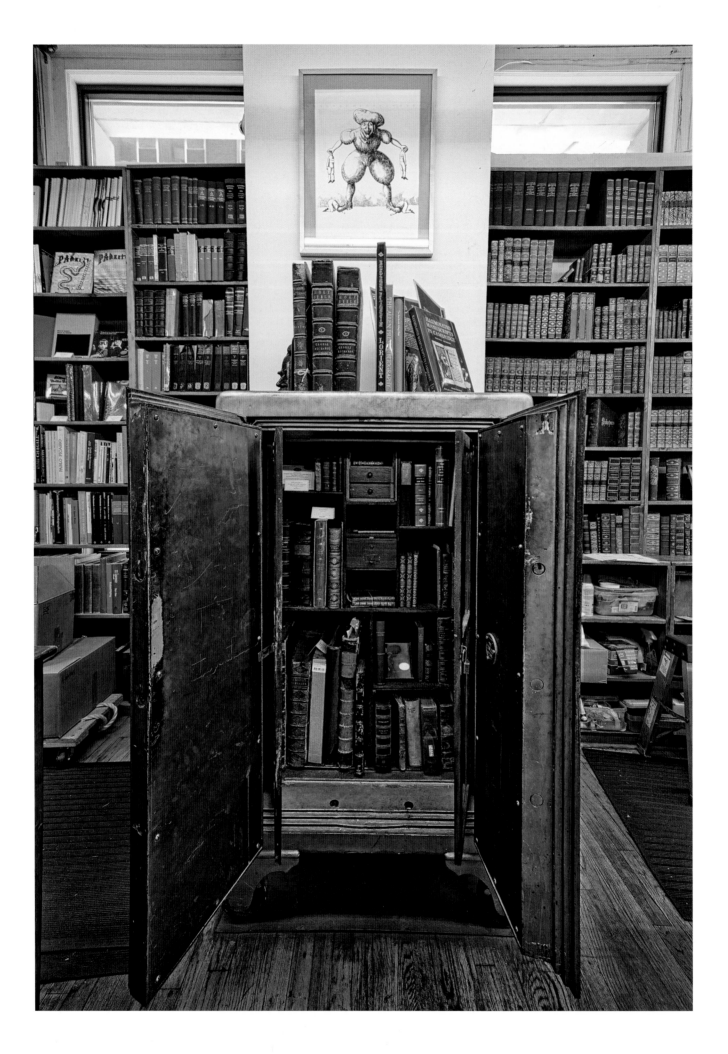

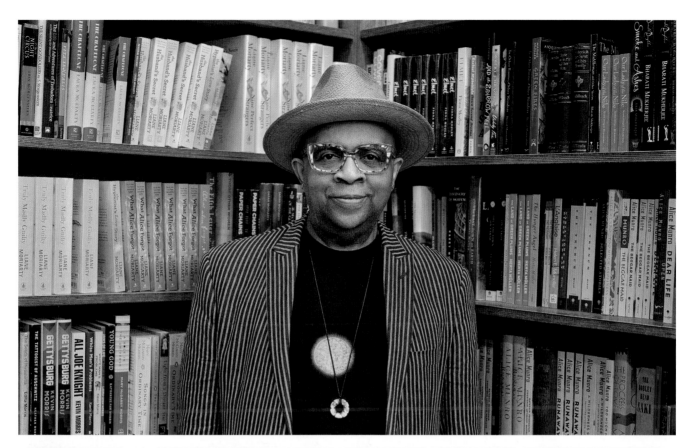

THE STRAND — NEW YORK CITY

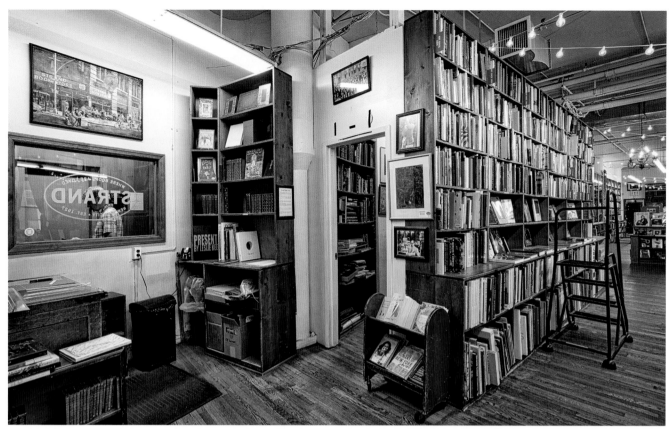

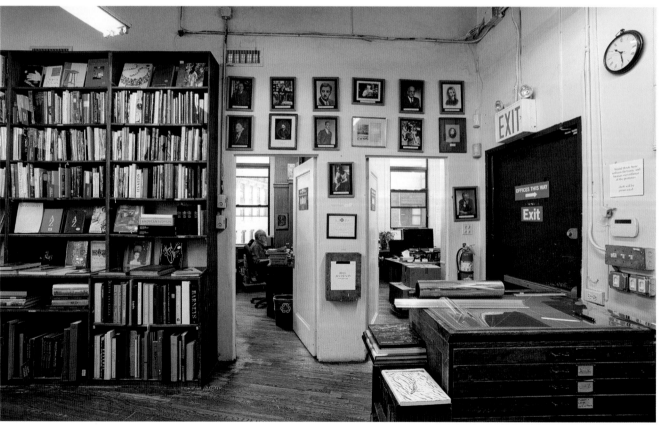

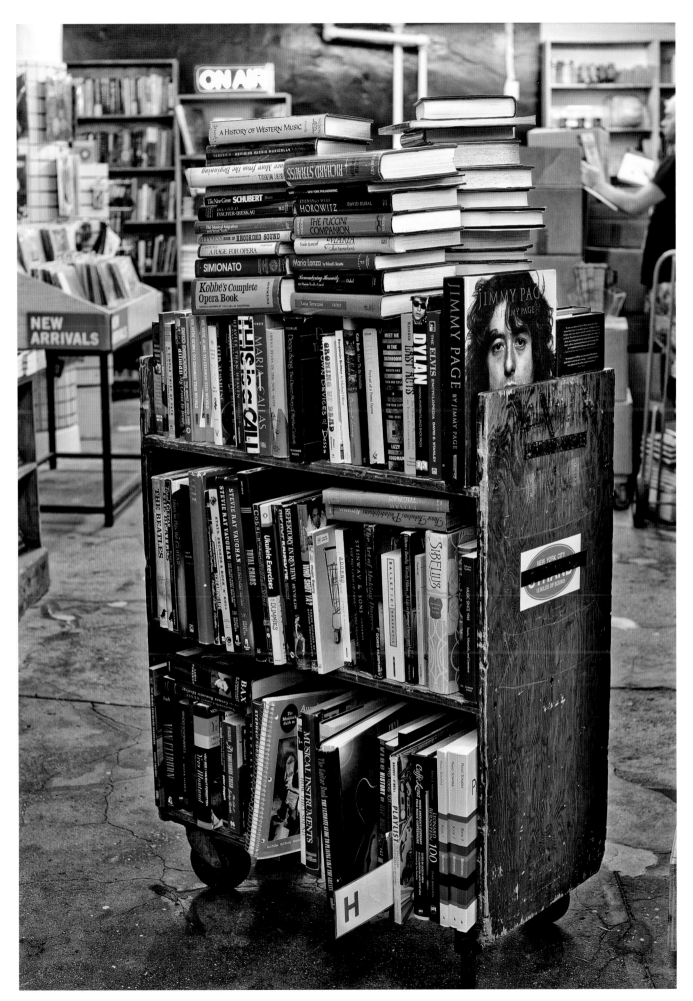

THE STRAND — NEW YORK CITY

Spoonbill & Sugartown

JONAS KYLE

We're not as mainstream or run-of-the-mill as other stores. A lot of them are straight, like the majority of people who live in New York City today. You don't have the freaks and weirdos and quasi-bohemians or poor starving artists or the substratum of people outside of society any more. Money swept in and drenched everything in sameness. So we present a little bit differently, which is maybe why people come in every day and say it's the best store they've ever seen. We'll have rare first editions, and interesting art monographs or academic treatises – like a photobook documenting the place of women in post-punk culture – and we'll stick with books that other people wouldn't even dream of ordering, like *Wabi-Sabi* by Leonard Koren, about the Japanese art of finding happiness, which has sold briskly here for fifteen years.

My favourite part of the store is our "Thought" section, which encompasses philosophy, literary theory and Barack Obama. We've purposely cast our net wide, because we want people to think. I also like having the classics to hand, like George Orwell's *1984*, which is never not relevant. We'll place them next to the newest authors, so that Virginia Woolf, say, can have a little conversation with Sally Rooney. We like to blur the lines. In fact, a lot of what we do is completely blurred.

This business keeps you young. I've had twenty years of intimate interactions with customers, which keeps you on your toes. And, if you take a step back, you realize that you've played a part, however small, in the city's intellectual culture. You have a sense of the currents running along under the surface of things – like Joan Didion and her sense of pervasive unease still being a thing, or the newer writers doing sci-fi as literature to explore our present dystopias. It's good to have had that vantage point.

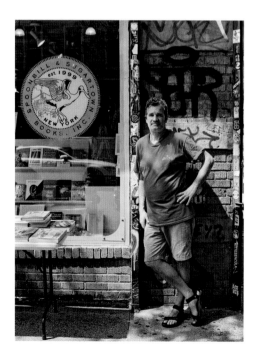

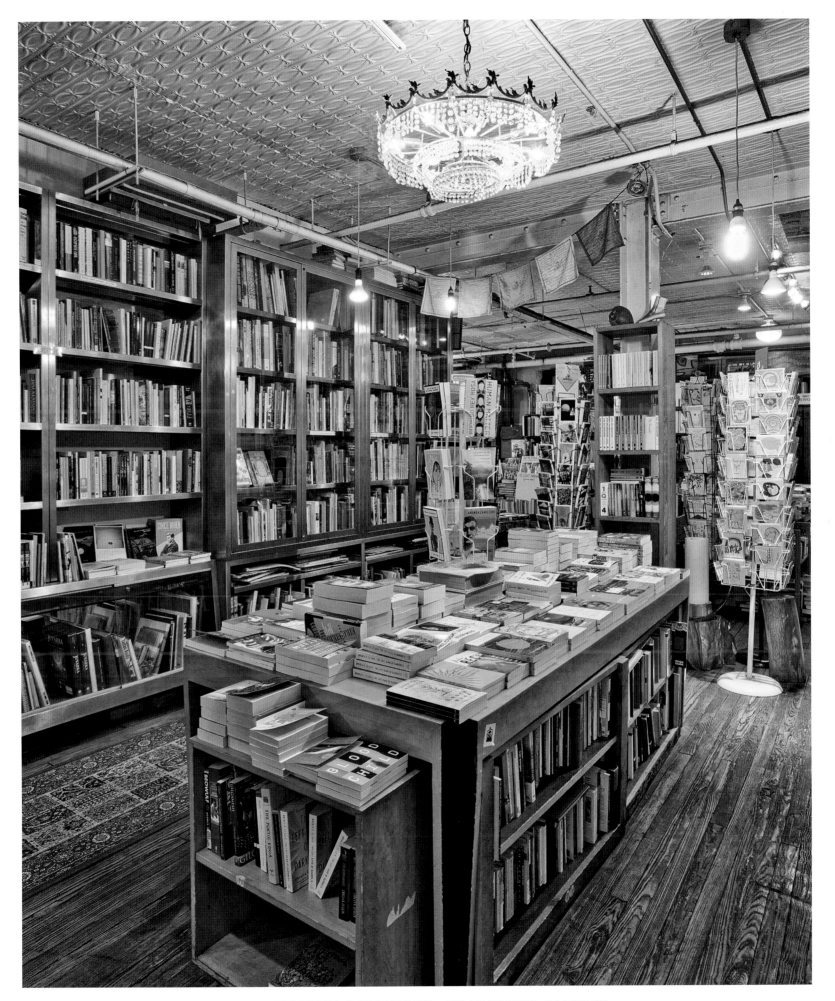

SPOONBILL & SUGARTOWN — WILLIAMSBURG, BROOKLYN

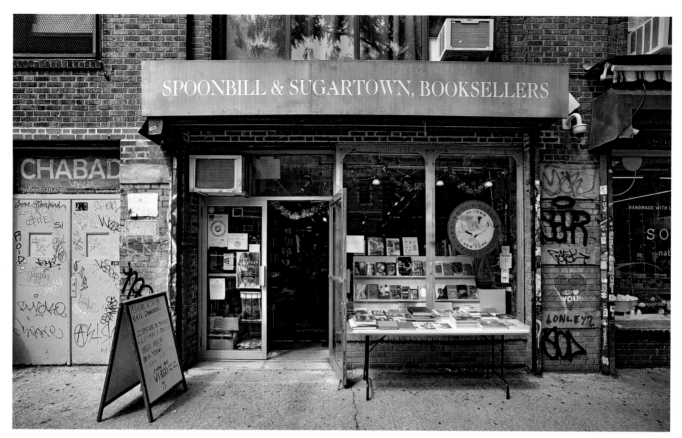

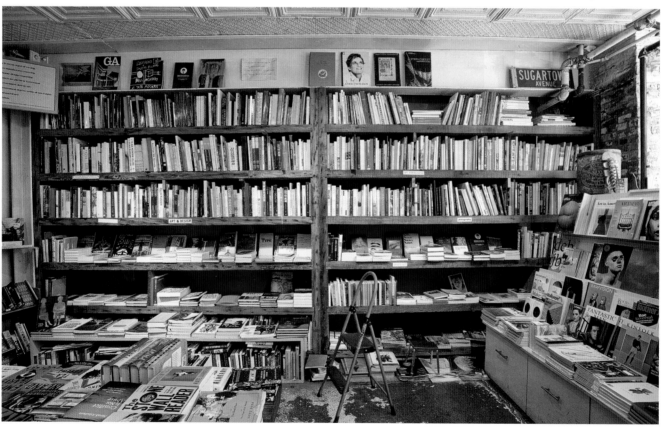

Dashwood Books

DAVID STRETTELL

Around 95 per cent of our stock is photography titles, from rare vintage finds to exciting new books from little publishers all over the world. People told me I was insane to open this place, but I was convinced I could make it work – there wasn't a place like it in New York and never really had been. I'd previously worked for Magnum, the photo agency, in their New York office, which was great, but because it's a cooperative, I had about forty bosses, some of them quite grumpy. After leaving, I thought, I just want to do something on my own, with a very small piece of real estate, where I call the shots.

I see Dashwood as a portal for ideas, to inspire other artists and photographers and even publishers. We're in a basement, and I wanted to keep the interior very plain and simple. It's not consciously Japanese-inspired, but I'm attracted to the way their stores are really thought through. I think it's old-fashioned in many ways, like one of those bespoke hat or shoe shops in Jermyn Street in London where they keep the patterns of your head or feet. Here, we have boxes for our regular customers, where we collect titles we think they'll like or find intriguing, to present to them each time they visit. It feels very custom. Given the internet, and the state of retail, you have to prioritize the customer, make them feel special.

The best thing about doing this? On any given day, anyone can walk through the door, from the artist Richard Prince to a bunch of students who probably won't know who he is, and interesting discussions will usually ensue. Things aren't incredibly expensive here, and we don't have an elitist attitude. It's idiosyncratic little spaces like this that make a city tick, I think.

This is a good period for photography books, if not a golden age. It goes hand in hand with the medium being recognized as an art form, and the books getting collectible, not to mention the likes of Martin Parr donating his collection of photobooks to the Tate. Actually, Martin was very helpful when I was setting this place up. I buy things every day and I'm always surprised by what I find out there, so I know my customers will be too.

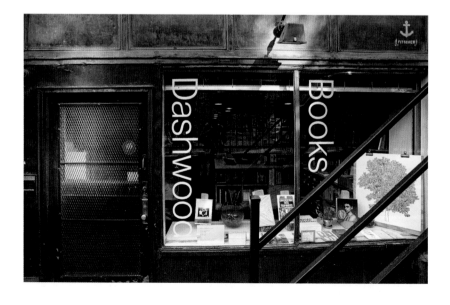

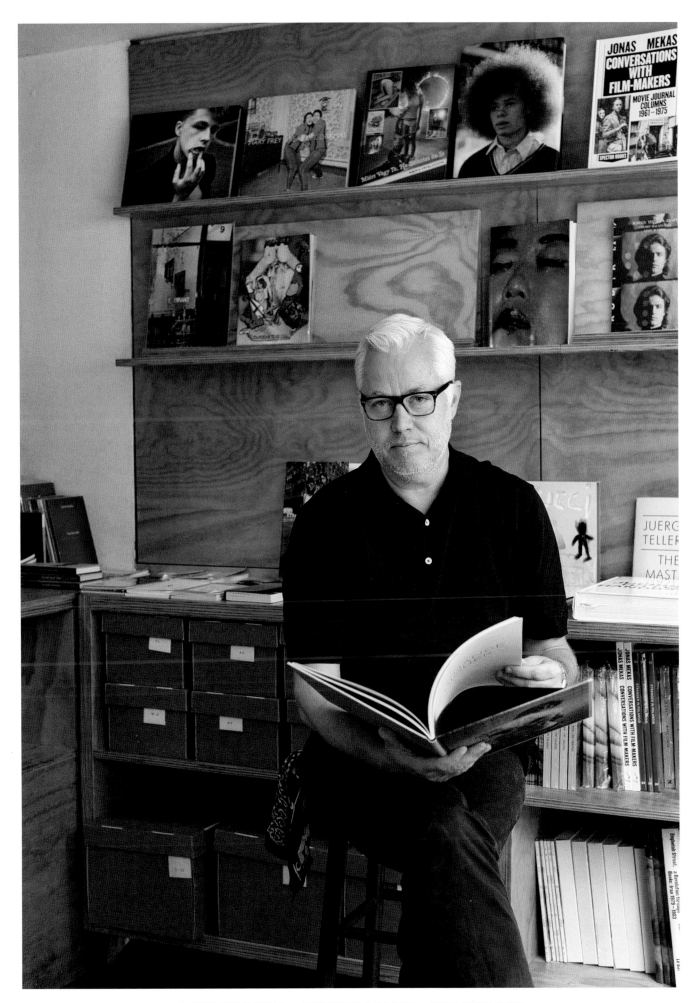

DAVID STRETTELL — DASHWOOD BOOKS — NEW YORK CITY

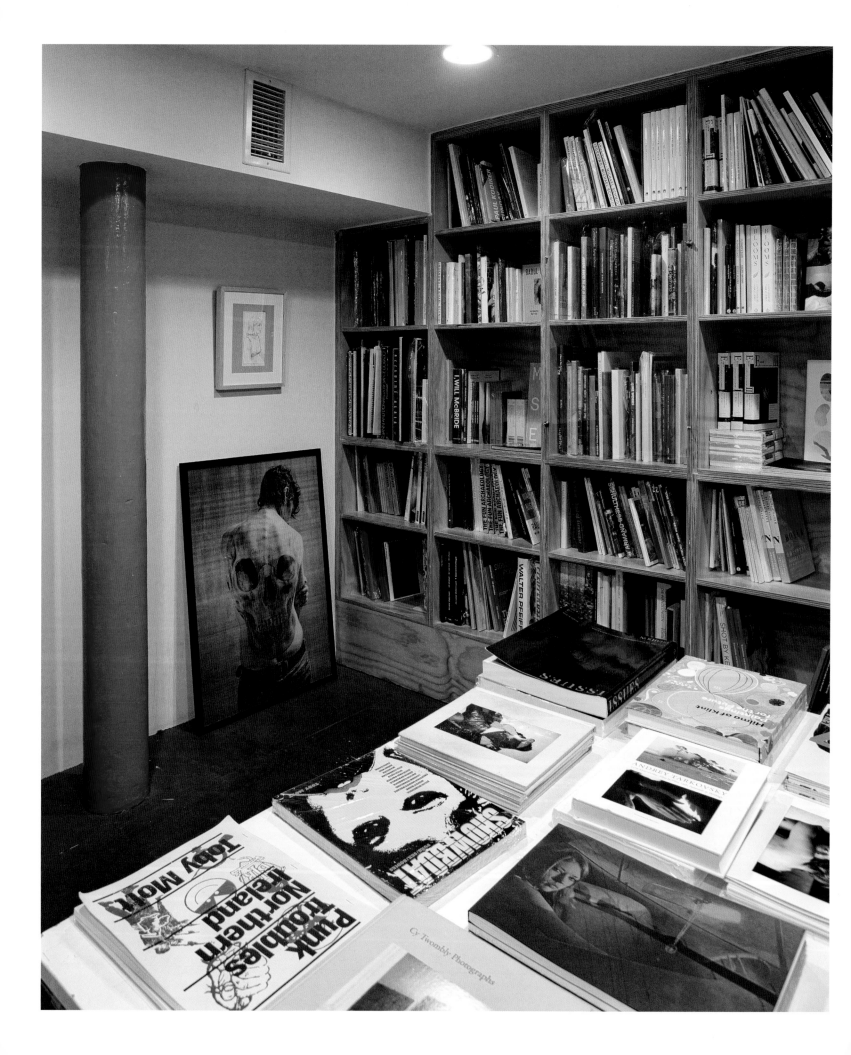

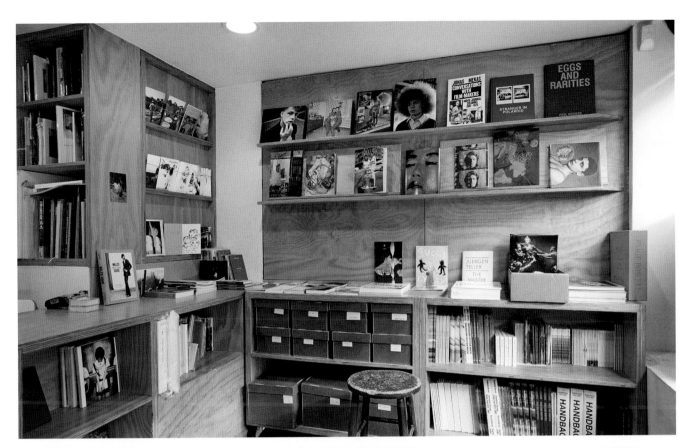

RIZZOLI

LIVIA SENIC-MATUGLIA

We had a store on 57th Street for over thirty years, but the building was demolished, and it closed in 2014. At the time, many independent bookstores were closing in Manhattan – high rents, Amazon, a perfect storm – but we wanted to keep faith with the city, and with Angelo Rizzoli's original mission, which was to provide beautiful books for an international audience. So we found this perfect space in NoMad – 5,000 square feet, eighteen-foot ceilings, three separate rooms and a skylight. When I first saw it, I thought it was it was a place where culture could be brought to life. We'd saved the furniture and chandeliers from the old store, and we got Fornasetti to design the wallpapers, which is an elegant connection with our Italian roots. So it sets off the luxury books perfectly, but we can also stage launches and events – all the things that a modern bookstore should be attentive to.

The ambience of the place? Well, New York can be loud and crazy, so there's a cathedral-like aspect to it; come in and have a break from Fifth Avenue, relax in our salon – there's pew-style seating – but we'll also warm the place up with weekend jazz brunches. Our clientele is really diverse, like New York City itself, so we have to keep pace with it.

The visual aspect of working with books is so important now, especially for an art and photography specialist like us. Book design has really come on in recent years, and we play a lot with display, like hanging pictures in a gallery. Cookbooks look amazing these days, and even our children's section is curated with an eye on the quality of illustration.

Books are the best way I know to really engage with the world of ideas. They're a long way beyond mere "content". They help train your brain, open it up to different ideas and viewpoints or to beautiful or challenging things. You're not just receiving information from them – you're getting a sentimental education.

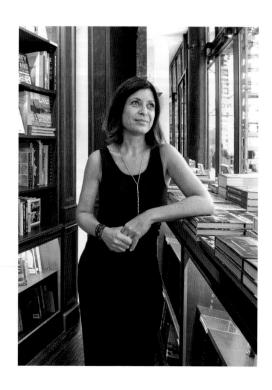

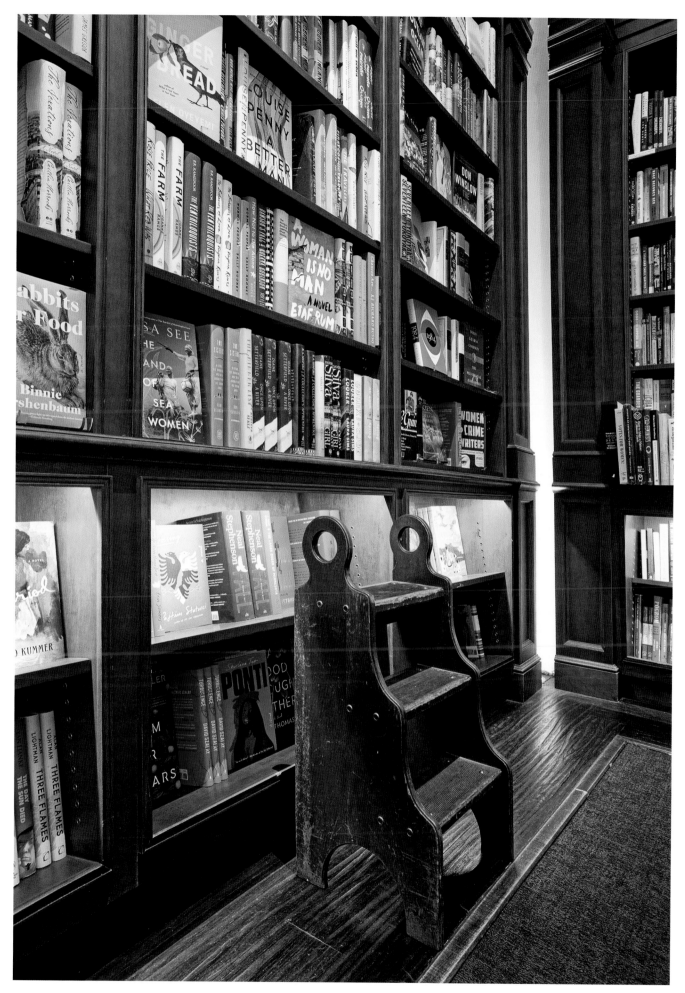

RIZZOLI — NEW YORK CITY

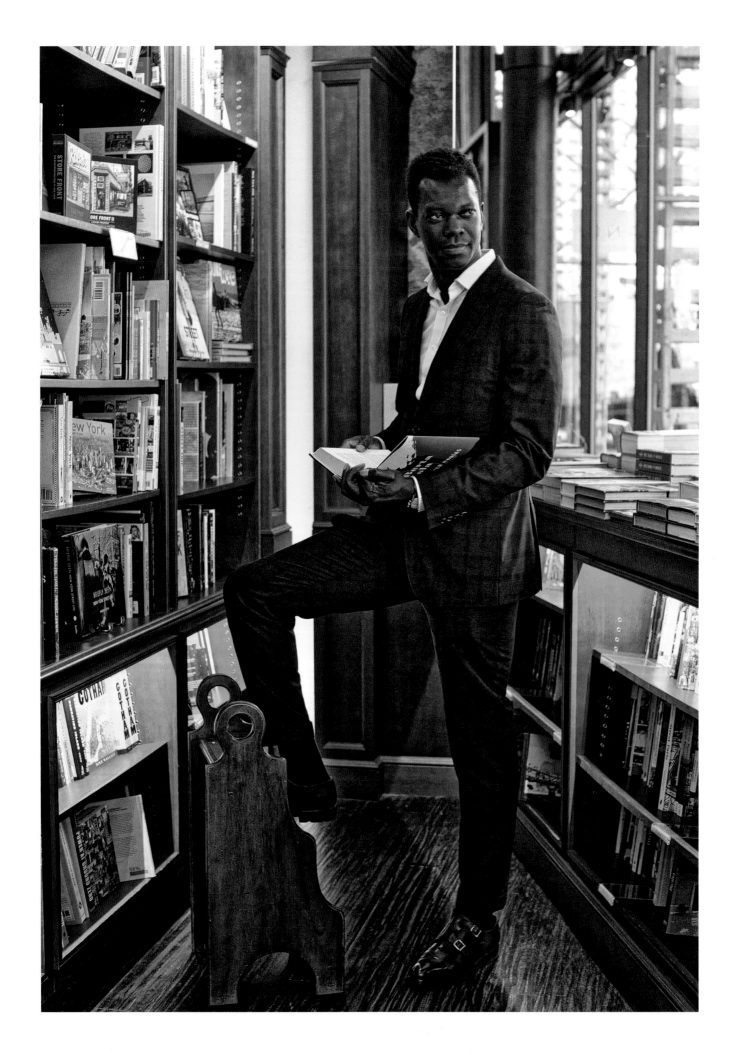

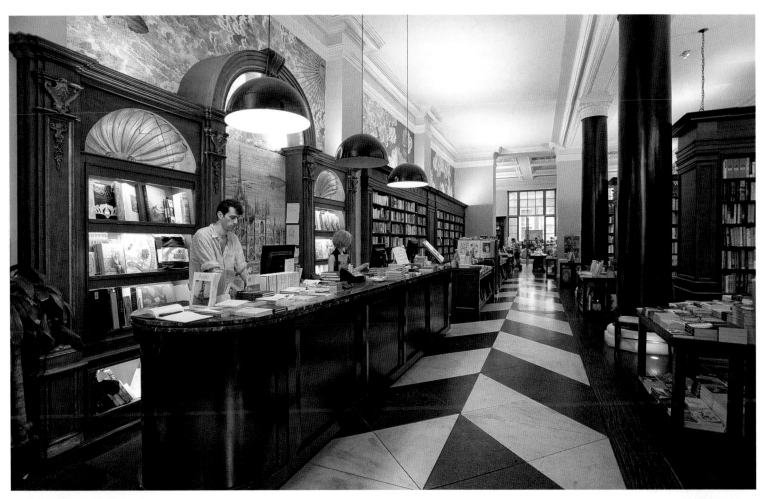

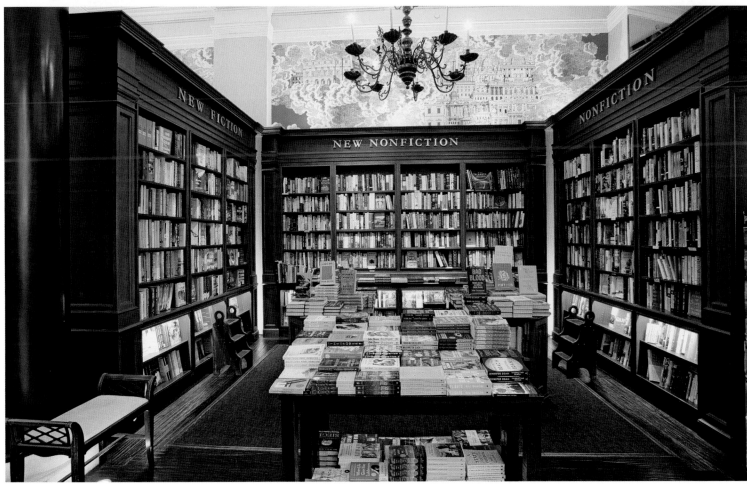

RIZZOLI — NEW YORK CITY

Books Are Magic

EMMA STRAUB

I'm an author who runs a bookstore. There are more of us than you'd think – Ann Patchett has Parnassus Books in Nashville, and Louise Erdrich owns Birch Bark in Minneapolis. And if you think about it, there's no better grounding for doing this, as we've all seen hundreds of stores on our book tours, and we've got a pretty good idea of what works and what doesn't.

I like to say that we – that's my husband Mike and I – opened this place out of necessity, when our local store, BookCourt, closed down after thirty-plus years. We were horrified; it was my family's favourite place in the world, just to go and hang out, and I knew there were plenty of other people who felt that way. We didn't need other jobs, as many people pointed out to us – I was making enough money off my books to support us, and Mike had plenty of design work. But to me, a community without a bookstore is like a body without a heart.

We got lucky with this space. It's warm, like books are, and we have lots of places where big and little people can sit. Lingering is encouraged, and the kicking off of shoes is positively commended. It's usually filled with people sprawling and reclining amid piles of books. I love it when spontaneous things happen, like I'll hear there's an author in town and I'll phone them up and get them to come do a reading in the kids' nook, or we'll make little films for our social media feeds. We're still in the honeymoon phase. Mike and I are significantly older than most of our booksellers, but we're the ones bringing the goofy energy.

For me, this place goes beyond a community hub – it's my entire social life. Our events programme is really diverse, from cookbook launches to kids' stories to science and literary fiction readings and signings, and we get completely different audiences for each. We had a panel of romance authors, and the room was filled with 200 women, most of whom hadn't been here before. And every poetry event we hold is packed, which is extremely heartening to me. I don't claim to be a good businesswoman, but I know what's important to me: giving people a place to go where they can commune with ideas.

Sure, people can buy every book ever printed online – if they don't care about their soul or the rest of the world. Luckily, people who read tend to care about those things. Maybe out-of-print or hard-to-find is fine for the internet, but when people come here their bodies are bathed in glitter – figuratively, mostly, but literally, if they like – and they become part of our world of solace and refuge, which is more important than ever when we feel so powerless in the face of all the horrible things happening in the world. My megaphone got a lot bigger since we opened; we have "melt the guns" tote bags by Carson Ellis, a children's illustrator, 100 per cent of the proceeds from which go to the fight against guns. And we have a poetry gumball machine, from which minds are fed and a different charity every month is compensated.

Running this place has impacted negatively on my writing life. I'd publish a book every two years before; with the new one, it's been four years. But now we're up and running, I think I'll be able to get back to work. I'll have to split my days, but I like the mix of solitary and social. It probably wouldn't have suited J. D. Salinger, but I'm so happy selling someone a book, talking to their kids, petting their dogs, crawling around on the carpet with children who don't belong to me, or telling people what to read on their honeymoon. There isn't a day when I don't feel vindicated. I get emails at least once a week from writers who want to open bookstores. I say be realistic, it's a business of course, but if you can make it work, it'll be so rewarding.

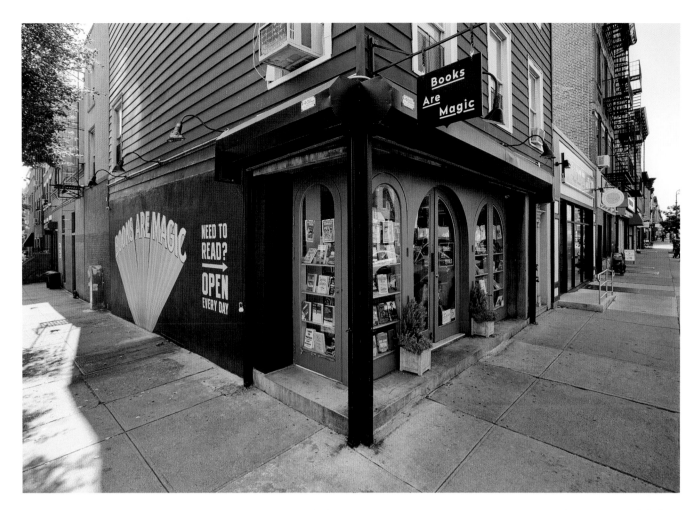

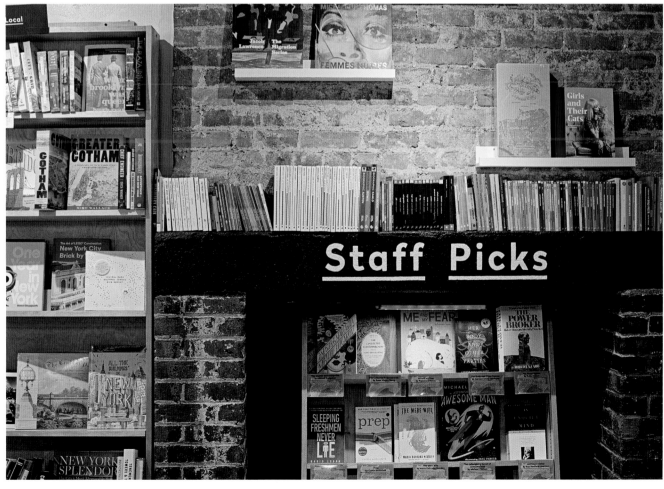

BOOKS ARE MAGIC — COBBLE HILL, BROOKLYN

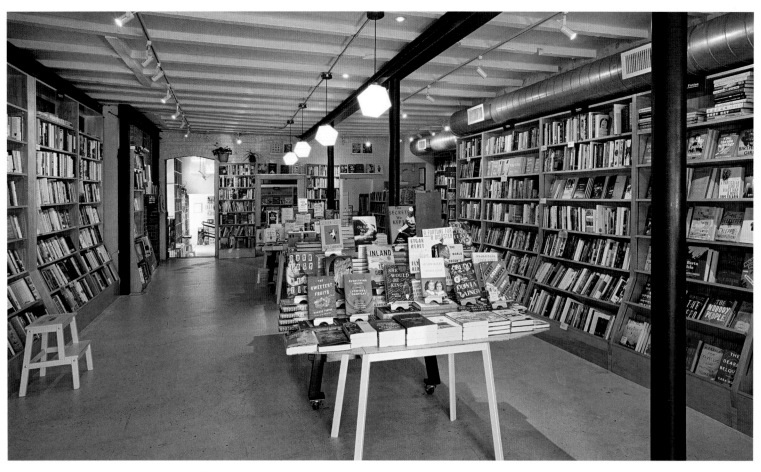

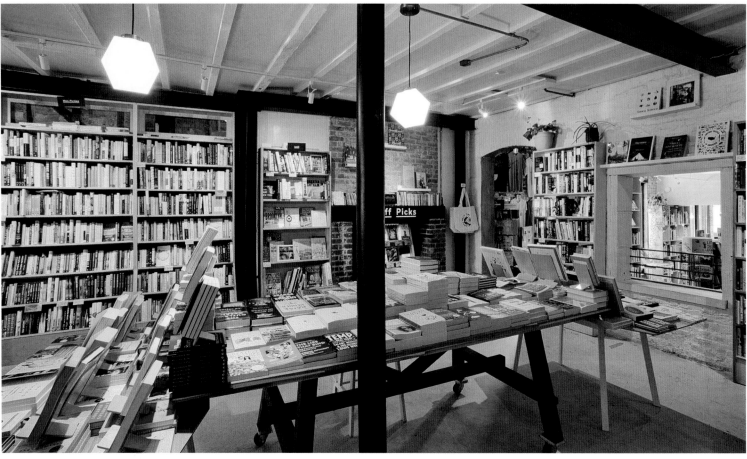

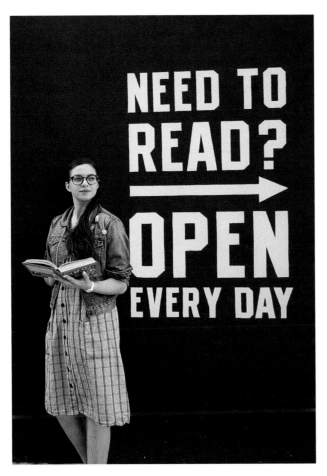

EMMA STRAUB (TOP RIGHT) — BOOKS ARE MAGIC — COBBLE HILL, BROOKLYN

City Lights Bookstore

PAUL YAMAZAKI

When Lawrence Ferlinghetti founded this place, it became the epicentre of mid-century counterculture. He'd seen a lot of carnage while serving during World War II – he'd been at Normandy during the D-Day landings – and he wanted to create a community of curiosity, where people from diverse backgrounds could create their own system of values rather than the received values that had led to the world going up in flames. He was a poet, author and translator – and he's still with us; we celebrated his 100th birthday in 2019 – and he thought of literature and art as a larger river of resistance. So it wasn't that City Lights begat the Beats, or vice versa; it was simply that when Allen Ginsberg and Jack Kerouac came west, it was natural for them to land here, where their ideas could take root. City Lights democratized the act of reading; independent bookselling after the war was still a middle-class endeavour, with paperbacks looked down on as cheap pulp. There was a huge reading population not being catered for. So Lawrence, along with his early partners Peter Martin and Shig Murao, made City Lights all-paperback, and published his own titles, including Allen Ginsberg's *Howl*, for which he was famously prosecuted for obscenity. The idea was that everyone would feel comfortable here. There are still plenty of alcoves and nooks to sit and read. Lawrence felt, and still feels very strongly, that the fundamental aspect of City Lights isn't transactional, but to absorb and process what we're offering, and if a transaction comes out of that, then fine.

I started here in 1970. I was politically active, but I'd never heard of City Lights till a friend brought me here. It's been an immense privilege to spend the decades here. We've become a pilgrimage site, of course – we've had people's ashes scattered on and around the premises, and we get many postcards thanking us for simply existing – and we're a San Francisco landmark, but we're still about those initial ideas of subversion and resistance. There have been opportunities to make a lot more money over the years, believe me, whether that's to franchise the name, or force the staff to wear berets and turtlenecks, like some kind of Beat theme park, but the spirit would be lost. The driving force is still in presenting alternative ways of thinking and being. We involve the staff as much as possible in book selection, and they find their own Diane di Primas or Allen Ginsbergs, which keeps the store vibrant and relevant. Things have to move forward – this place can't just be a heritage stop-off.

There was a period, around fifteen years ago, when people thought print was going to die, and bookstores with it, but then a new generation came through, with a commitment to books that I haven't seen since the 1970s. Physical books became sexy again, and we're also seeing a revival of the book as social signifier, in the way that, back in the 1960s and 1970s, carrying a Pocket Poets or a Grove Black Cat in your hand was a sign that you were tuned in to the counterculture. Now the book under your arm is a statement all over again, and it's being led by younger readers – to me, that's anyone under 40 – perhaps as a reaction to devices and earbuds. It's not a Luddite rejection of tech – they're living in both worlds, analogue and digital. They can coexist!

My favourite section? I like "Muckraking", but I'm immensely proud of our "Third World Fiction" section and its breadth of African fiction in particular. What we're trying to demonstrate here is that literature, particularly contemporary literature, comes from so many different traditions and languages. I'm very optimistic that we'll keep the flame alive. My father is 103, and I'll be the same age when City Lights turns 100. I'd love to come back here on that day, and see the next generation opening minds, engaging with ideas, passing them on.

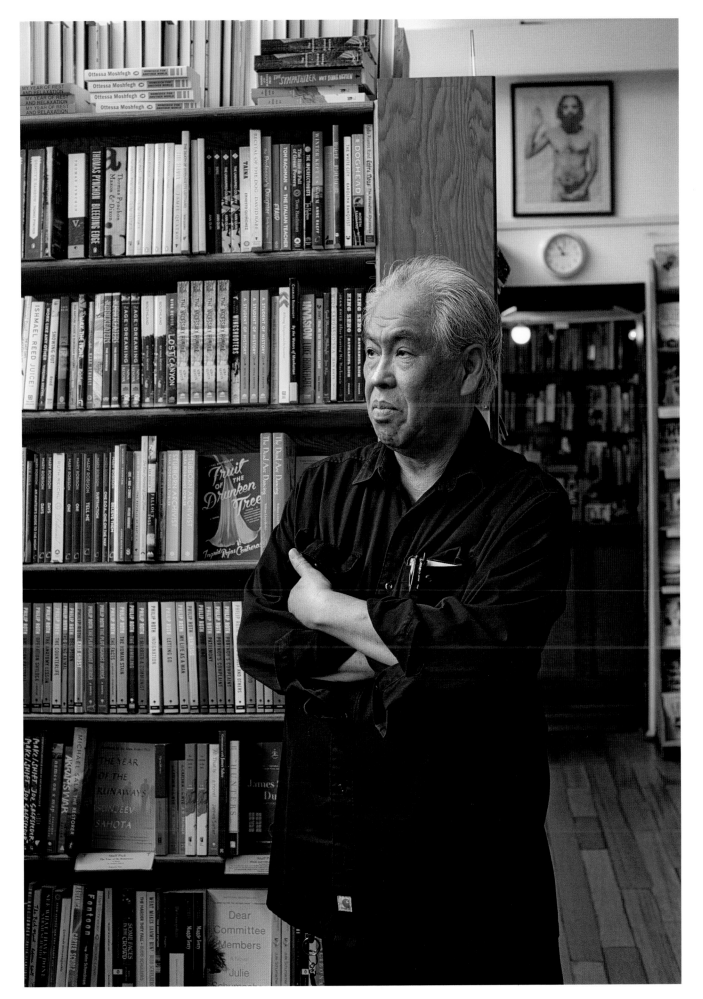

PAUL YAMAZAKI — CITY LIGHTS BOOKSTORE — SAN FRANCISCO

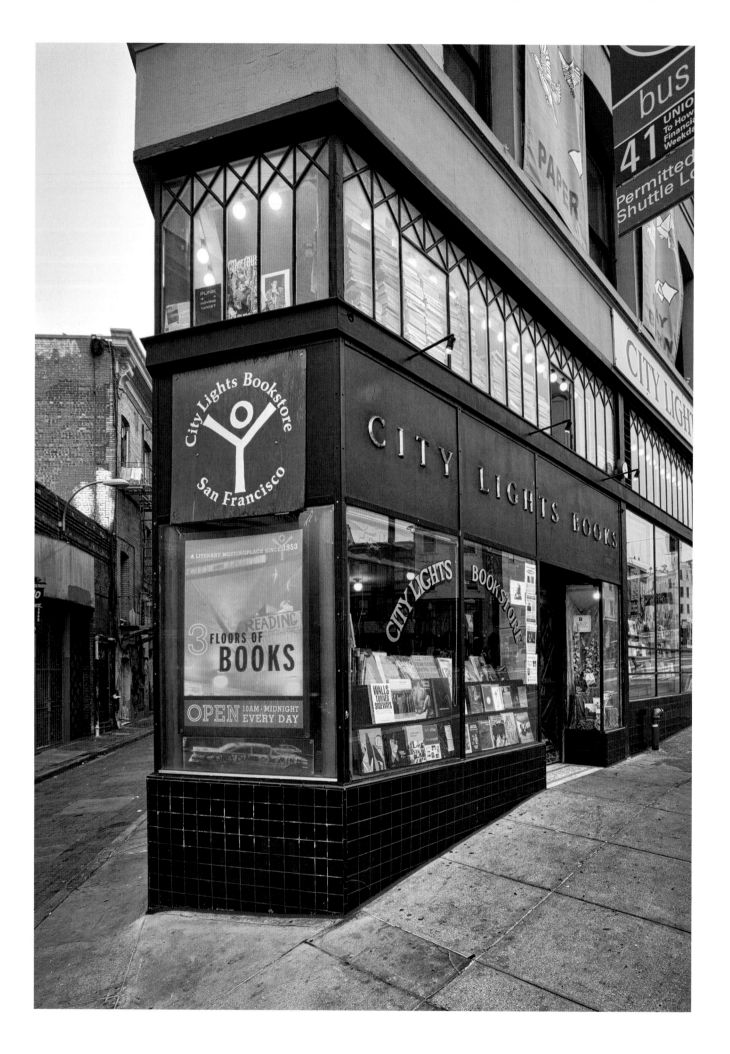

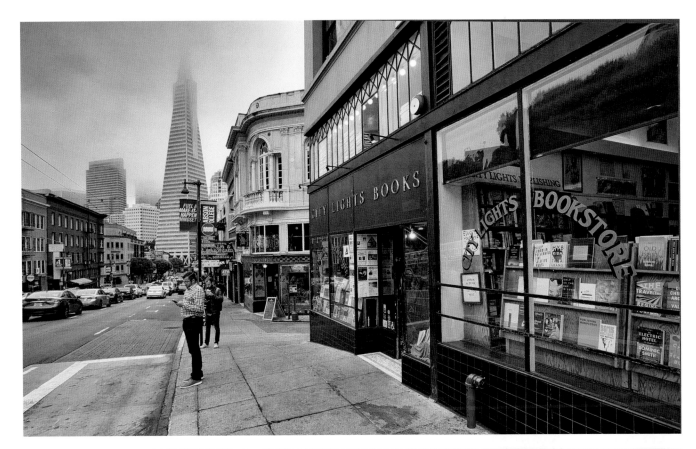

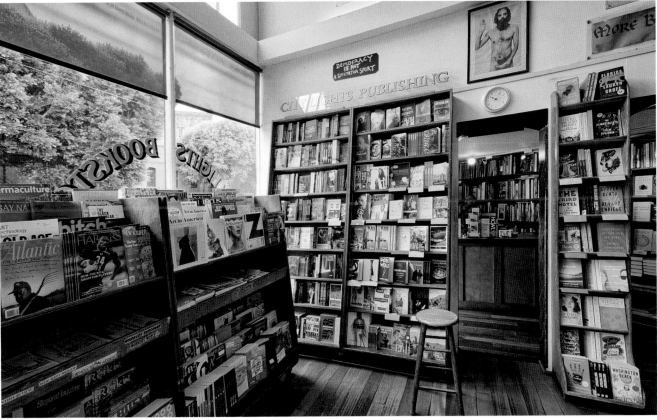

CITY LIGHTS BOOKSTORE – SAN FRANCISCO

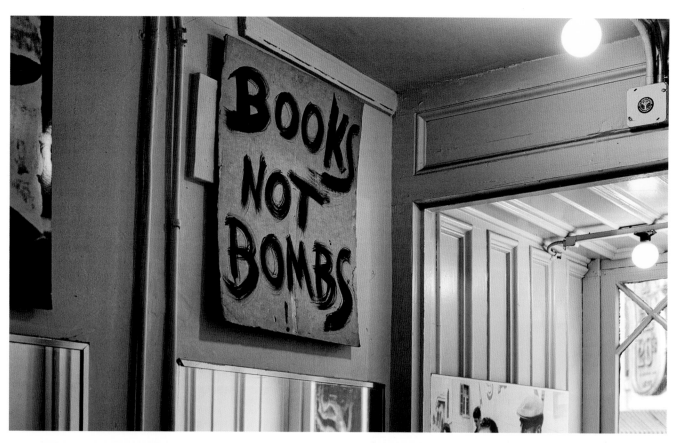

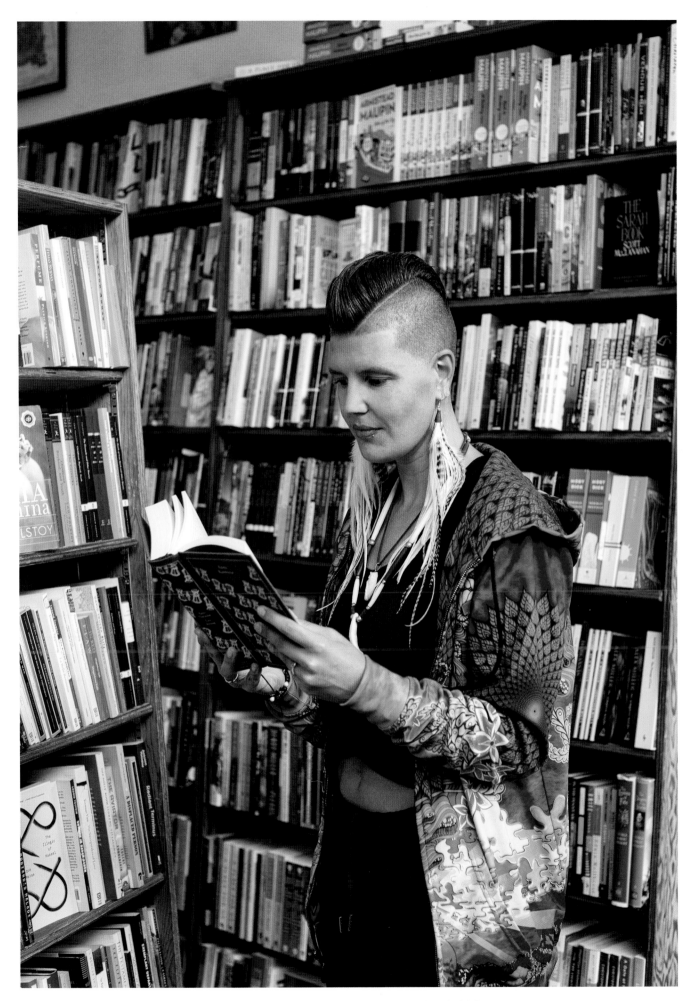

CITY LIGHTS BOOKSTORE — SAN FRANCISCO

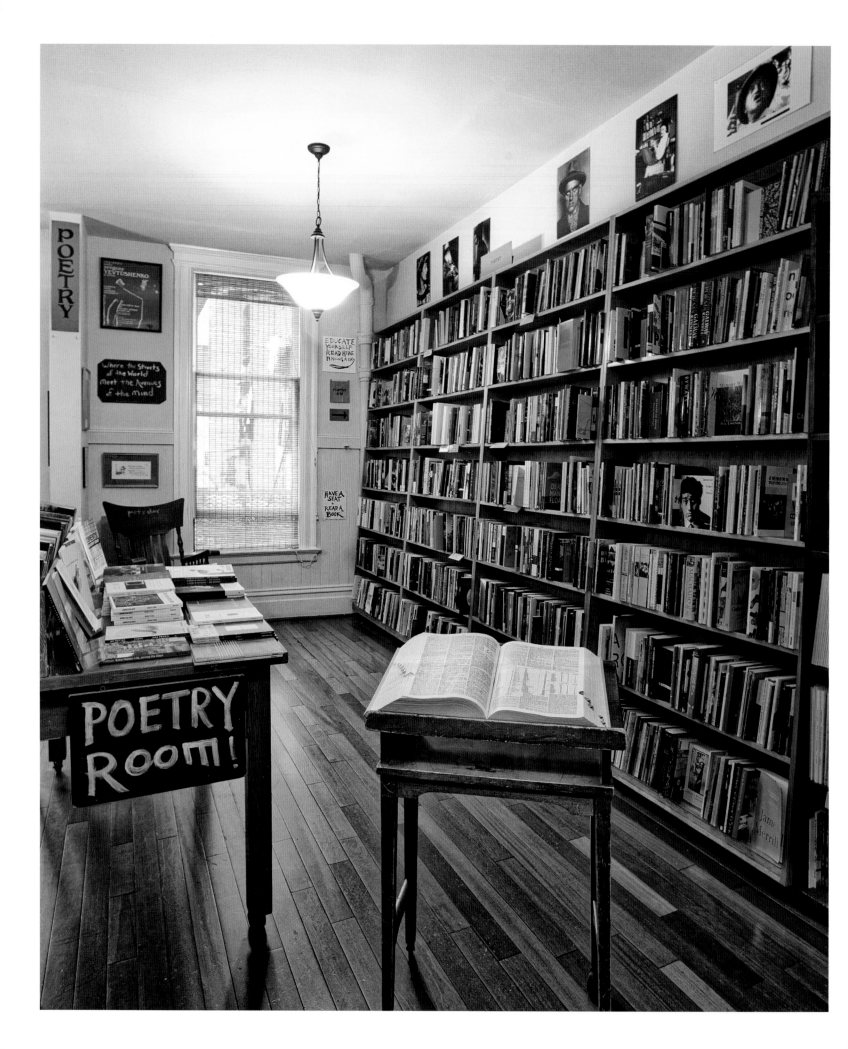

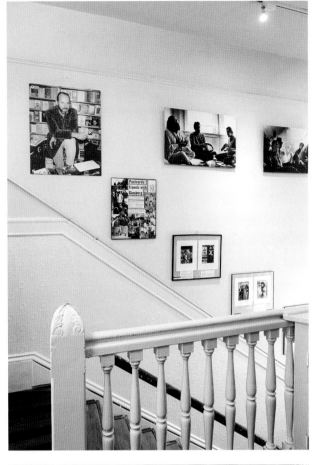

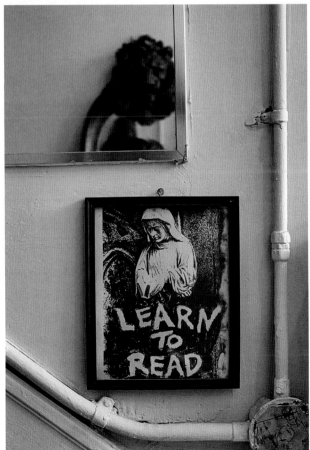

CITY LIGHTS BOOKSTORE — SAN FRANCISCO

Green Apple Books

KEVIN RYAN

The thing that marks us out? I honestly think that it's the physical beauty of the store. This is a pre-1906 earthquake building, and the space has expanded piecemeal over the years to the point where it's quite labyrinthine – we have many odd turns and dead ends, about ten different flooring surfaces, and quite arcane section headings like "Circus Magic and Hobo". And you'll find things randomly stuck on the wall a decade ago that have just hung around, like someone designating the place we're sitting in "The Granny Smith Room". You can't focus-group that kind of thing. This is a literary town and we can sell lots of offbeat, interesting things. We bought Paul Kantner's books when he left the neighbourhood, and among them we found an Abbie Hoffman book inscribed to the Jefferson Airplane.

It was like the ultimate San Francisco artefact. I wish we hadn't sold it.

Sure, people could buy any book they want on the internet, but we had some videos on our YouTube channel with the tagline "pull on some pants and get out of the house". And people are so loyal to this place. They'll say, I grew up amid those racks, or I met my boyfriend here. We've had a proposal, and some marriages, and at least one death occur here. No births that I know of, but maybe some conceptions. Actually, someone shot a porno here one time. Not the money shots, but the sort of browsing-the-racks-and-making-eye-contact shots. They didn't ask our permission, but hey, we're a bookstore. We're pretty open-minded.

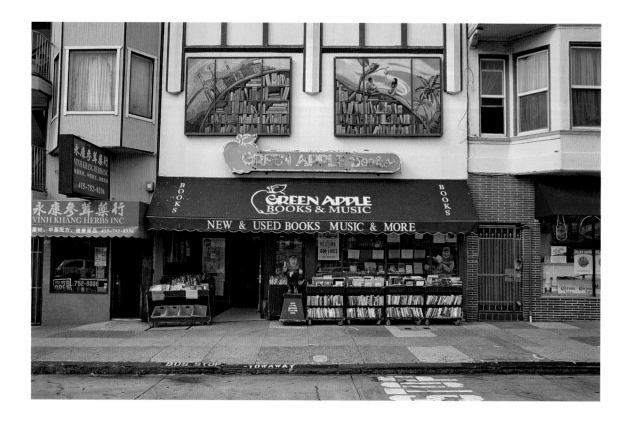

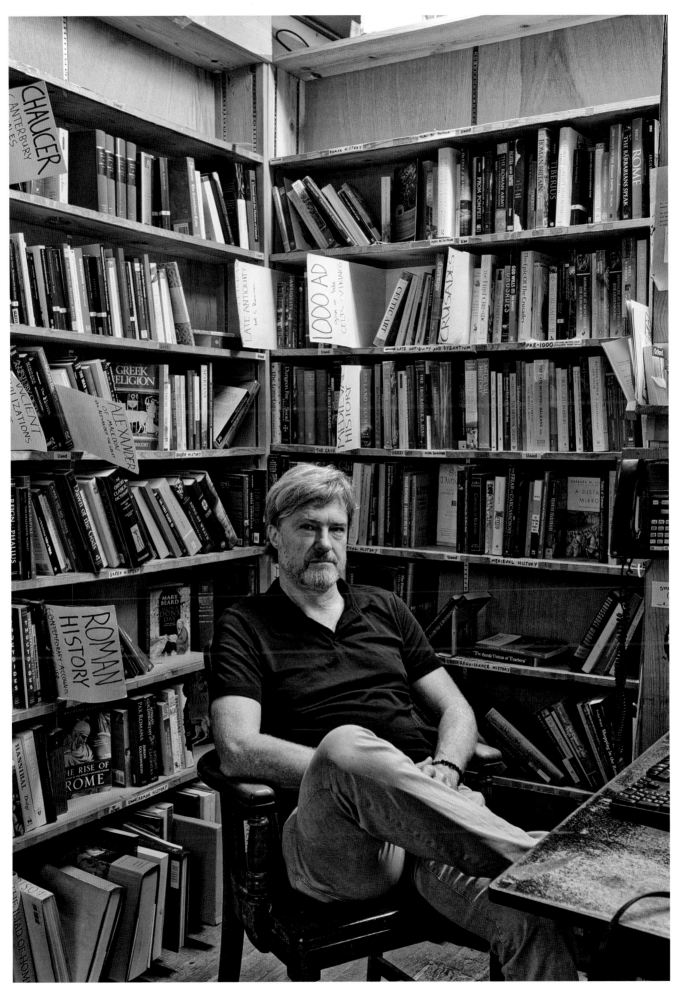

KEVIN RYAN — GREEN APPLE BOOKS — SAN FRANCISCO

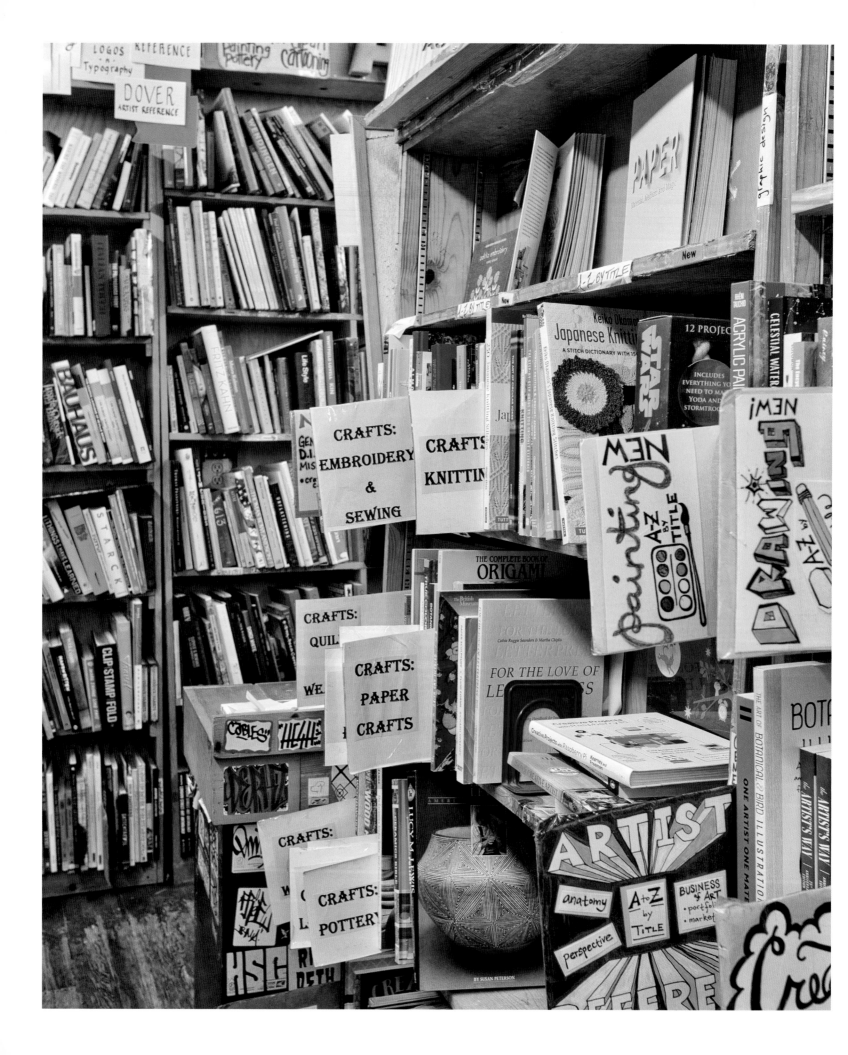

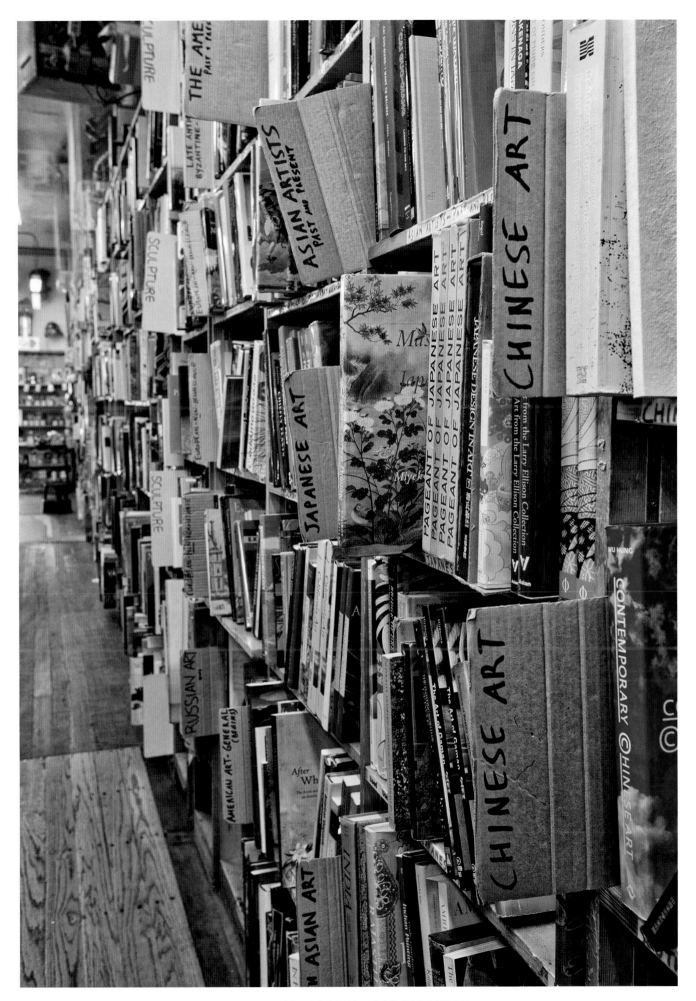

GREEN APPLE BOOKS – SAN FRANCISCO

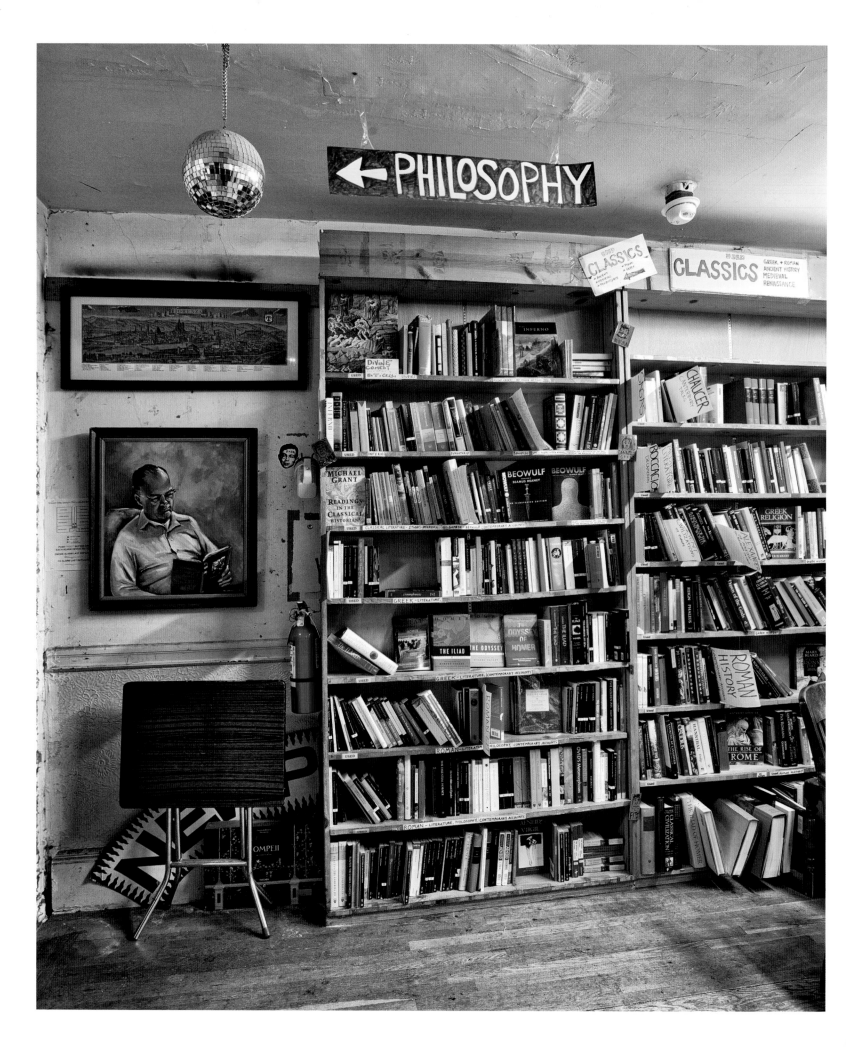

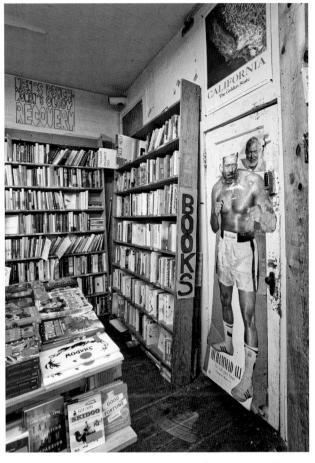
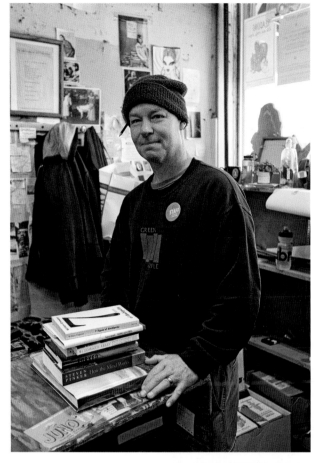
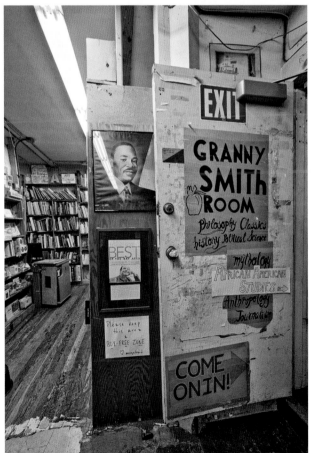
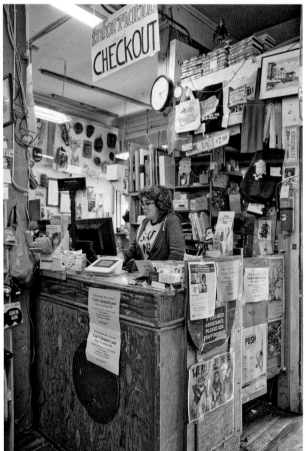

William Stout Books

WILLIAM STOUT

I'm an architect who's built up a library of architecture, design and art titles. We have around 70,000 titles altogether. I would bring back rare and interesting titles on my trips to Europe, and I started the store in my apartment in 1974, which I opened up from 11 a.m. to 2 p.m. It became a kind of salon for architects, but as the stacks grew higher I thought the floors might give way. We've had several stores since, but when we moved here twenty years ago there were around 200 architects within ten blocks, so we acted as a kind of ideas hub. It was a way for me to still be in touch with architecture without practicing.

I stock books that make the store unique and reveal what's going on around the world. It's a learning experience for me, as well as the customers. The best of the books are beautiful and very-well designed. I personally have a huge Frank Lloyd Wright and Le Corbusier collection – 300 to 400 books on each, including a signed copy of Wright's *The House Beautiful*, which was hand-printed in 1890 in an edition of ninety. But there aren't too many of us left in the United States doing this kind of thing. We're mostly on the West Coast, and you can count us on the fingers of one hand. Current architecture students don't value books as much – they probably will later, when they realize all the information on the computer's outdated – and younger people don't collect in the way they used to. I have to lead by example. But that means that people sometimes come into the store expecting to find me there, so I tell the staff to say I died some years ago. You have to have a sense of humour or you would go crazy.

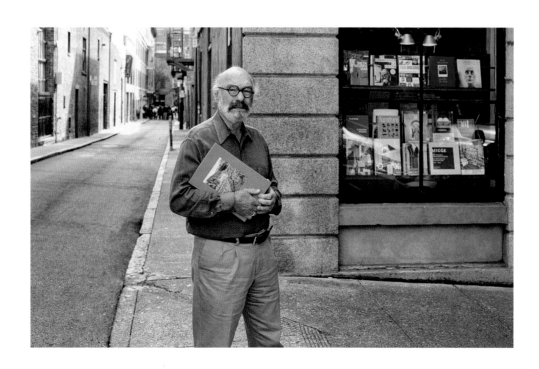

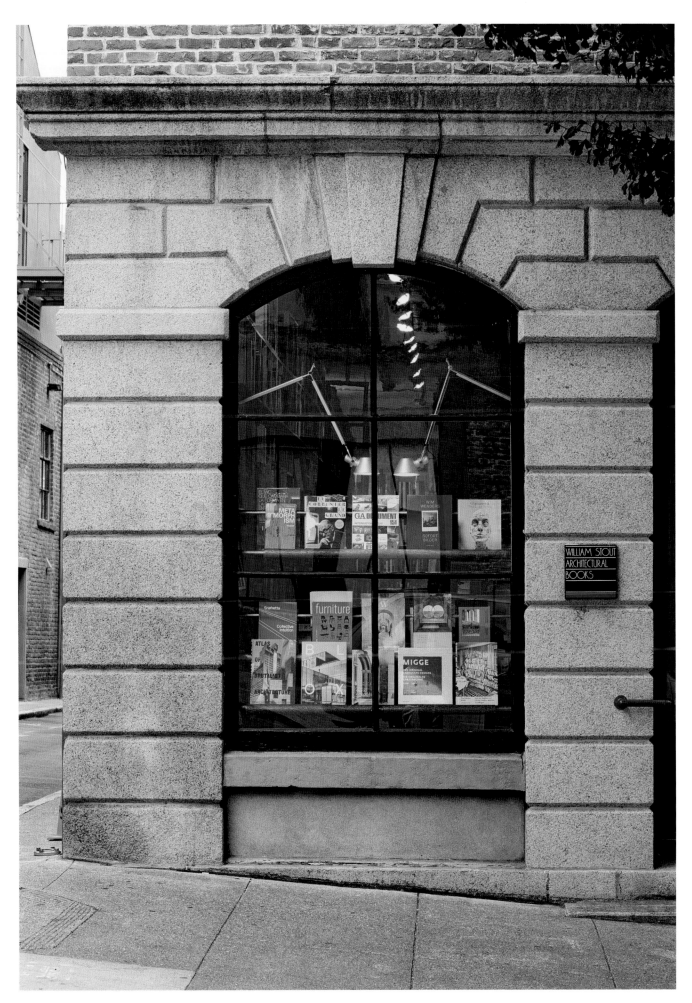

WILLIAM STOUT BOOKS – SAN FRANCISCO

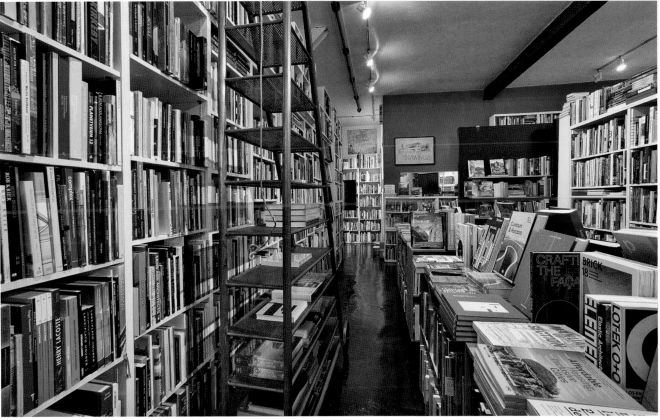

Dog Eared Books

KATE RAZO

I've been running bookstores since 1985 – I've had five stores in eight locations across the city. I'd been to college for about a year and realized it wasn't for me, then I had a series of terrible jobs, then I got a job in a used bookstore and thought, this is it. All of it spoke to me – being surrounded by books, handling books, looking through them and finding things people had hidden – keepsakes, photographs no one should see, social security checks, and money. My lifetime total for money that I found in books so far? $105.

The imperative thing for me in running a bookstore is that you have to have an open mind. You can't get stuck, because you won't stay in business. Once upon a time we set the trends for culture and thought; now things move so fast, we're trying to hang on to the tail. But that means we've become a space where people seek respite from the rest of their lives, a place where they can think more clearly and deeply.

We received legacy business status from the city in 2016, which means our value in making a "significant contribution to San Francisco's identity" has been recognized. It also means that landlords are incentivized to grant long-term leases, which has been a huge help, because in some ways we're living through the death of retail. I've hung onto this place through five different landlords, which is remarkable. I think it's important that we can act as a constant in an ever-changing city.

What do we do better than other bookstores? Well, I'm stubborn, I haven't caved in. And I'm not so arrogant that I think I have all the answers. For example, we used to have really tall shelves in here, and one of my managers said we should take them down, make the aisles less canyon-like. I thought, but that means fewer books! That can't be right! But we sell more now.

I think there's a big analogue pushback to the digital culture. We have signs in the store saying that cell phone reception is much better outside. We're careful about the music we play, the atmosphere we've created. It's not just anywhere, so I ask people not to be on their phones in here. The nicest thing I've heard? People say this store is one of the reasons that they want to continue to live in this city. It's wonderful to see generations growing up with books, discovering the joy of reading for themselves. I've tried to inspire people, and I've loaned money to people so they could start their own stores. It's been a great ride – I started when I was 24, and I'll soon be turning 59. No regrets. I'd do it all again.

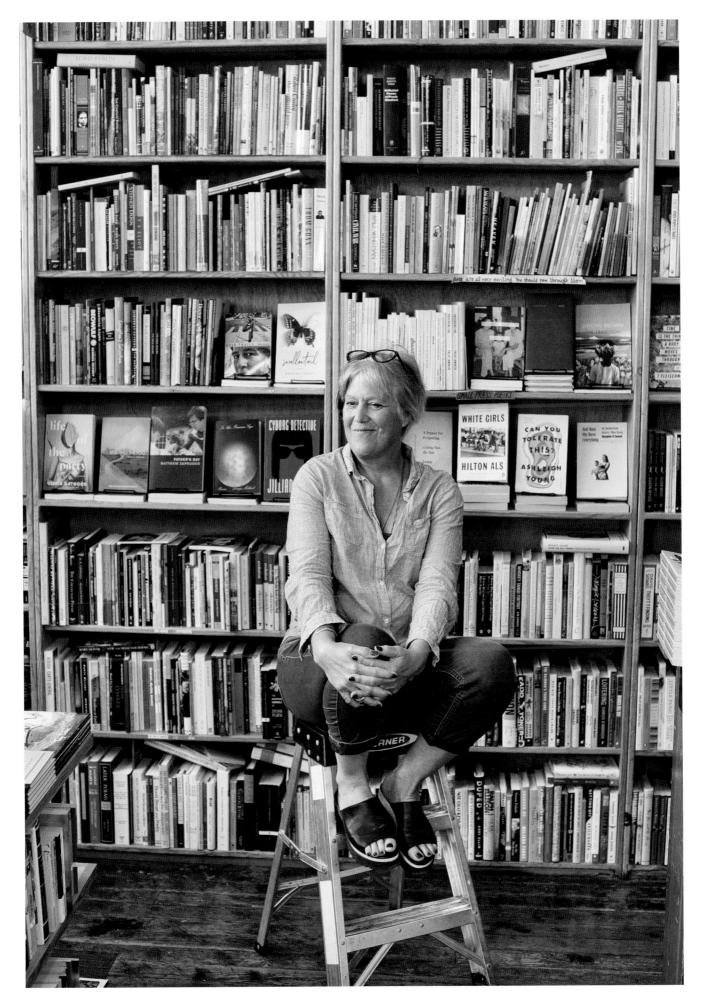

KATE RAZO – DOG EARED BOOKS – SAN FRANCISCO

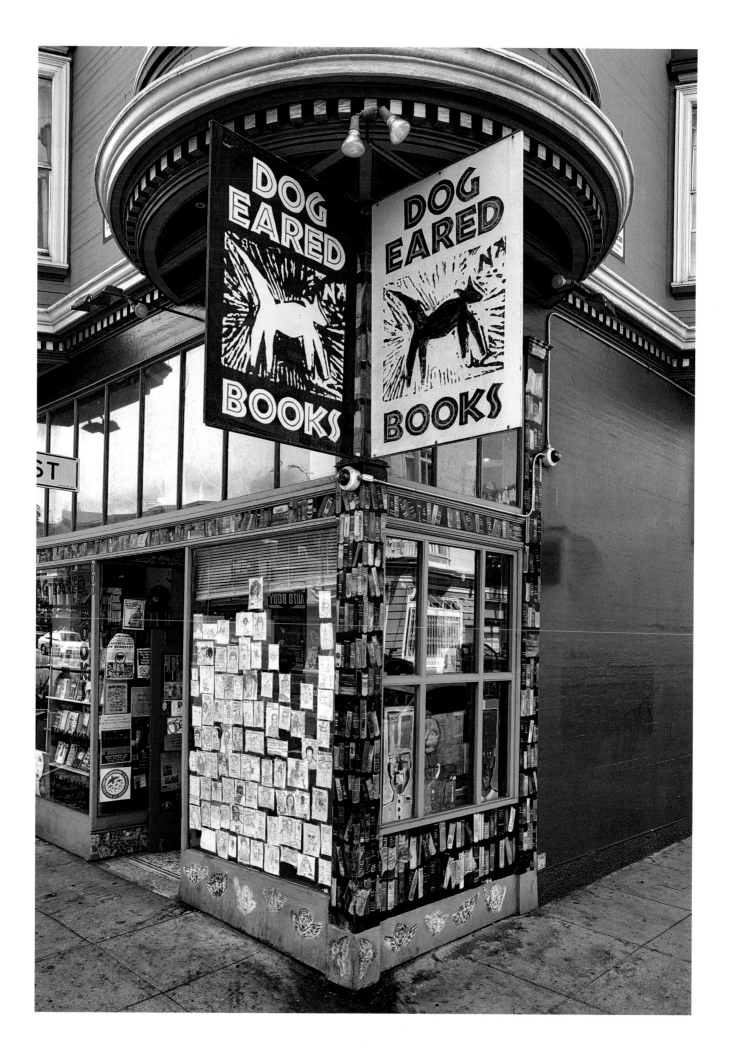

DOG EARED BOOKS — SAN FRANCISCO

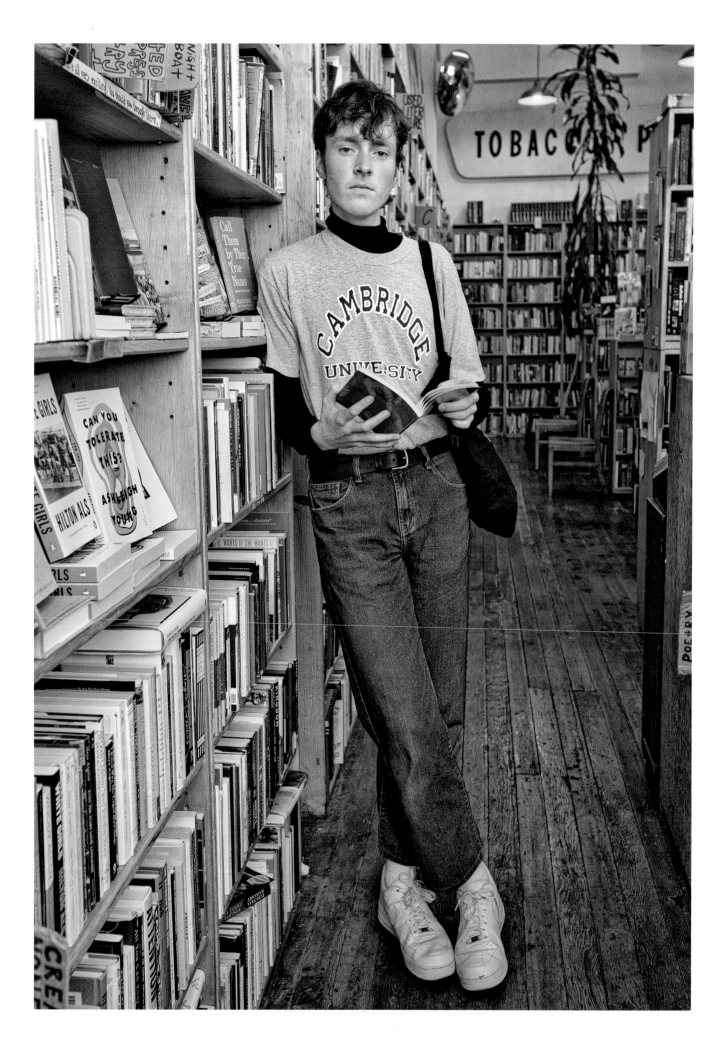

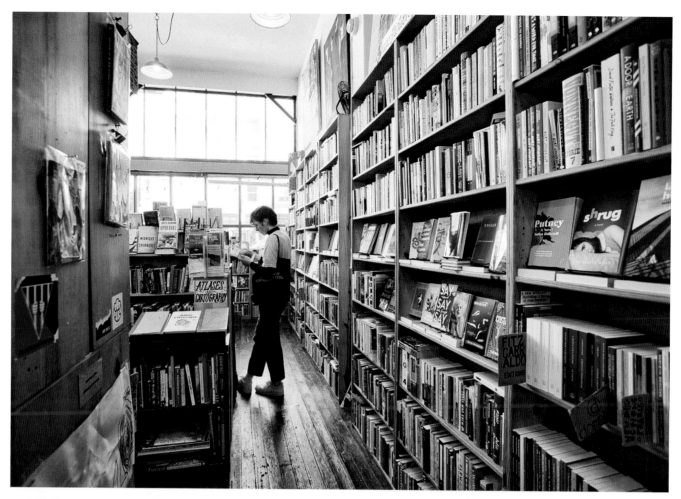

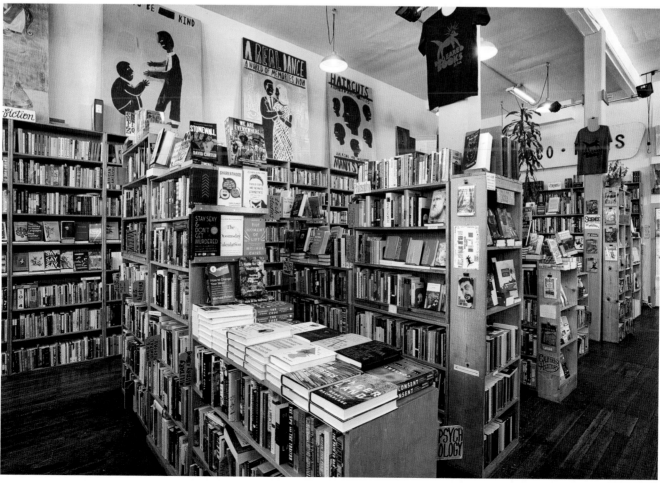

DOG EARED BOOKS — SAN FRANCISCO

Baldwin's Book Barn

FRED DANNAWAY

This was a dairy barn, built in 1822. Mr Baldwin, who just died recently, had run a book business since the early 1930s – he had a book wagon, and would roll from town to town – and he bought the place and added three extra floors to accommodate his growing inventory. You'll find a lot of vintage fruit crates that we use for shelving. It's definitely got an old-world charm, though we tend to huddle round the stove in winter.

I was a schoolteacher in my previous life. I taught English and this place was a great resource for me – I'd be here at least once a month, sitting upstairs and reading, seldom buying. The day I retired, I woke up and thought, what did I do? Two hours into it, and I was bored. So I jumped in my car and came here, and as it happened, Mr Baldwin was looking for help. The key to our success? It's a place of serenity and retreat. We have a living room where people can sit all day, or study, or write poetry. A Quaker family built the place, so that may factor in. And thanks to Facebook and Instagram, people come from far and wide. Just recently a couple drove all the way from Illinois just to visit, and the lady was crying when she came in; she was overcome.

I found a first edition of *The Great Gatsby* when I was clearing out an old storeroom. There were bugs and leaves in the cabinet drawers, and I reached down and saw a copy of *Gatsby* with a dust jacket. That's pretty rare in itself, but the "Jay" had also been misprinted with a small j throughout, and a capital J had been hand-stamped over it. So that turned a $10,000 book into one that we sold for $100,000.

I'll stay here till they carry me out. I have a hard time believing I'm being paid for this.

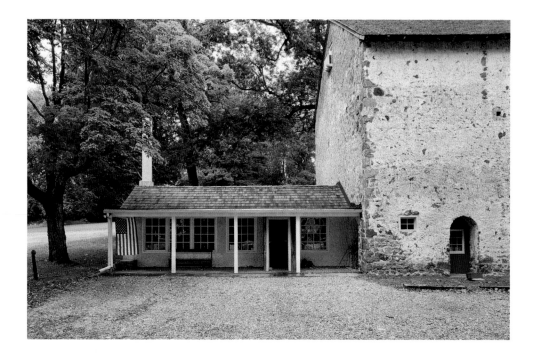

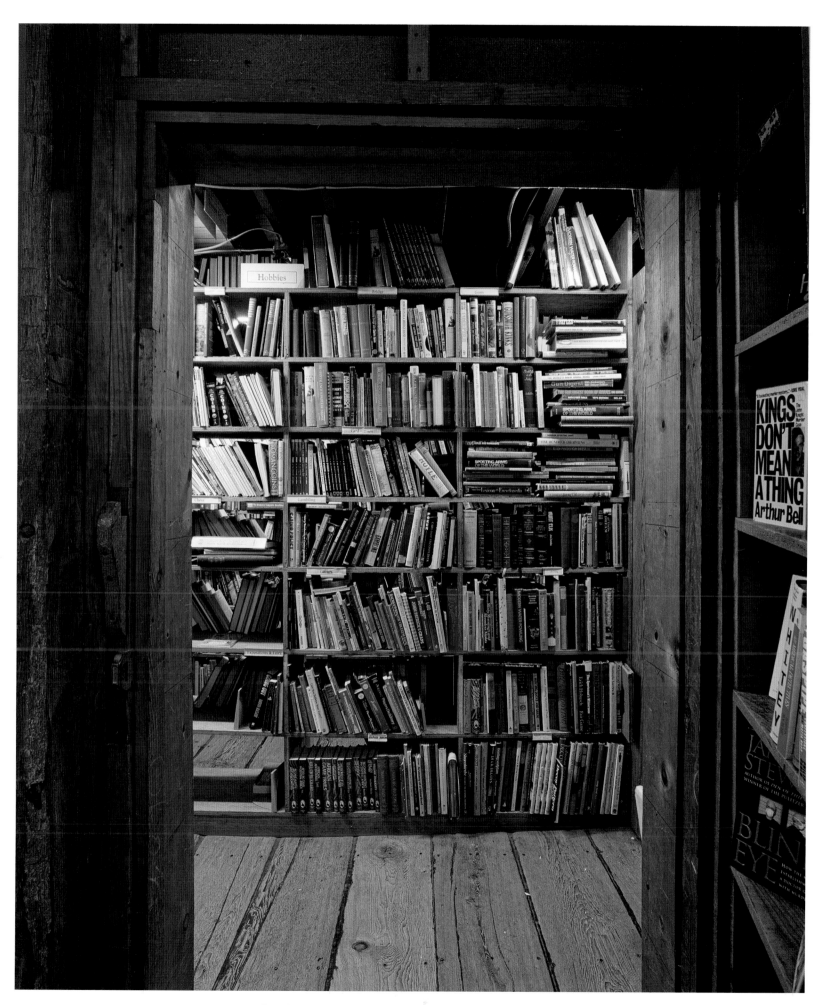

BALDWIN'S BOOK BARN — WEST CHESTER, PENNSYLVANIA

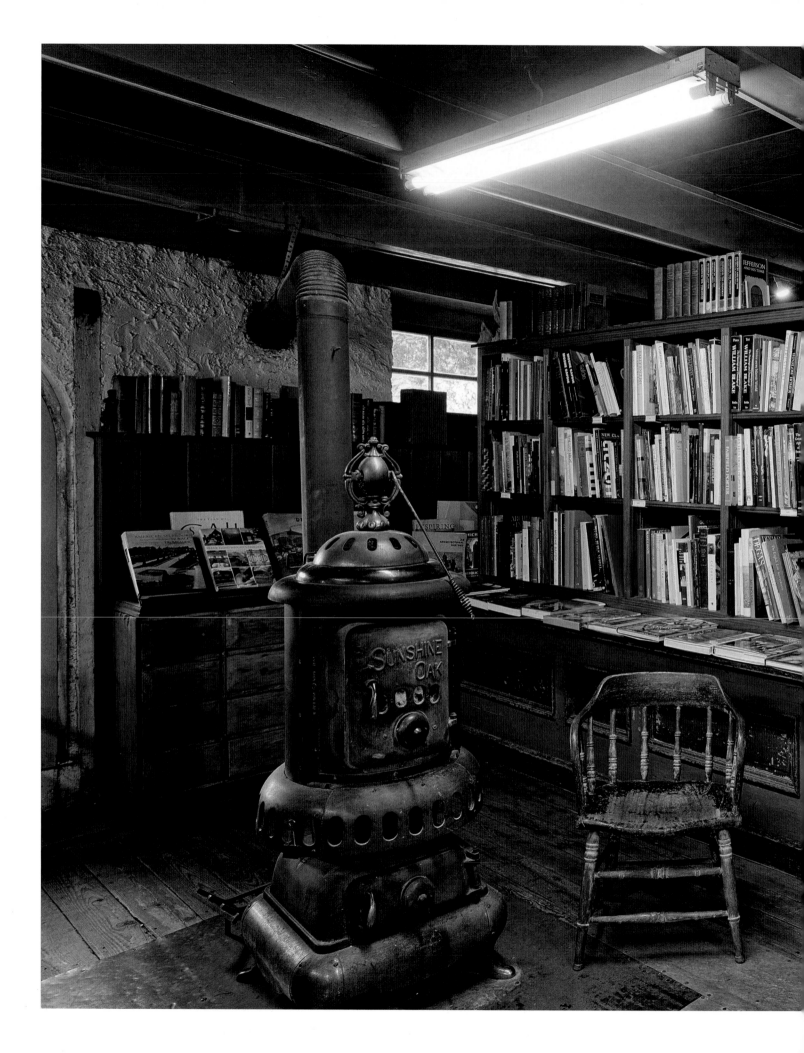

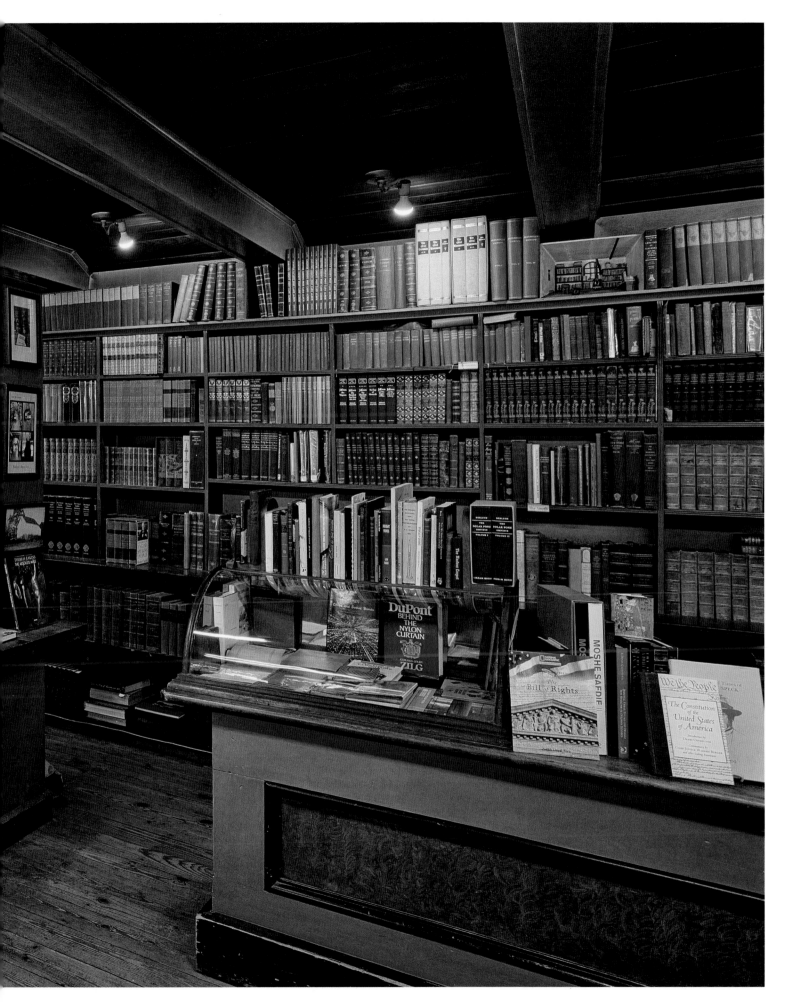

BALDWIN'S BOOK BARN — WEST CHESTER, PENNSYLVANIA

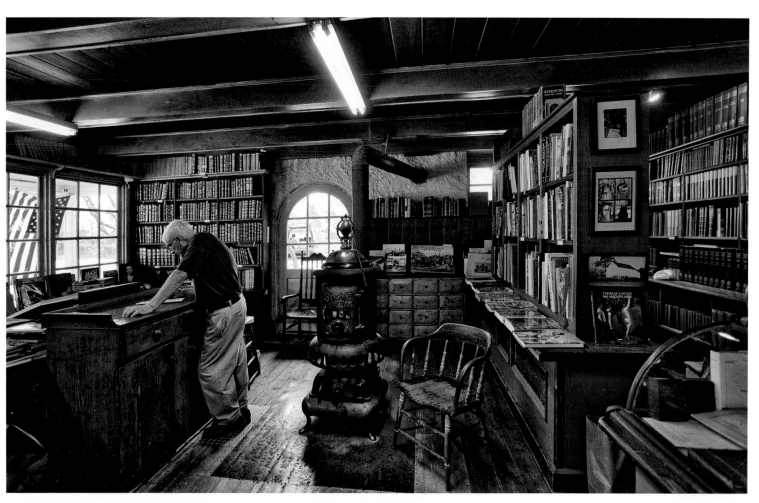
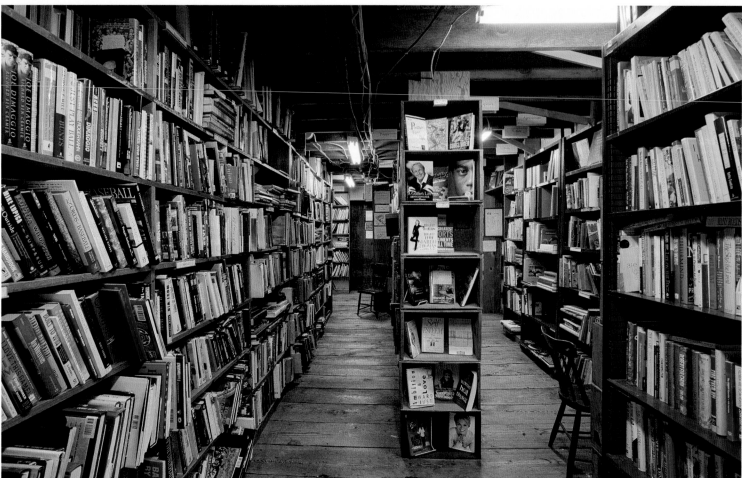

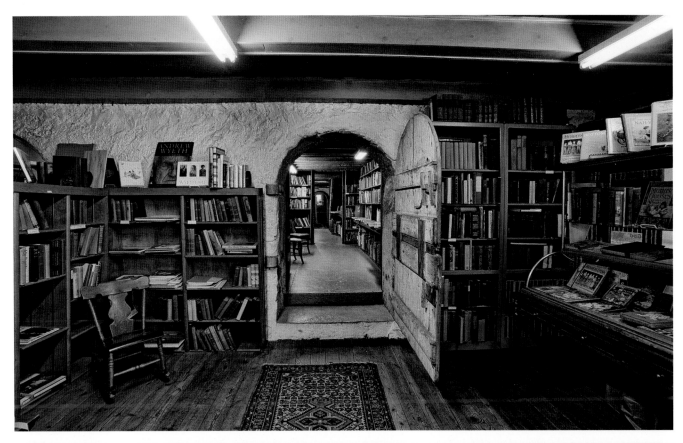

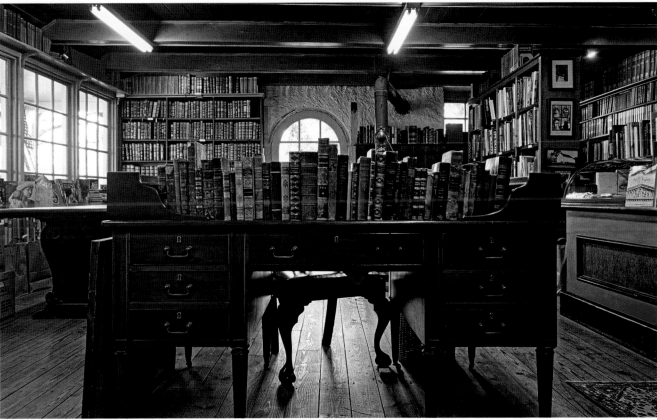

BALDWIN'S BOOK BARN — WEST CHESTER, PENNSYLVANIA

Maggs Bros.

ED MAGGS

We're one of the longest-established antiquarian book-sellers in the world. We've handled some very old and very rare things – two Gutenberg Bibles, Caxton's Chaucer, the first book printed in England, as well as the odd curiosity, such as Napoleon Bonaparte's penis. We're currently in a Georgian building on a salubrious Blooms-bury square – an area thick with bookish history. The front door is open, but it doesn't look much like a shop.

The pursuit of good books is a major part of some people's lives, and we've worked with families and institutions over many generations. We're deadly serious about books but we try not to be too serious about ourselves. We don't like self-important pomposity, though this world can be prone to it.

Do I think old things have a soul? Walter Benjamin, in his essay "The Work of Art in The Age of Mechanical Reproduction", talks about the aura of original objects. I think that's a very nice word to use, because there's a magic to them. What gets us going is a sense of discovery, manuscripts or maps that no one's read or seen before, or letters falling out of bin bags that form the key to a writer's whole life. It may all hang on something rescued from flames or mildew. And yes, we do find a few dead mice. I would say I'm a mixture of amateur historian, anthropologist and frustrated novelist. I just absolutely love the storytelling aspect, the piecing together of people's lives from the detritus they leave behind, along with the detective work, though it's more Sherlock Holmes than CSI. You also stumble across a lot of forgeries and scams, but that's part of the fun.

A few years ago this trade was in a bit of a slump, but it's much healthier now. We have a fabulous team of youngsters who are all experts in their chosen fields, from travel and Japanese/Chinese manuscripts to early printed books and incunabula.

What I find most moving about books is their stability, the way they can remain unopened for hundreds or thousands of years, and still have the ability to change your life. They're like little bombs waiting to go off. W.S. Graham said, "An artist's job is love imagined into words or paint to make an object that will stand and will not move." That's the great thing books do, they stand and don't move. That's more important in the electronic age than ever before.

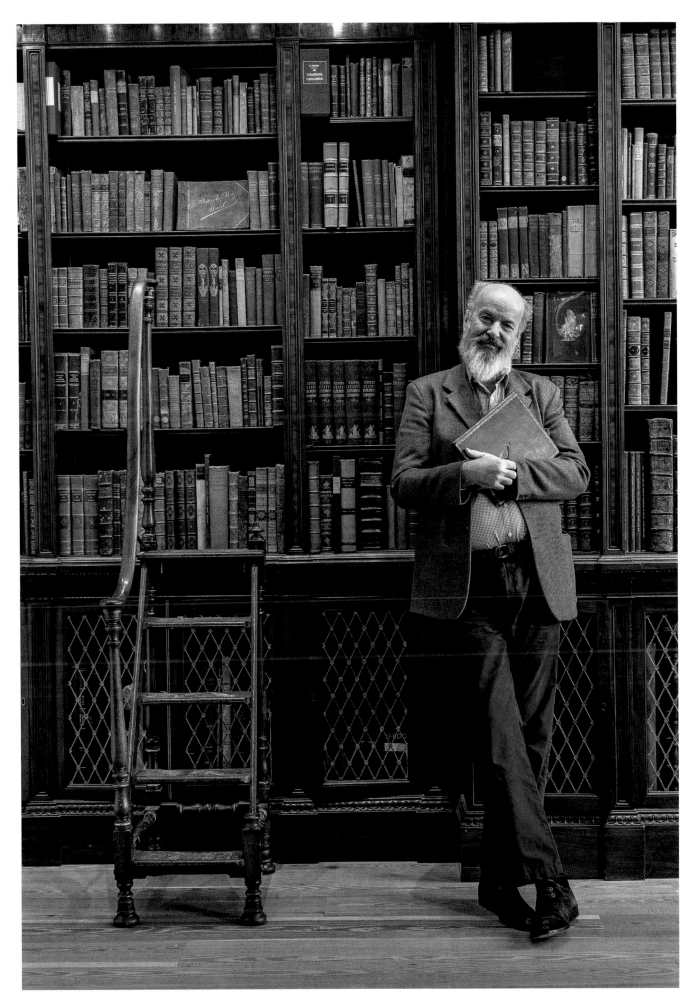

ED MAGGS — MAGGS BROS. — LONDON

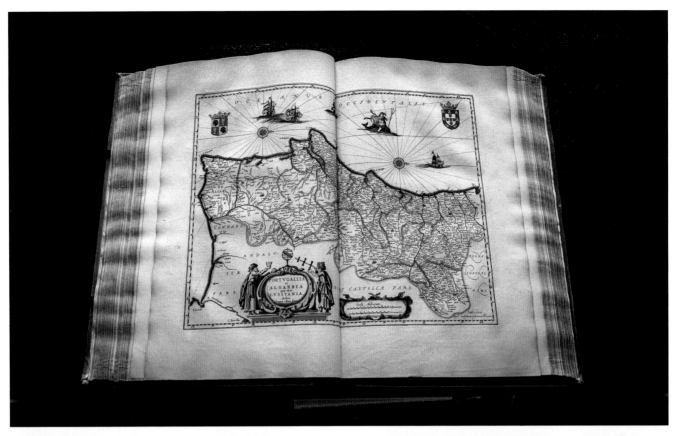

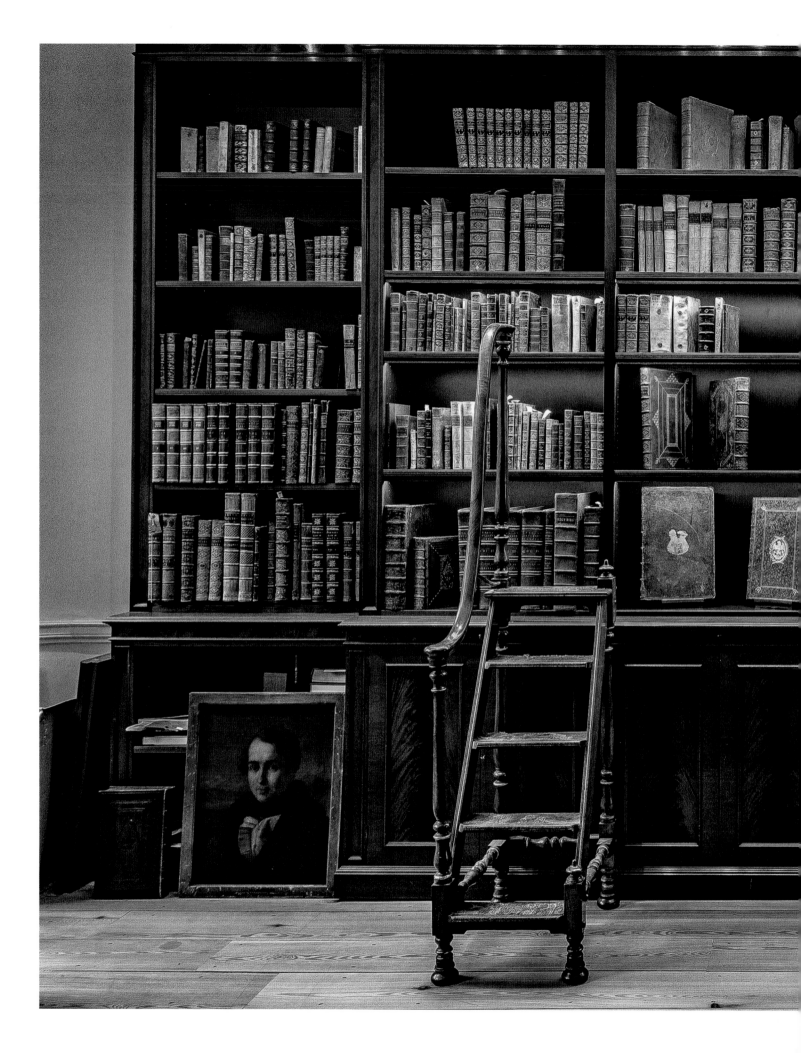

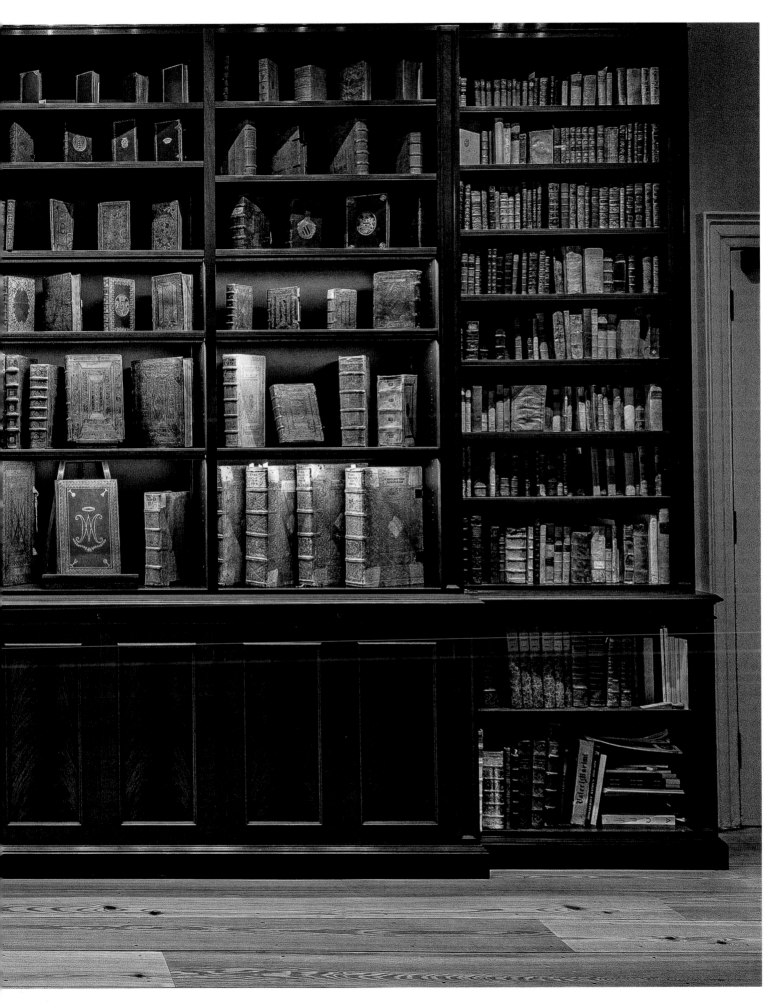

MAGGS BROS. — LONDON

Heywood Hill

PEREGRINE CAVENDISH, 12TH DUKE OF DEVONSHIRE, AND NICKY DUNNE

NICKY DUNNE: There's always been a slightly raffish element to Mayfair, which we're in the heart of. George Heywood Hill, the shop's original owner, sold automata and art alongside books, so this place was like a Wunderkammer. And it still is, socially. He had the brainwave of employing the Duke's aunt, Nancy Mitford, when she was looking for work during the Second World War. It was the beginning of the family's connection to the shop.

PEREGRINE CAVENDISH: It was reinforced by the fact that my parents bought a house two streets away, and my father would pop in here on the way to his club. Nancy was friends with Evelyn Waugh and his set...

NICKY DUNNE: So it became a place where the literary and social worlds intersected. Mitford was gregarious and engaging, and people would come in to chat to her.

PC: They were looking for some distraction during the war. It's one of the reasons that the place resonates with people all over the world. They say, oh, my godfather took me there, or, my parents used to hang out there. Considering its physical size, or lack thereof, it's extraordinary how it's imprinted itself on people's psyches. And they feel warm towards it, which is a great start. So when my father left it to me, I was happy to take it on, but we needed the right person at the head of it. Nicky, who's my son-in-law, had expressed an interest in getting involved...

ND: I came on board in 2011, when the place was on its uppers financially. But I noticed that, with Mayfair being such a world crossroads, all these extraordinary people would come through the door; there were leaders of business, politics and culture, buying their books and staying to hobnob a bit. There's a density to this tiny shop, a gravity that's quite far-reaching and that people are drawn to. We try to maintain Heywood Hill's original ethos, which is a personalized approach to bookselling. We have a subscription service called "A Year in Books",

where we send out a book each month based on what we know of a customer's tastes. We have thousands of subscribers all over the world. The wonder of it is our team, downstairs.

PC: Literally, the engine room.

ND: There are six of them, and they read well over 100 books a year each. Multiply by four years, and that's 2,500 books they can draw on for our subscribers. We also create libraries for people; just recently we put together a fantastic collection of 5,000 books on the history of Western civilization. All we do is based on human rhythms rather than algorithms. But the shop itself remains the core of our identity.

PC: In some ways it worries me that the shop is set back from the road. People immediately think, am I allowed to come in? But it actually makes it rather special. It's like a portal from external reality into our own little world.

ND: Someone called it an oasis of civilization. It's a big claim, and we aspire to live up to that. And things happen here that set this place apart. There's a homeless man around the corner in Berkeley Square who always has a book on him. A customer got chatting to him and set up an account for him here. Every week he comes in and chooses a book. There's a nourishing element to what we do, for ourselves and for our customers.

PC: I personally delivered one of our books to Anna Wintour at her American *Vogue* office in New York. I made the appointment way ahead of time, and they asked me on the phone whether I'd like still or sparkling water when I arrived, and it was waiting for me when I got there. It was a reminder that brilliant service, the personal touch, is more important than it's ever been. If you look after people, they'll come back.

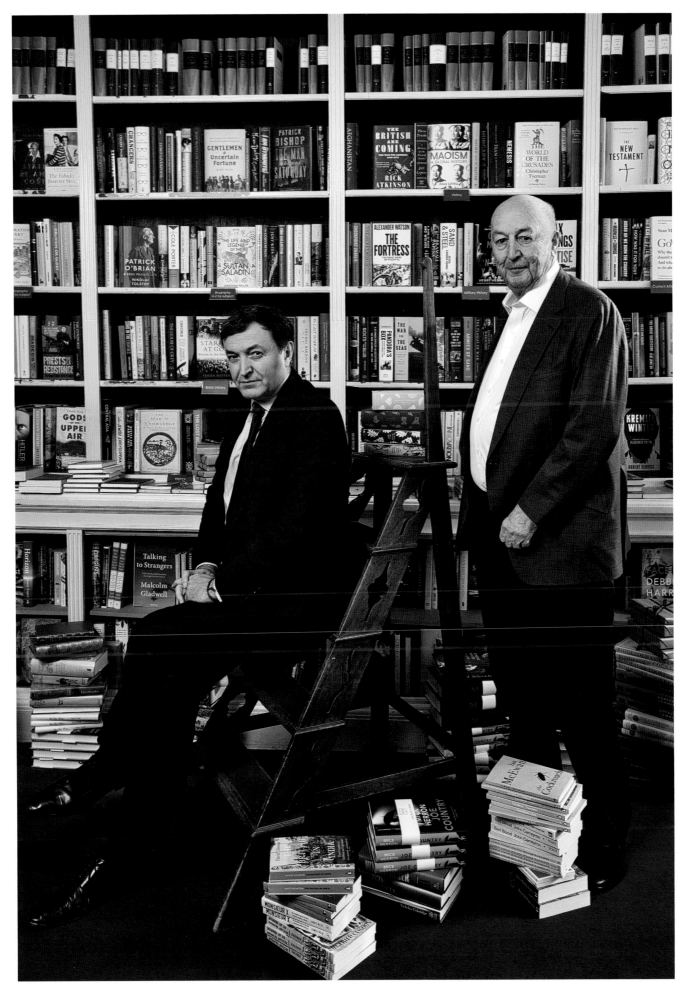

NICKY DUNNE AND PEREGRINE CAVENDISH — HEYWOOD HILL — LONDON

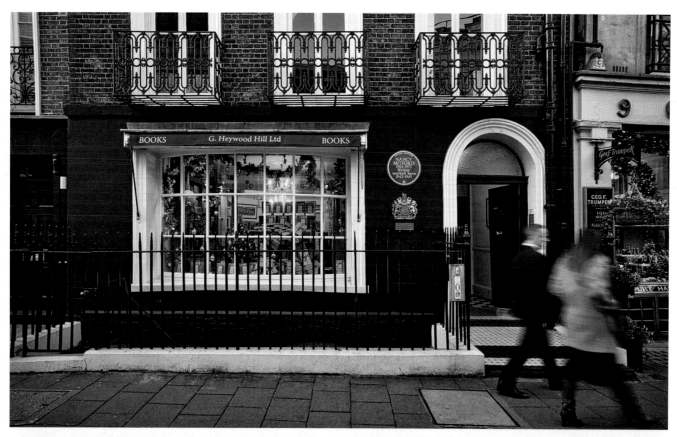

HEYWOOD HILL — LONDON

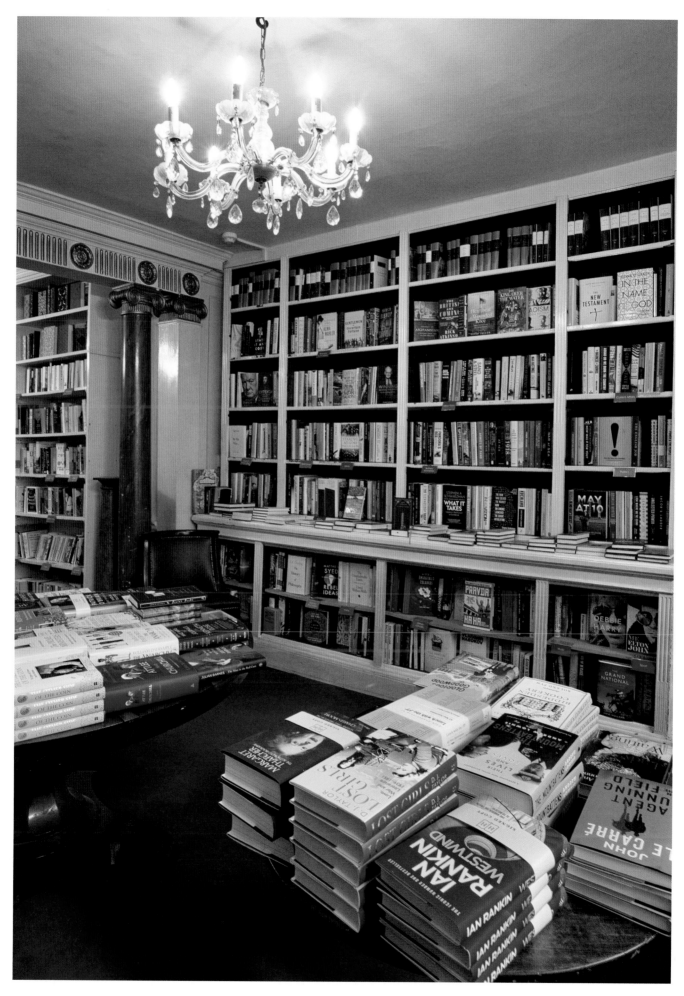

HEYWOOD HILL — LONDON

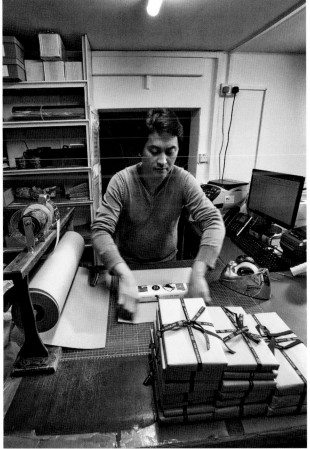

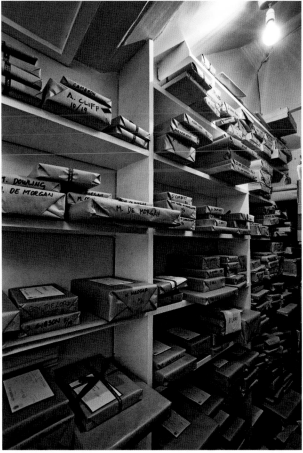

HEYWOOD HILL – LONDON

John Sandoe Books

JOHNNY DE FALBE

The romantic idea of the bookshop involves enchantment and intoxication. I love seeing young people gaze round in wonder as they stumble into John Sandoe and exclaim, "It's just like a bookshop in a film!" But there's something else; an attitude of mind, a reflection of curiosity, a desire for discovery. People who read books have enquiring minds. They don't just want to get what they already know about; they want to see what else you've got. I don't like the word curation – I prefer taste – but our selection reflects the things we find interesting and diverting, rather than the ubiquitous titles. We don't put signs up in the shop, firstly because they kill conversation, but also because it leaves the browser open to what we call bookshop serendipity – to coming upon something they didn't know existed, or they never knew they wanted, with that thrill of recognition which is common to all those engaged on a quest, whether intellectual or material.

John Sandoe once said to me that he saw his role as comparable to that of an old-fashioned family doctor. What he meant by that was that he had long relationships with many of his customers, and that they were, in a way, intimate. That continues today; we have ongoing conversations with people, and choose their reading lists accordingly. It's a bit different from a best-guess kind of algorithm; you're trusted enough to shape their reading lives, which is a great privilege. And it works both ways; many of the books that we come to love and sell will be prompts from customers. Often a book will take its time to find the right buyer; we recently sold one that had been on our shelves for twenty-three years, though that was exceptional, and it was rather a relief to sell it.

I'm sure Instagram has been valuable to us in the last few years. It presents a shop window, distilling our essence, and it helps people, particularly younger people, to find us. We need to adapt to the changing clientele; as an old song that my grandfather used to sing went, "It makes no sense sitting on the fence, all by yourself in the moonlight." But I believe it's profoundly important that people continue to have access to the physical space of a bookstore. We need active, busy town centres, places of wonder in high streets; places in which to stretch the mind and the senses – and indeed the legs.

A few years ago, I arranged to meet an old friend outside the shop before we opened, so we could go and have breakfast together. It was the novelist David Mitchell on a rare visit to London, and I came upon him looking in our window. Seeing me, he stepped back, opened his arms wide as if embracing the world, and said, "Every time I look in the window of John Sandoe's, I take courage that civilization will last at least another ten years." That was nice to hear.

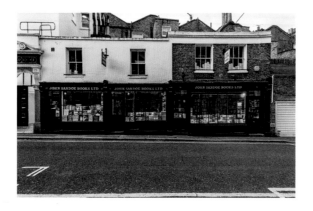

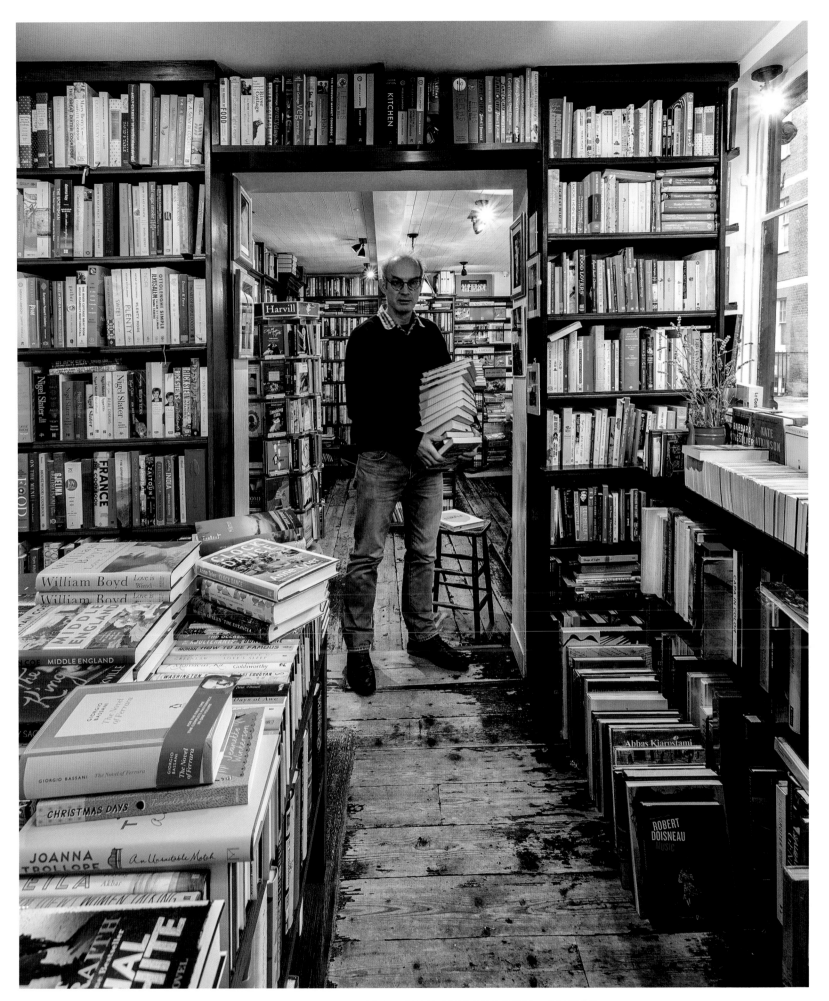

JOHNNY DE FALBE — JOHN SANDOE BOOKS — LONDON

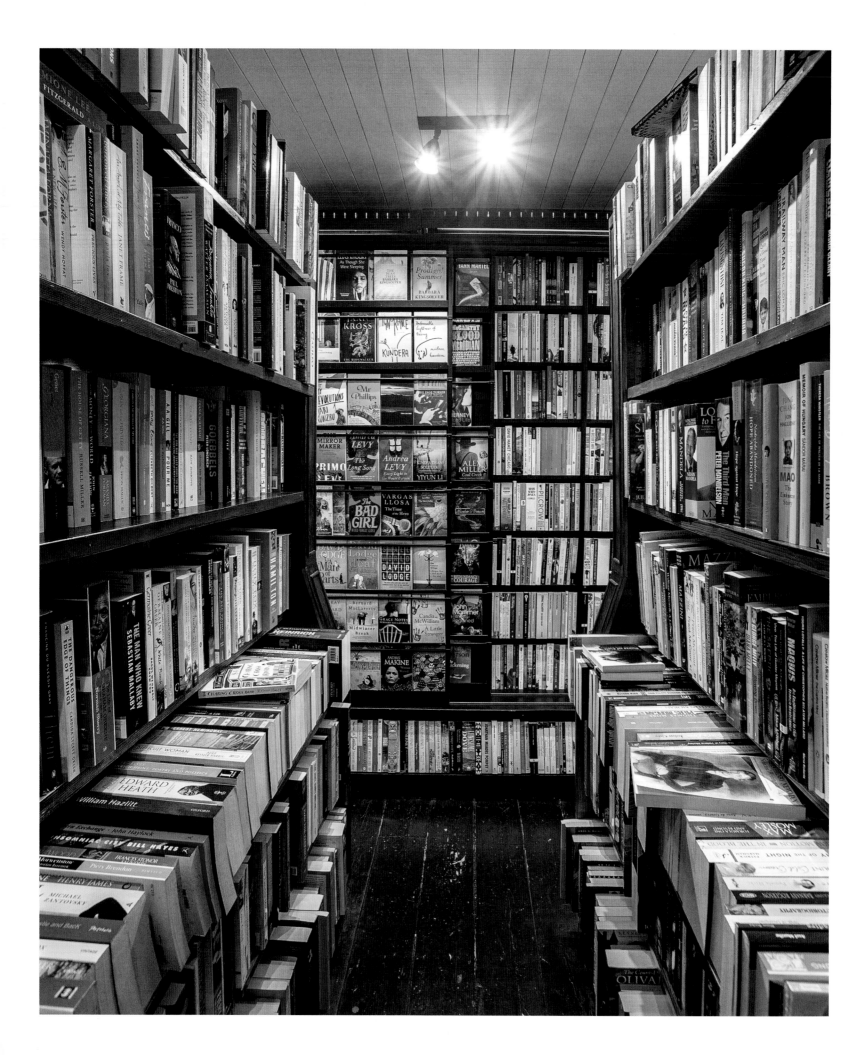

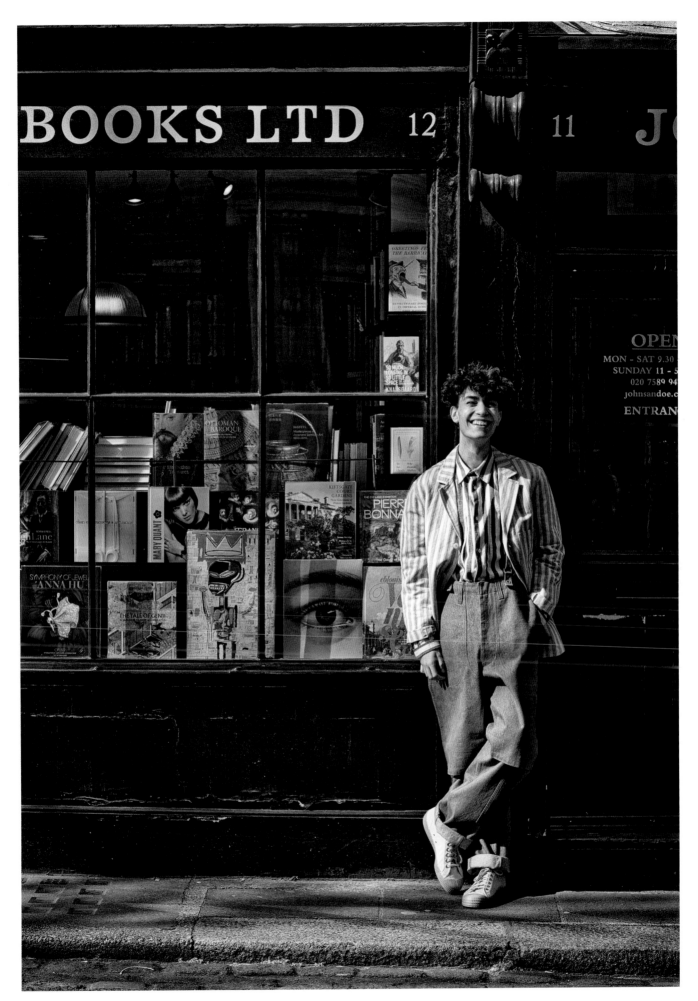

JOHN SANDOE BOOKS — LONDON

Hurlingham Books

RAY COLE

I was working as a surveyor when the offer on this shop came up. The guy who ran it had to disappear fast and he just handed me the keys. I thought I'd sell bric-a-brac, like he did, but then I got access to this huge bunch of books that were part of the estate of the painter Augustus John. I bought twenty or thirty chests for a song, brought them here in a huge lorry, and piled them in the shop and along the pavement. And I was up and running.

People accuse me of being a hoarder. I know the place looks disordered, but I know exactly where everything is. People are the problem - they pick something up and put it back in the wrong place. I think it all adds to the charm. I never turn down the chance to add more books. My staff try to dissuade me, as do my wife and daughter. My home looks like the bookshop, and I have another two million books in a warehouse down the road. I've thought about putting a new carpet down, or painting the shelves, but it would destroy the soul of the place, I think. We've become a photo opportunity for hundreds of people. They're doing Buckingham Palace, Tower Bridge, the Houses of Parliament, and us.

Books don't mean much to a lot of people these days - they're all on computers. But to others, they're precious things. I get people coming in and stroking old books, like they're petting a dog. That's my favourite part of all this - meeting all the lovely human beings we get in here. We get everyone from MPs to street-sweepers, and I've got something for all of them. A bus driver came in recently and was looking at a Bible from the 1800s, fifty quid, and he bought it for his family. People come in for a browse and they quite literally stumble across something they didn't know they were looking for. I'm 75, but I wake up in the morning and I think, "Yes! Another day in the bookshop!" We're keeping the art of conversation and the art of listening alive. I wouldn't want to be anywhere else.

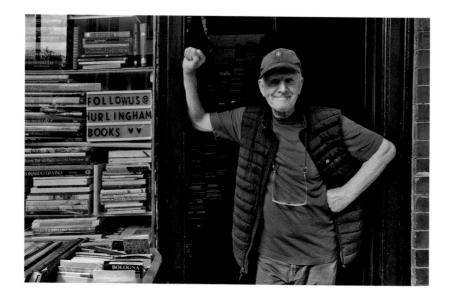

HURLINGHAM BOOKS – LONDON

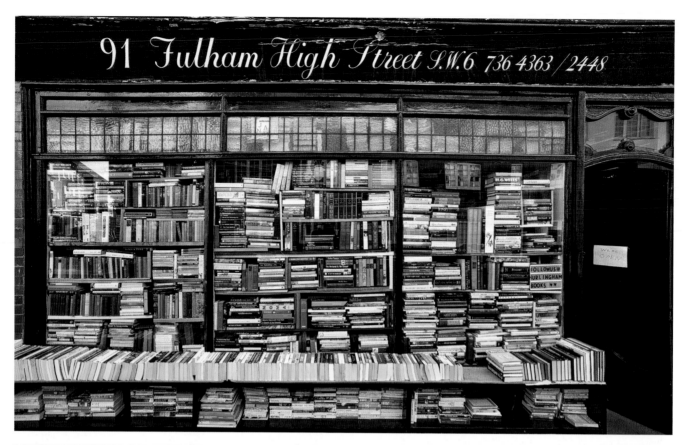

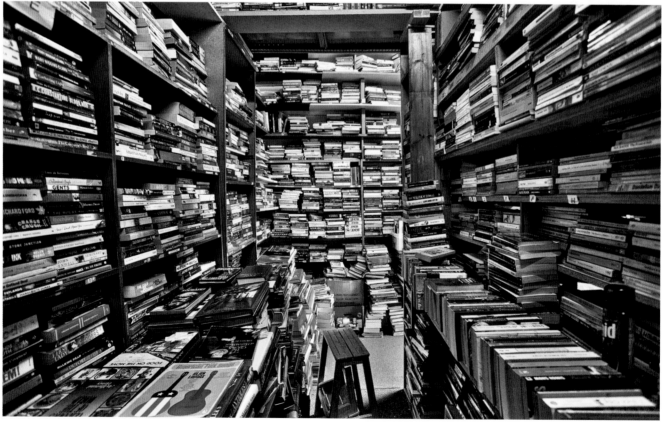

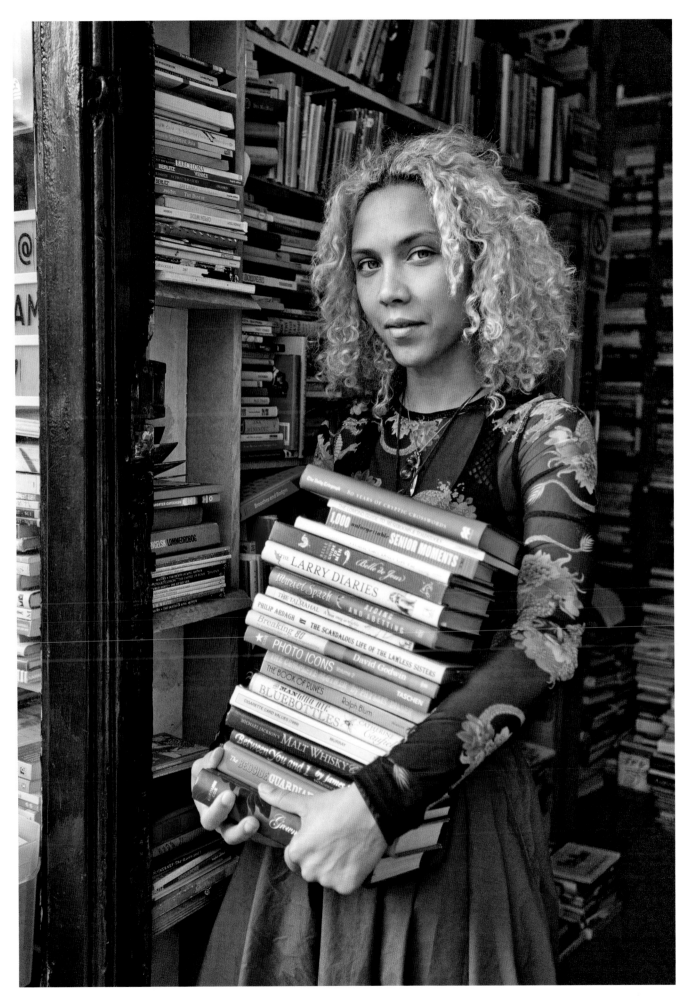

HURLINGHAM BOOKS — LONDON

Gay's The Word

JIM MACSWEENEY

The first time I came to the store, I was an out-of-work actor from a small town in Ireland, and I was too nervous to go in. I ended up walking round the block until I screwed up enough courage to cross the threshold. I never even got as far as erotic fiction. That's one of the reasons that, now I'm the manager, I think it's really important that staff are pleasant and welcoming. This is a non-judgmental space, or at least you try. It's for people from 16 to 90, for those who've just come out and for those who've lived it for decades. I had a young woman recently – this happens all the time – who suddenly choked up as she was buying books, and apologized. I said, no need to apologize, this is your space. You're home.

We're still the only dedicated LGBTQI bookstore in England. We've always been visible, both literally and figuratively; the name is emblazoned outside and you can see straight in. It's never been about hiding away. And while that means we faced a raid by Customs in 1984 when they deemed certain of our titles obscene, and even now we occasionally get bricks thrown at the window, it also means we've served as a community hub – we've hosted everything from lesbian book groups to early Pride committee meetings to gay black groups and Trans-London. We had a lesbian wedding here. It's always been a place where people meet and create networks of friends and family.

We've gone from being political and campaigning on the frontline to being part of the furniture to becoming dusty and forgotten to being regarded as iconic. But it's more important than ever to have queer spaces like this. There are still so many environments where you police how you behave – Do you hold hands with your partner? Are you affectionate in a bar or restaurant? – so places where you can be yourself are vital. And where else do people learn their history? I recently had someone looking at a biography, going, "Oh, was Tennessee Williams gay?" How will they know? It's not taught in school. If you're ordinarily careful about revealing certain aspects of yourself – if you're bi, non-binary, into S&M – this is a veritable treasure trove of subcultures and ways of being; there are so many siren voices calling from the shelves.

People now come from all over the world to see this place. We're far from secure – every rent increase brings us back to the point of collapse – but I think people now realize how much they'd lose if we weren't here. And we've helped make history ourselves, in our own quiet way; we're not just witnesses, but players. We had the likes of Armistead Maupin, Edmund White and Sarah Waters all talking about how much this place meant to them for our 40th anniversary. And now there's a younger generation with new stories to tell. But the values here are eternal: love, desire, respect.

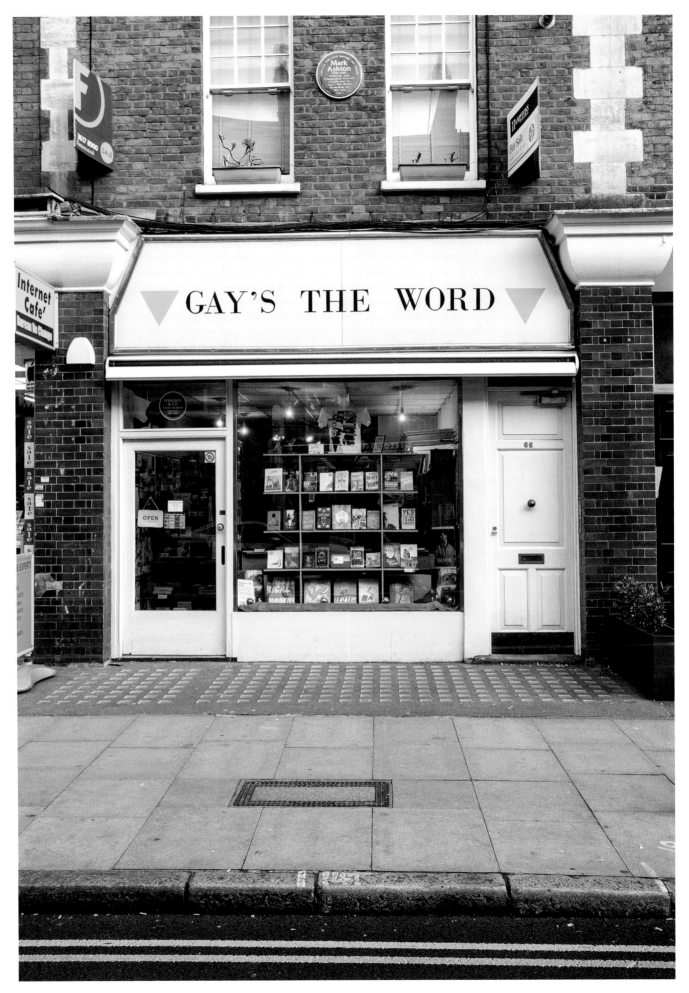

GAY'S THE WORD – LONDON

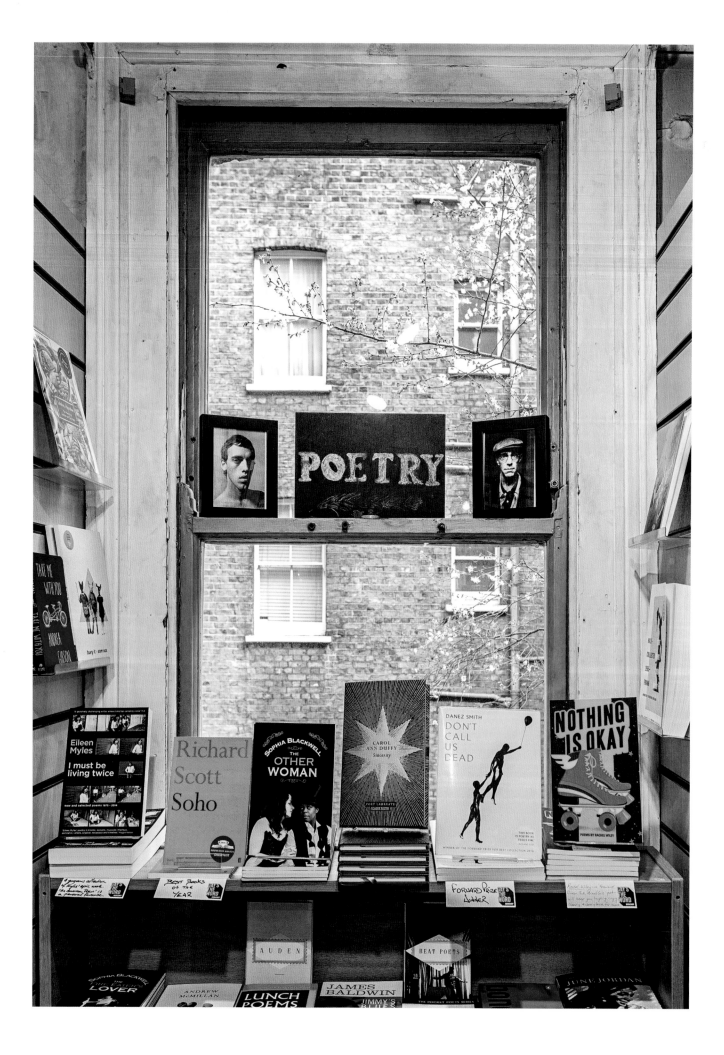

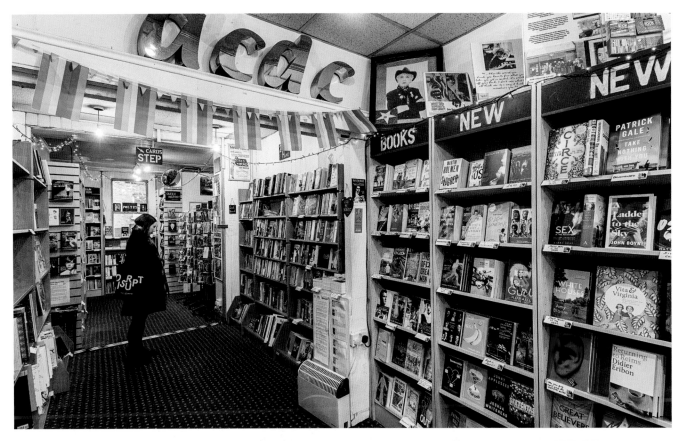

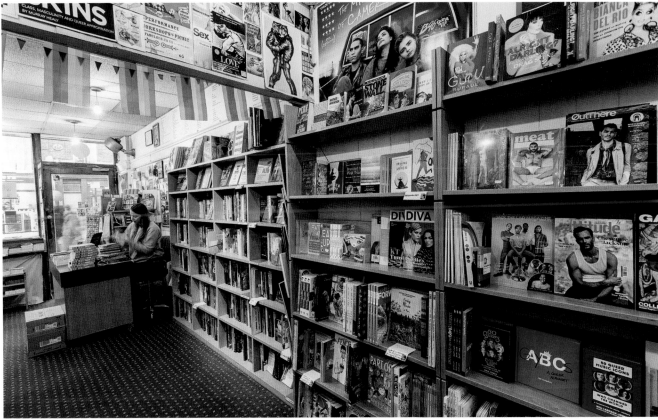

Daunt Books

BRETT WOLSTENCROFT

This is the oldest purpose-built bookshop still in use in the UK – it dates from 1910. It was derelict when our founder James Daunt came across it, all dust and rubble, about to have its interior ripped out and be turned into a restaurant. It's still not listed, which is shocking; it's like an Edwardian gallery, and the stained-glass window is really special.

We get visitors from all over the world now, and it's great when you see first-timers come in here and gasp. Obviously that can bring its own problems, with people on their Instagram tours who aren't interested in the bookshop at all. But you've got to try and strike a balance; it's not our building, it's a public space, a special London experience.

We're not a travel shop, but we've always arranged books by country. That throws up some interesting juxtapositions; Stockholm guides next to Scandi crime fiction, or *One Hundred Years of Solitude* alongside Latin American history. All the recent trends in books, from the boom in translated literature to people's curiosity about the world through documentaries and politics, has helped us out; shifts in geopolitical interest are reflected by publishing, and we can capitalize on that in a way many other bookshops can't. We don't arrange things alphabetically on shelves; we prefer to make odd connections you'd never get from a computer program.

We hold talks and events here; we try to be a cultural glue in the way that libraries used to be. We have a subscription service and we organize regulars' reading lists. We're building a world of people who cherish the shop. Our staff are key to this, of course. We've got some of the country's best booksellers, who are stars at what they do. I remember bookshops being quite intimidating when I was a kid, but if you come in here you'll hear conversations about everything from Sartre and Proust to *50 Shades* and the new titles we have by the tills that staff members might have just read and loved. It's no good having a pretty shop if the staff don't care.

We've weathered some storms in our thirty years, but the book has subverted every attempt to outmode it. And people still clearly value bookshops. You get people saying, "Oh, I used to come here an awful lot ten years ago when I was going through a terrible divorce, to get some respite and sanctuary" – well, it even looks like an old chapel, doesn't it? You can just tuck yourself into a corner and get off the treadmill for a while. James Daunt always said that a book bought in a nice bookshop is a better book – the experience enhances the product.

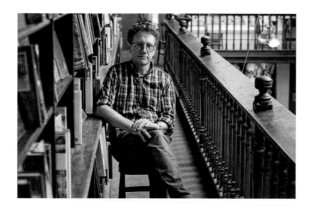

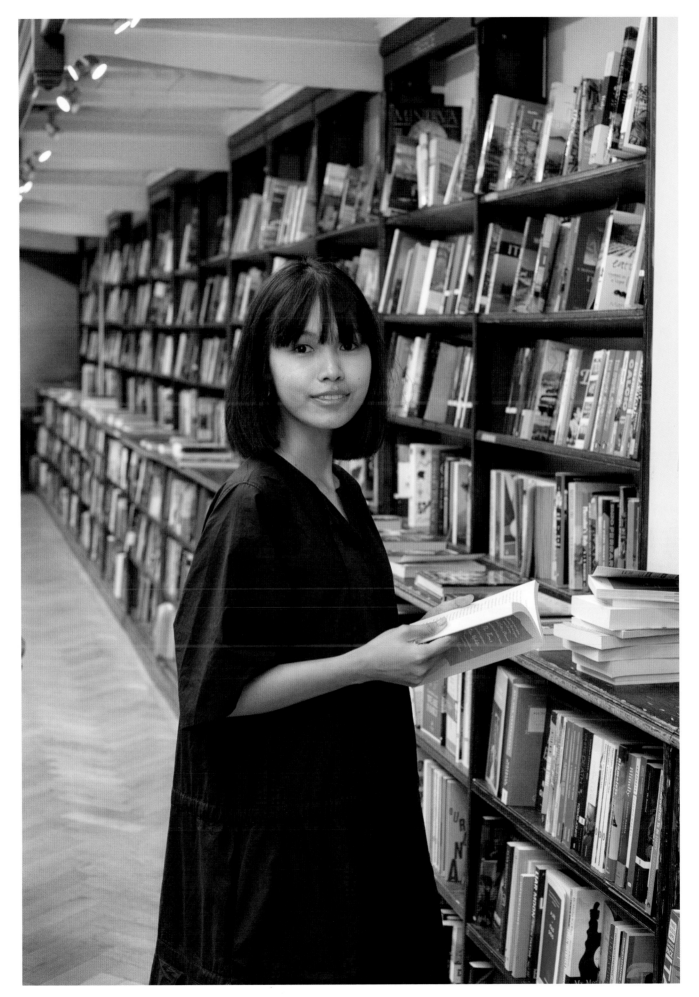

DAUNT BOOKS — LONDON

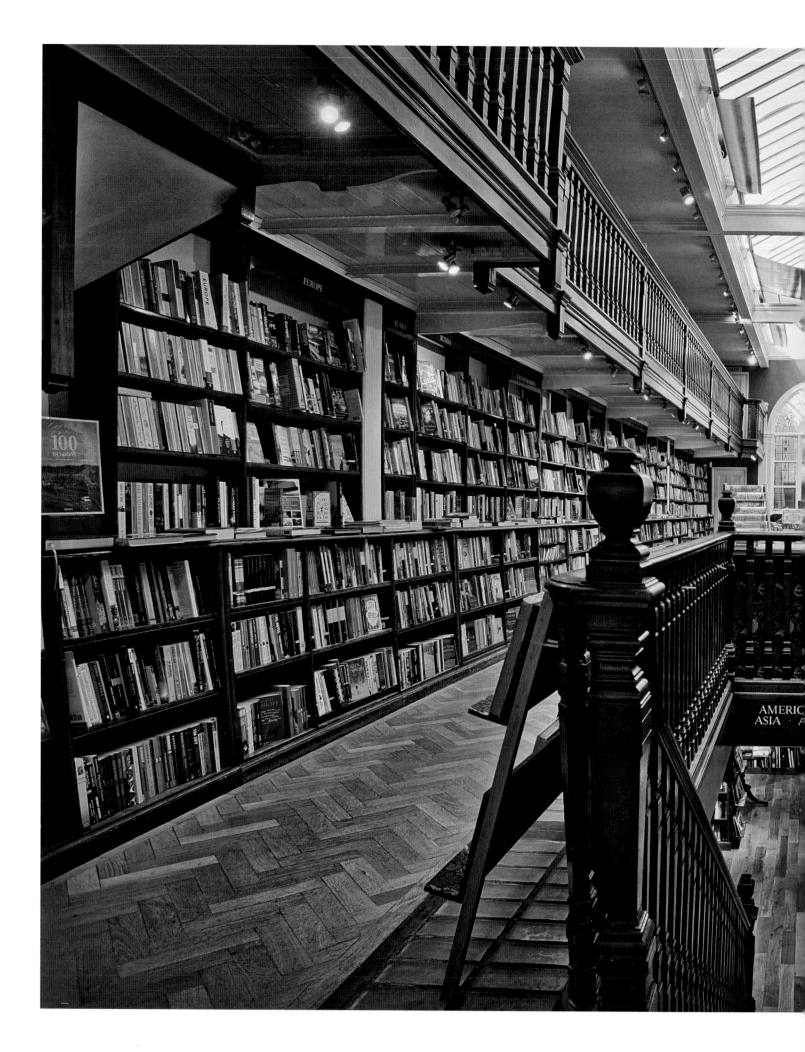

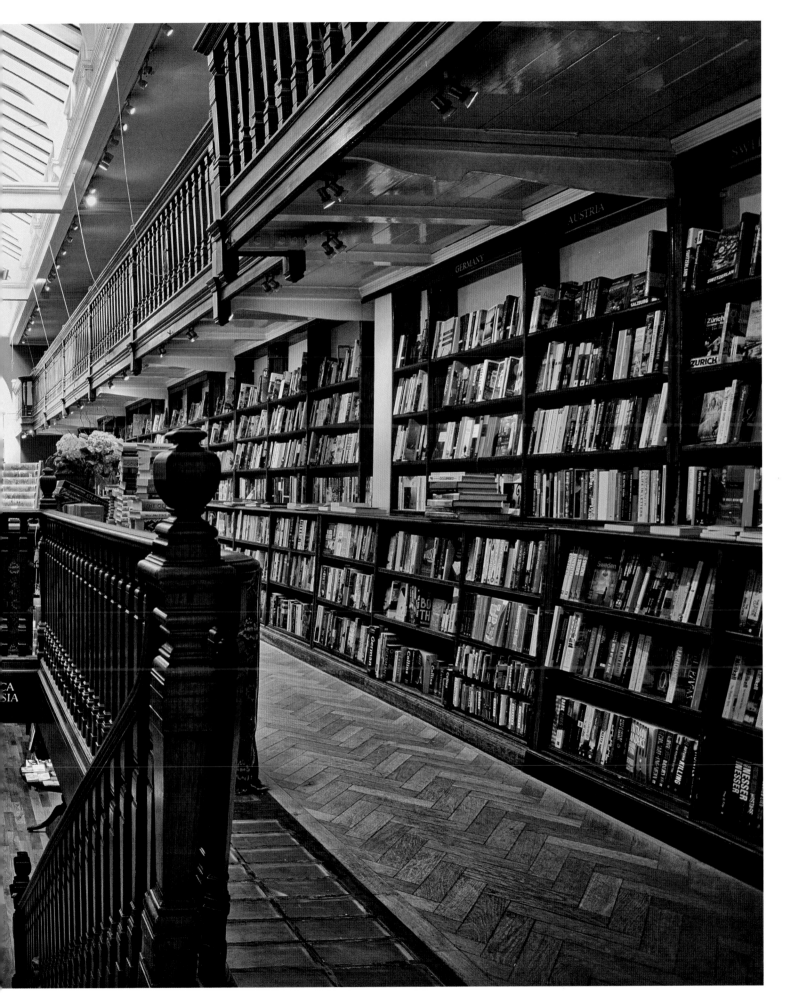

DAUNT BOOKS — LONDON

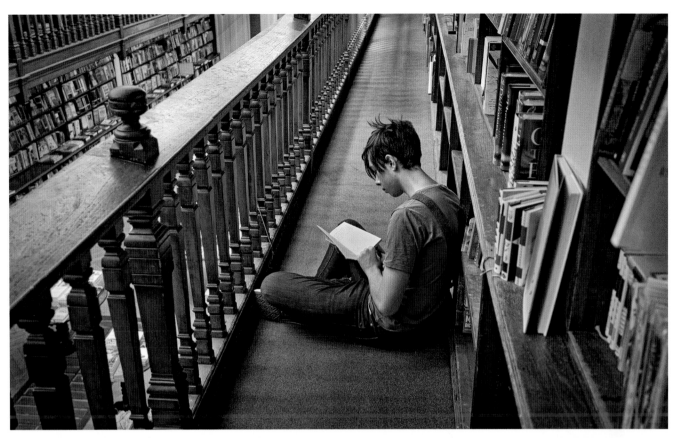

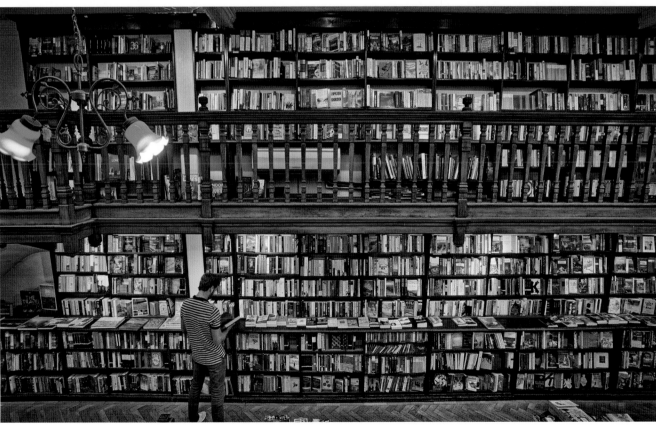

ST. JOHN THE BAPTIST PARISH LIBRARY
2920 NEW HIGHWAY 51
LAPLACE, LOUISIANA 70068

DAUNT BOOKS — LONDON

Persephone Books

NICOLA BEAUMAN

We republish overlooked or forgotten books by women writers from the 1920s to the 1950s under our own imprint. I've always had this huge interest in early twentieth-century fiction by women – what academics would call middlebrow, and I would call a good read. We started in a basement, but then we got a best-seller – *Miss Pettigrew Lives For A Day*, a 1938 novel by Winifred Watson – so we were able to open the shop. I say a silent thank you to her every day. Why Persephone? She symbolizes creativity as the goddess of springtime. Cleverclogs people come in and say, well, she was violated by Zeus. We say, "Yes, we know", with great forbearance.

The shop also houses our office, and it's very open-plan – we have stripped floors and posters in keeping with the era, and we mix fresh flowers with the false, which makes the false less naff. Bookshops are really important spaces, because they offer a kind of unofficial social work program – there's no other kind of shop where you can walk in, talk to someone, try all the products, and leave two hours later having bought nothing. Try doing that in a boutique! What's our motive? I don't want to say passion or love; I feel like saying kindness. Or respect maybe, for other people and for the product. My mother was a solicitor on the Portobello Road, and I sometimes think working here is not so different.

The criteria for a Persephone book? It has to be readable, and take you out of yourself. I'm sorry to use this crude word, but I want to get to the end and be gutted. We only have 132, because we're so choosy. But we're doing our bit to show that the physical book is far from dead. Books look wonderful now, and physical environments full of wonderful things are more important than ever.

Our audience is hugely wide-ranging – there are 25,000 subscribers to our magazine. We're very proud that it's varied. We're a feminist publisher, but we're not exclusionary. We have some male writers, and normal men are feminists. All the books we publish have points to make. Just because they're women writers and beautifully bound, it doesn't mean they're silly and sweet. Women's lives have never been just sweet, even when they come in a beautiful grey dust jacket.

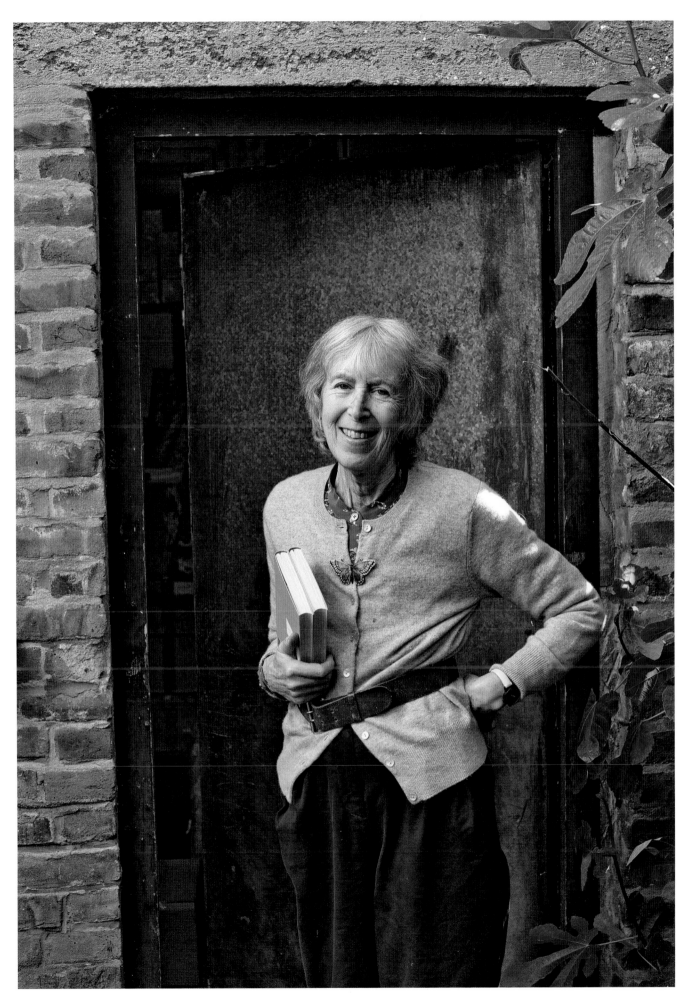

NICOLA BEAUMAN — PERSEPHONE BOOKS — LONDON

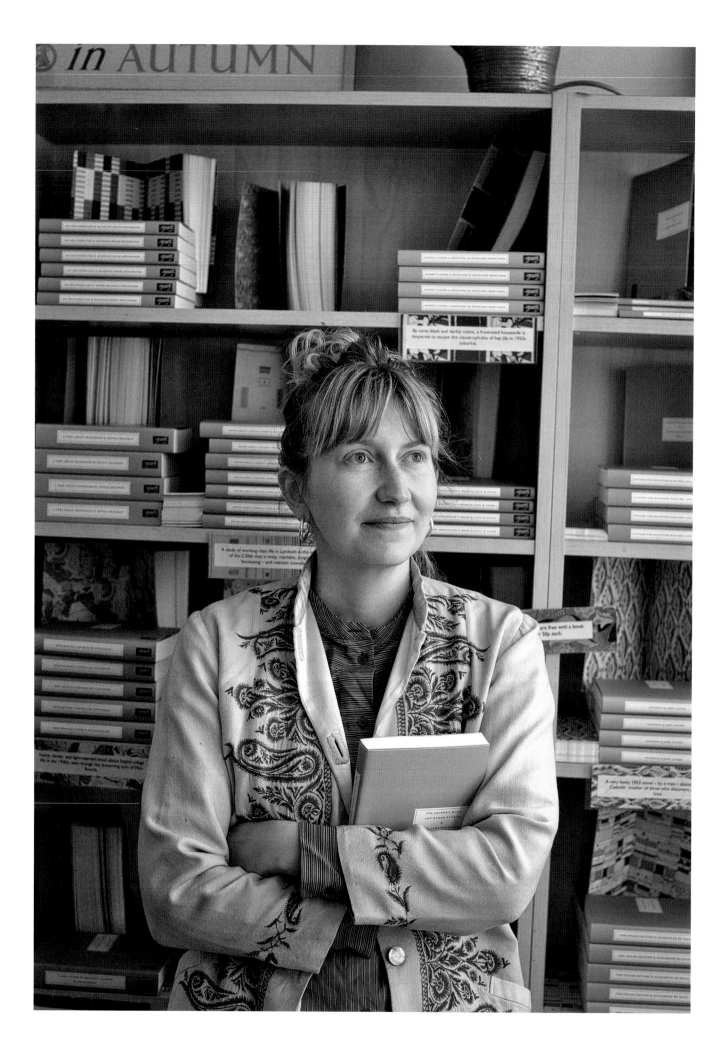

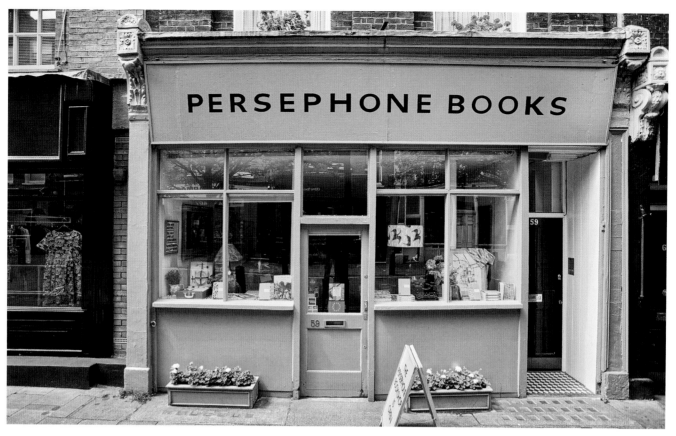

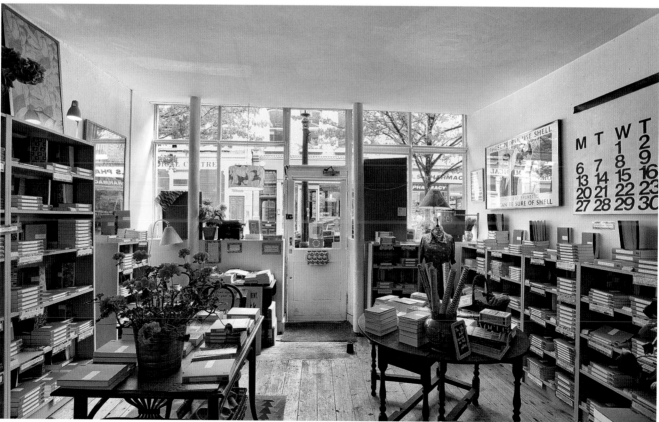

PERSEPHONE BOOKS – LONDON

Tate Modern Shop

SIMON ARMSTRONG

I was obsessed with music as a teenager. I started working in a record shop in the north-east of England, and began working out how to introduce people to things they may not have realized they wanted. It was all about sharing ideas, and discovering things and passing them on, and there's a great deal of joy in that. When I went on to work in bookshops I saw it as the same thing; giving people access to the tools they needed, the inspirational ideas, to turn them from spectators into creators, which will ultimately mean that there are even more good books to read and better art to look at. Ideally, it's a kind of virtuous circle.

I came to London and became head of retail at the Design Museum before becoming book buyer for the Tate bookshop in 2010, but at each place I've worked I've seen my role as broadening the range outwards from the exhibition catalogues and artist monographs to encompass all the currents swirling around in society, from new queer theory to the climate crisis; I want the titles to act like a kind of cultural thermometer, taking the temperature of where we're at. For every exhibition we mount, I'll bring together around 120 different books that delve into the themes and wider contexts of the show, going from artist biographies to any relevant novels, literature, films, music and poetry. If people happen to have spotted an odd detail or reference in one of the artworks they just saw, we try to have a book on that particular thing waiting for them, as if we just mainlined directly into their mind. When that happens, it's so serendipitous that they often buy the book instantly. Being playful in that way, and leaving room for the strange and fascinating, is incredibly important to me. The greatest thing about bookselling is that even after decades of doing it, the unexpected surprises and inexplicable successes keep arriving.

I want the physical space of the store itself to feel like an oasis for people. I want them to feel comfortable, and that they don't have to buy anything, and I want them to chance upon something that maybe unlocks some doors for them and takes them somewhere new and engaging. That's why I want as big a range of stuff in there as possible, up to and including self-published stuff, indie presses and zines and DIY countercultural material. It all feeds back to the same thing, the thing that's driven me since I started: get people involved. And the physical bookstore, with its events, talks, launches and signings, is the perfect conduit for that. I'm happy to be still plugging away; harnessing all the creative energy out there, and channelling it through the shop. We just want to set people off and watch them go.

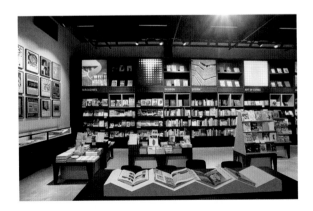

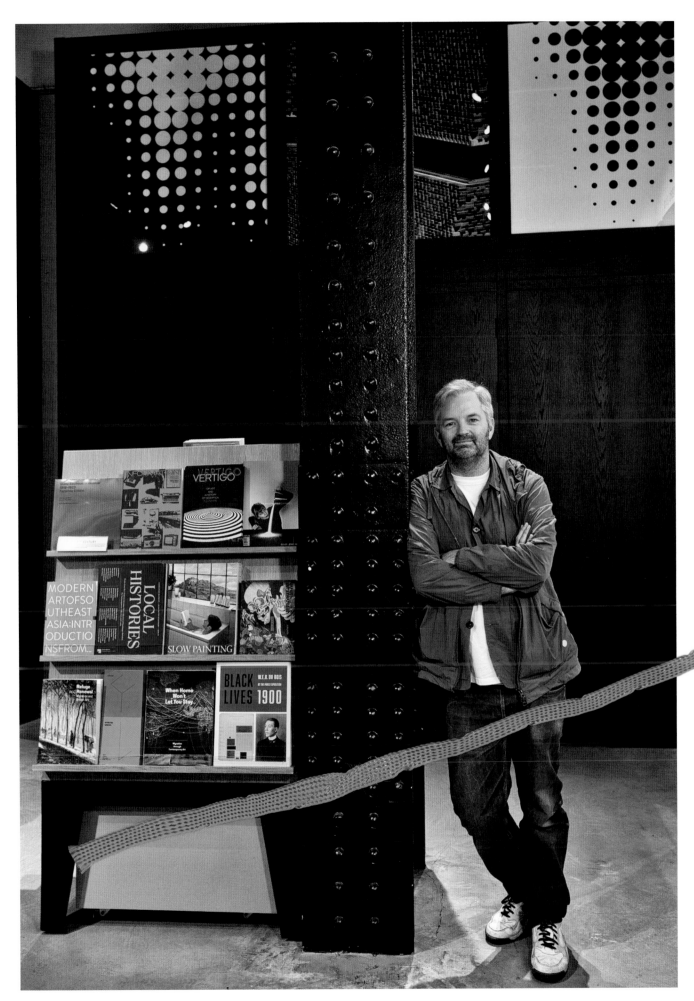

SIMON ARMSTRONG — TATE MODERN SHOP — LONDON

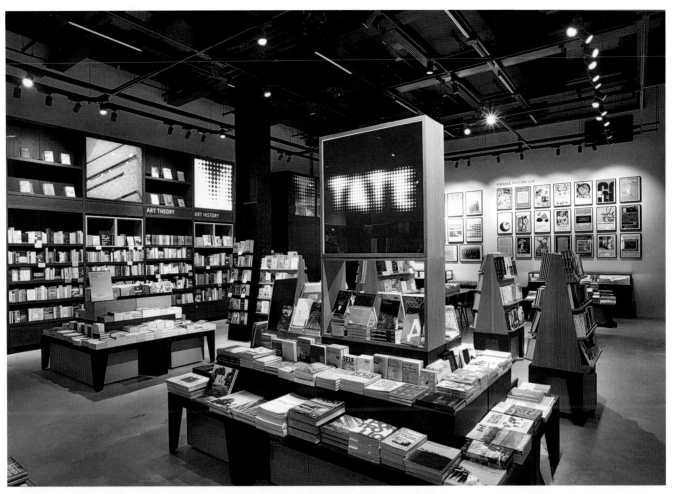

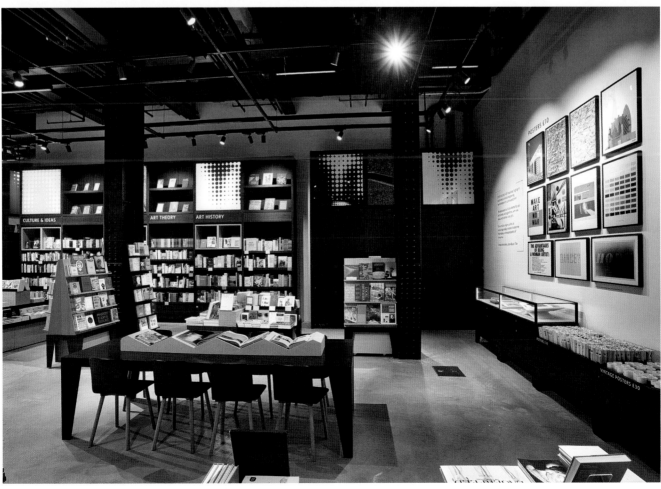

TATE MODERN SHOP – LONDON

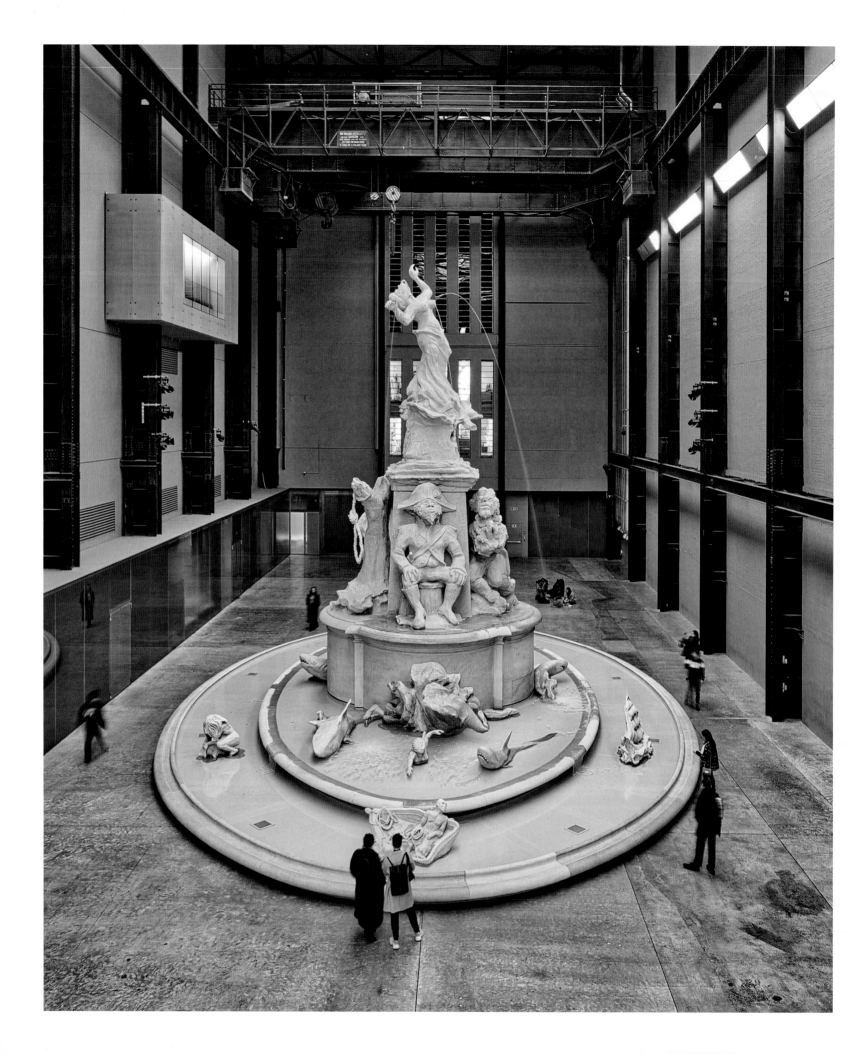

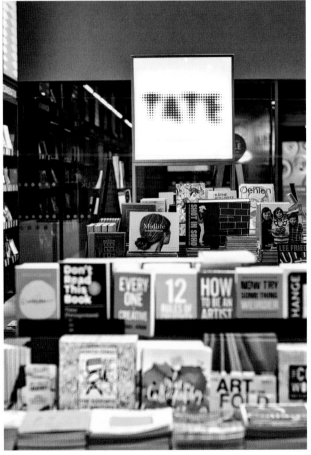

London Review Bookshop

NATALIA DE LA OSSA

Because we were set up by the *London Review of Books*, this has always been a place where people talk about books as well as buy them, and it's a real hub for events of all kinds – signings, talks, launches, a bijou cinema downstairs and even concerts. There's a sense that you can come here and get a full cultural experience. Our café also draws a lot of people in – we're in the heart of Bloomsbury, so we get a lot of publishers holding meetings, or agents meeting authors. There's one particular seat in the café where I know Kazuo Ishiguro sat most days, drinking a lot of coffee and writing *The Buried Giant*. It's nice to have a Nobel winner as a regular customer.

We opened just as the internet giants really got into their stride with their warehousing and discounting. We're the antithesis of that, really – we're a tight-knit team of seven with our own specialities, and every book we stock is considered in terms of quality as well as sale-ability. We were once accused of displaying books with "fiendish cunning" by a bookshop guide – they thought it was some kind of psy-ops thing where we lure people in with non-fiction amuse-bouches on the first tables before proceeding to the raw meat of novels. It's definitely a little more ad hoc than that, and a real contrast to online, where you're really controlled by what the algorithm thinks you want to see. A bookshop like this, in all its scrappy glory, is the antidote to all that.

We've embraced social media, and one unintended consequence of this is that our tote bags have become cult objects in South Korea.

Physical books have a future, sure – children's books are still selling really well, and you feel that there's a continuum, a base for growth there – but our survival really depends on landlords keeping rents under control and understanding the value we bring to a community. You have to keep convincing them that we're worth more than a betting shop. We need more landlords who read!

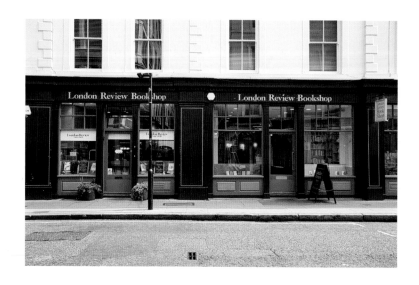

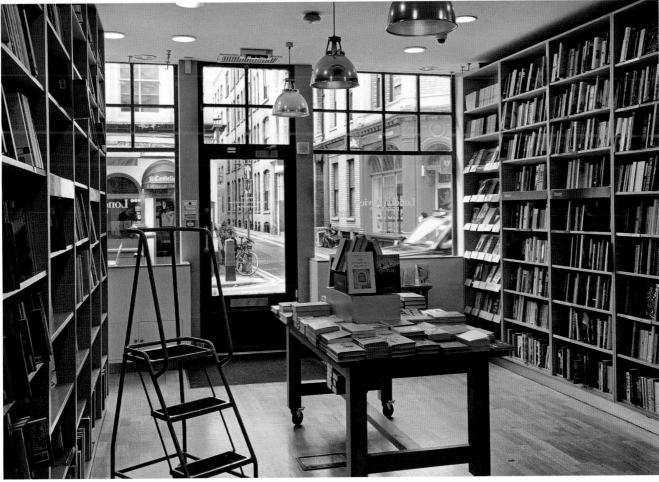

LONDON REVIEW BOOKSHOP — LONDON

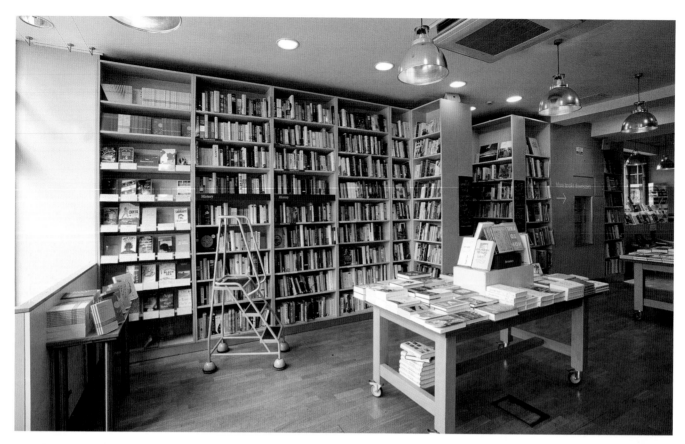

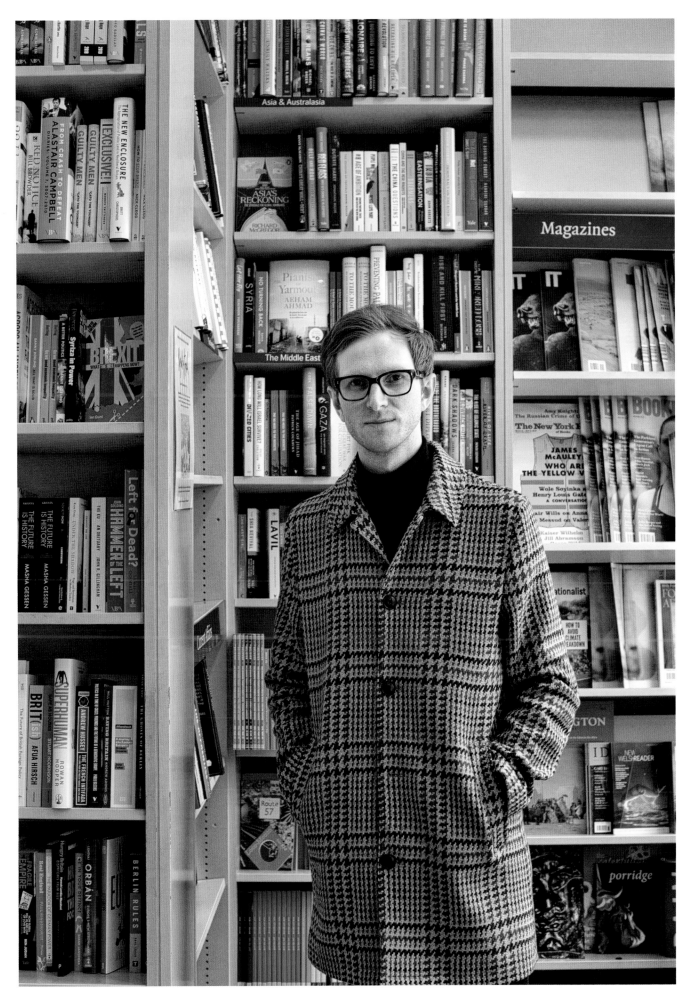

LONDON REVIEW BOOKSHOP – LONDON

Lutyens & Rubinstein

CLAIRE HARRIS

The store had an interesting genesis. Sarah and Felicity - Lutyens and Rubinstein - have run a literary agency for twenty years, and it was always their dream to open a bookstore. Then this site came up, and they canvassed hundreds of readers - writers, publishing contacts, friends - as to which books they'd most like to find in a store. So every book here has its place because somebody loves it or has recommended it, or is intrigued by it. That level of personal involvement set this place apart from the start. People feel very invested in it.

We're really embedded in the community here in Notting Hill. Sarah and Felicity are locals, and I've been here since the beginning, and I run a series of daytime book groups which has created a very loyal fan base. We've got a general group, a crime group, a classics group, and we've even started a Proust one. We also run a subscription service where people get sent a book a month which I choose depending on their preferences, plus a boarding program where we send books to kids in boarding school, and a baby book group, all tailored to suit everyone. The store itself is very compact and focused, and it doesn't have any sections - everything's arranged from A to Z - so you never quite know what you're going to stumble across.

Am I optimistic for the future of the book? Well, I think there's been a turn towards authenticity among the younger generation, a sort of rediscovery of the book as everyone gets screen fatigue. No one's found a better replacement for it yet, have they?

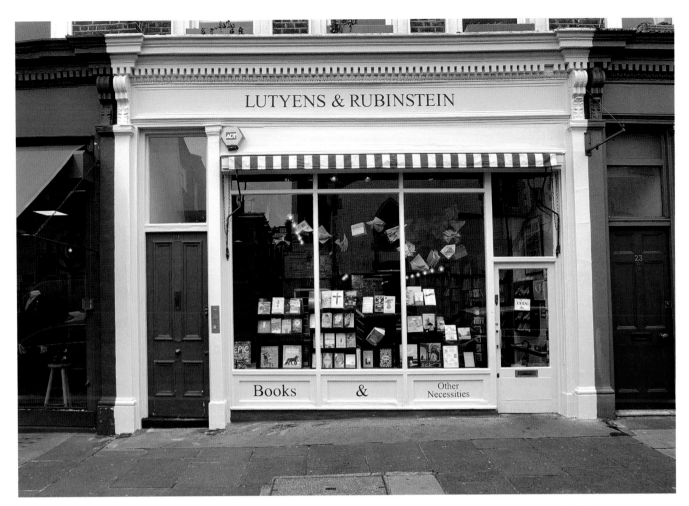

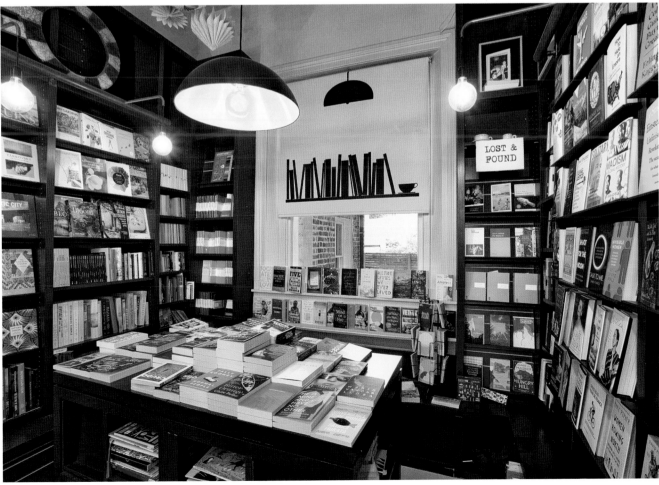

LUTYENS & RUBINSTEIN — LONDON

WOLF HALL · WOLF HALL · Hilary Mantel

'Genuinely outstanding' INDEPENDENT — Hilary Mantel — WOLF HALL — 'Dizzyingly, dazzlingly good' DAILY MAIL

WILDING · ISABELLA TREE · PICADOR

Shirley Jackson · We Have Always Lived in the Castle · MODERN CLASSICS

RICHARD YATES · THE EASTER PARADE · VINTAGE

Educated · A MEMOIR · TARA WESTOVER · WINDMILL

CHIMAMANDA NGOZI ADICHIE · AMERICANAH

Alice McDermott | The Ninth Hour

ELENA FERRANTE - The Days of Abandonment

ANNIE DILLARD · THE ABUNDANCE

Marcel Proust · In Search of Lost Time · The Way by Swann's · MODERN CLASSICS

POND · CLAIRE-LOUISE BENNETT

CLUNY BROWN · MARGERY SHARP

WILLIAM MAXWELL · SO LONG, SEE YOU TOMORROW · VINTAGE

THE LONELY CITY · OLIVIA LAING

THE SECRET LIFE OF THE LONELY DOLL · The Search for Dare Wright · JEAN NATHAN

MY COUSIN RACHEL · DAPHNE DU MAURIER

Word On The Water

PADDY SCREECH & JONATHAN PRIVETT

JP: I'd been running a bookstall for nearly thirty years, then I bought a boat to live on, and met Paddy on his forty-foot narrowboat. We'd both studied literature, and we got talking about books and reading.

PS: I was a locum worker, managing home-lessness and mental health projects. I remember sitting with John on our boats in Tottenham during a long, hot summer, eating wild cherries that grew on the canal banks, listening to José Feliciano, and both of us realizing that we were fine with very little money, so maybe we could take a risk with doing a project like this. Our overheads would be small, and we'd never have to leave the canal. And parked right opposite was this beautiful 1920s barge from Rotterdam that belonged to a French guy named Stephane Chaudat.

JP: He gave us the boat in exchange for an equal partnership in the business. He did a brilliant conversion and built a stage on the roof. We started with the books from my stall, and reinvested from there. Our first summer was great, touring the festivals along the London canals, from Shoreditch to Angel and Hackney Wick. Word got around, there was good press and positive feedback from customers. Then winter came and it was hard.

PS: It was like a Beckett play – two men in long coats, with blue faces, huddled round cigarettes on a barge that smelt of cat shit.

JP: And then it sank, after someone left an inlet open when they used the sea toilet. So we salvaged it, got rid of the sewage-saturated carpet, and found the beautiful floorboards underneath that we had no idea were there. And we started again.

PS: Our relationship with the Canal & River Trust, which maintains the canals, had always been slightly choppy. We'd get complaints because we'd hold jazz concerts on the roof and we'd be wrongly classified as a party boat. We got threatening letters, saying the boat would be scrapped or sold, and we put one of them online, and suddenly there was this explosion of support for us. Cory Doctorow, a sci-fi writer in the United States, retweeted it, and there'd been a million retweets by the end of the day. Then there was a change in the Trust's management, and months later we were on this permanent mooring in Granary Square at King's Cross. The developers wanted us, and London wanted us. It was a strange feeling, like being carried shoulder-high without knowing we'd been picked up. And we hadn't changed at all, we'd just kept plugging away.

JP: It was only after we got here that we started selling new books. We went without food money for a week to make our first order. But we won't have anything in stock that we haven't pre-approved ourselves.

PS: We have a problem with reverse shoplifting; people tend to smuggle books onto our shelves, as a good-will gesture. Sometimes they're self-published, or they're signed first editions. It's kind of charming. I think a lot of people see this place as a kind of secular church. Less than 50 per cent of people in the UK profess a religious belief, but I've seen people come here and cry when they walk in. It's something about bringing people together where there's music and culture and beautiful words; a place where, for whatever reason, people just quietly agree they're going to be nice to each other. I mean, this can't just be about the money, because there's not enough of it. And people see that in almost holy terms today – a place in the heart of London that's not all about money!

JP: My daughter was less than 10 years old when we started all this, and she's 16 now. I feel like it's helped me show her that there's another world, just to the side of the one you usually experience; a world built on mutual regard and trust and the power of words and ideas. That's why it's a kind of sacred space.

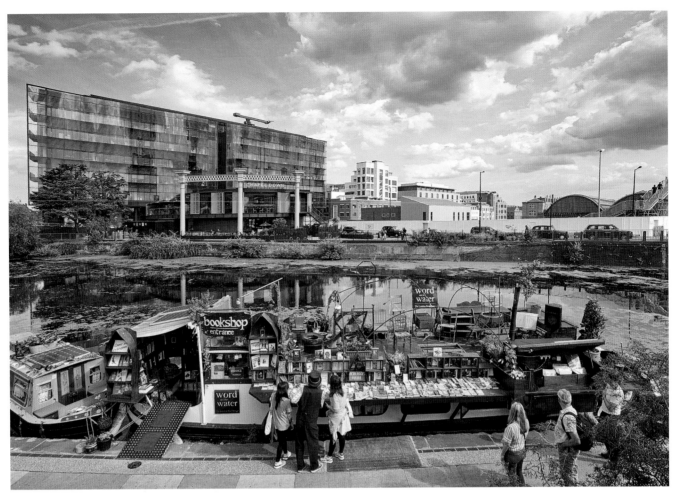

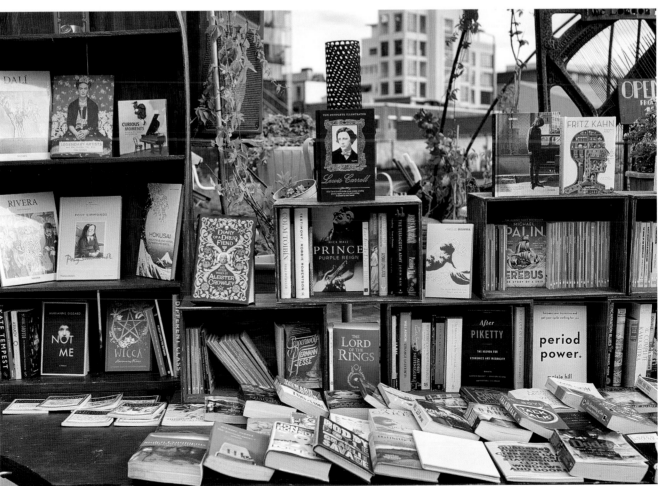

WORD ON THE WATER – LONDON

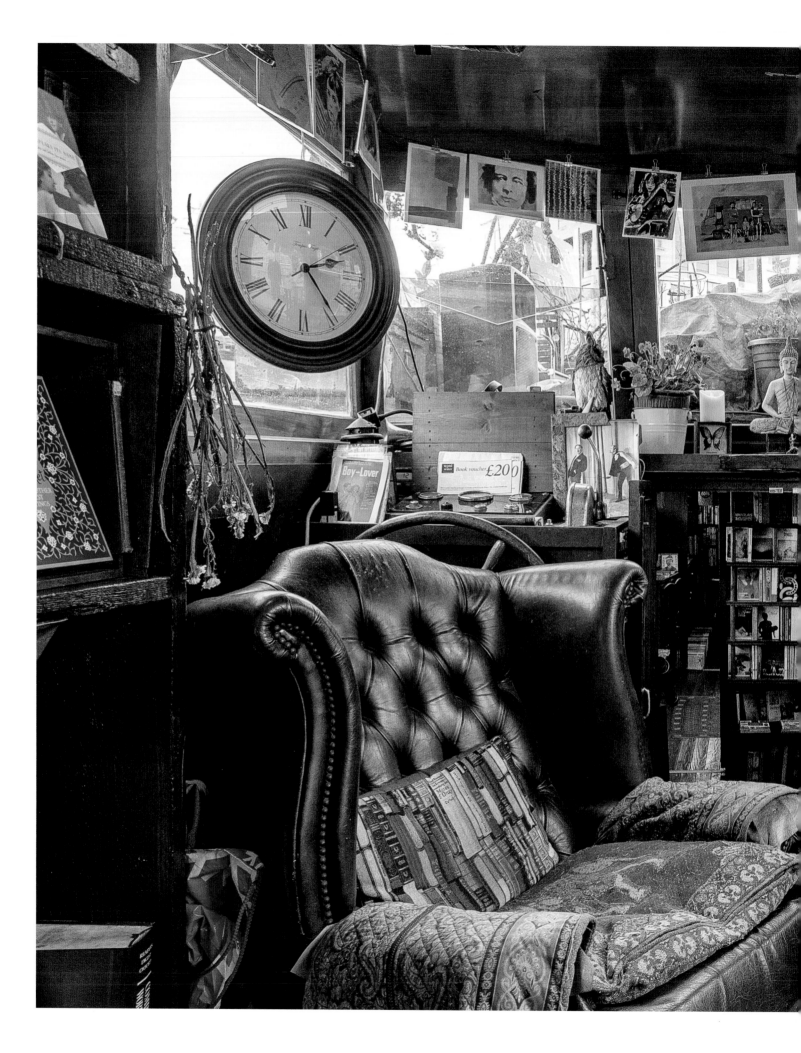

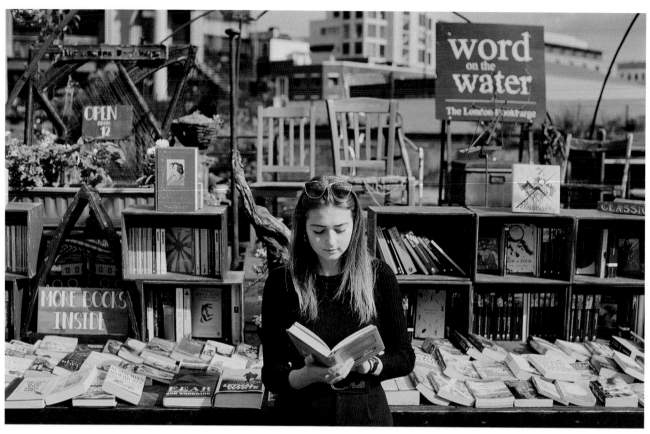

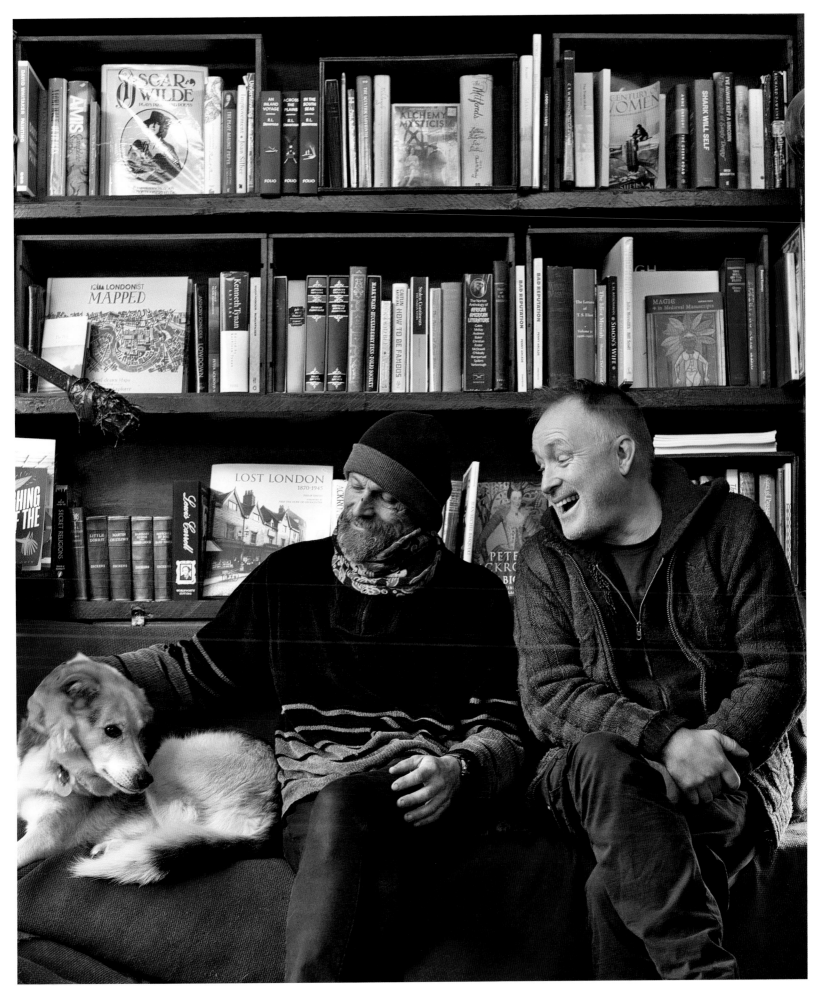

PADDY SCREECH & JONATHAN PRIVETT — WORD ON THE WATER — LONDON

MENDO

JOOST ALBRONDA & DANIËL FERWERDA

We once got a comment on our Facebook page: "MENDO equals book porn." We couldn't agree more. My co-founders Roy and Joeri and myself used to run an advertising agency, and we were always looking for visual inspiration. So we hired Concrete Architectural Associates and gave them a modest brief: design the most beautiful bookshop in the world. They came up with the idea of creating a bookshop made out of books. It's functional as well as fun; the six tons of steel shelving and the 2,000 black books are a modular system that enables us to alter and mould the store according to the needs of the collection. And with the contemporary lighting and leather walls, we think of it as a modern-day version of a classical library.

We're now in a position where people trust us to provide the latest and finest in photography, fashion, travel, lifestyle, interior, architecture, design and culinary titles, along with a unique series of collectors' editions. I think it's important that we don't offer what our customers want, but what we personally like. As a consequence, suggesting books to customers isn't a sales pitch, but rather a personal story and connection between us and them. That makes us an atypical bookshop, and our audience is much younger than would have expected to attract when we started out. I guess they're not just books, but interior elements – something that our own interior emphasizes. And in this age of information overload, people use books to help them define what they're really passionate about.

My favourite section in the store? The cash register. For the obvious reason, and also because it's neatly hidden in a drawer. New customers like the fact that it magically appears out of nowhere, and, such is the level of trust here, frequent visitors often open it themselves.

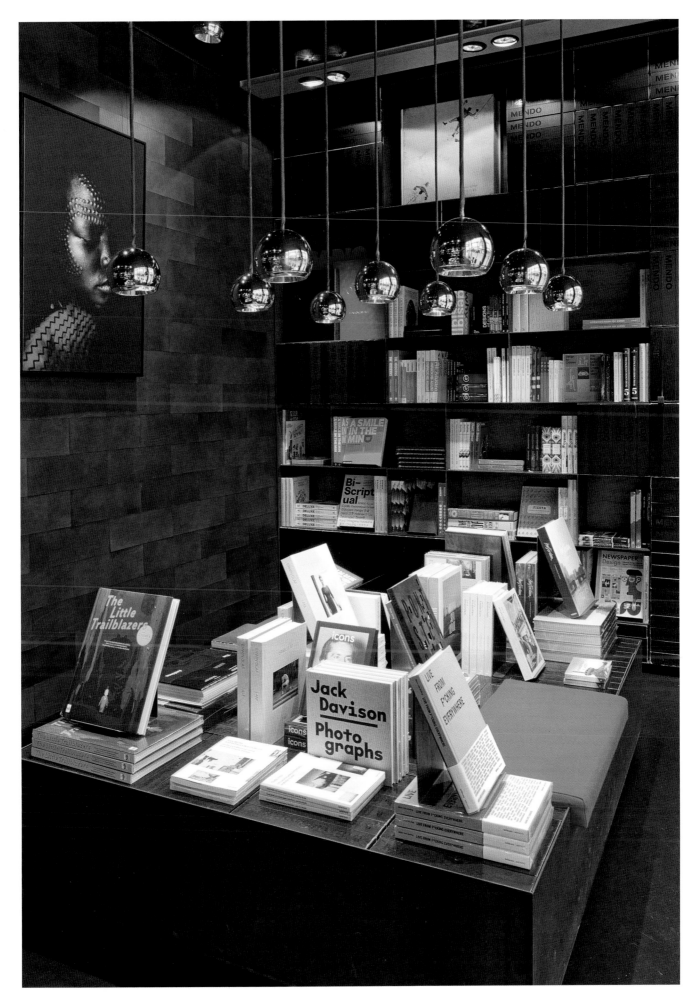

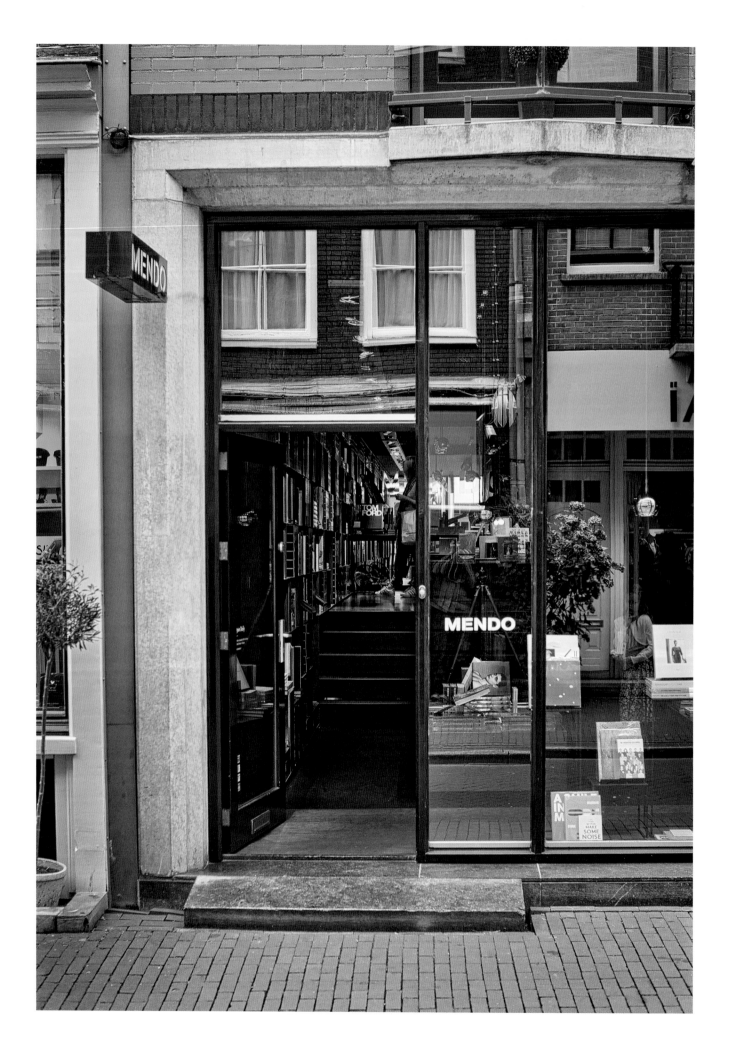

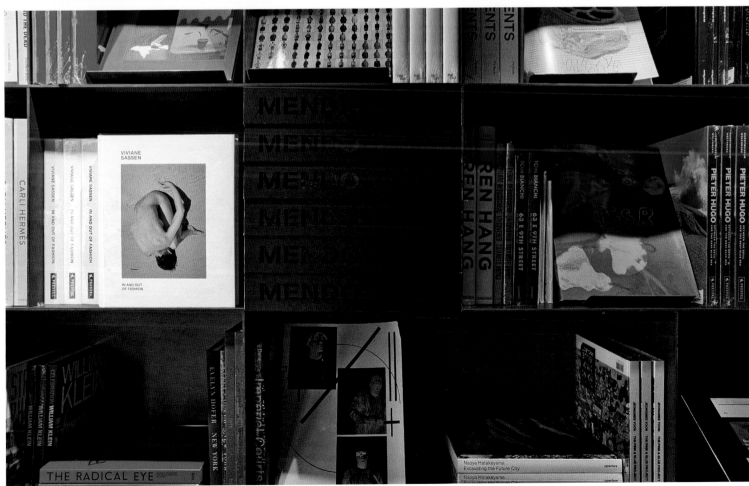

MENDO — AMSTERDAM

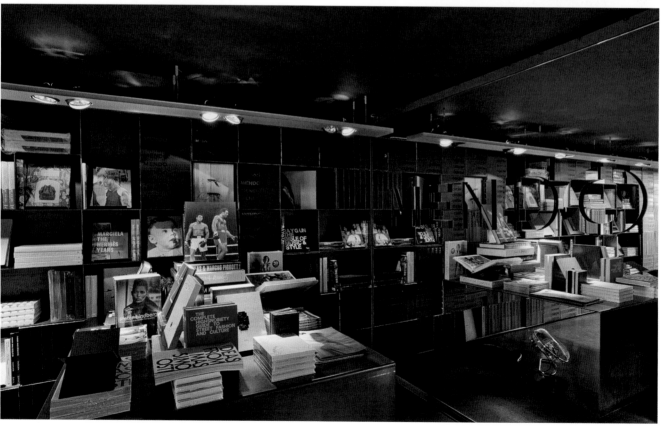

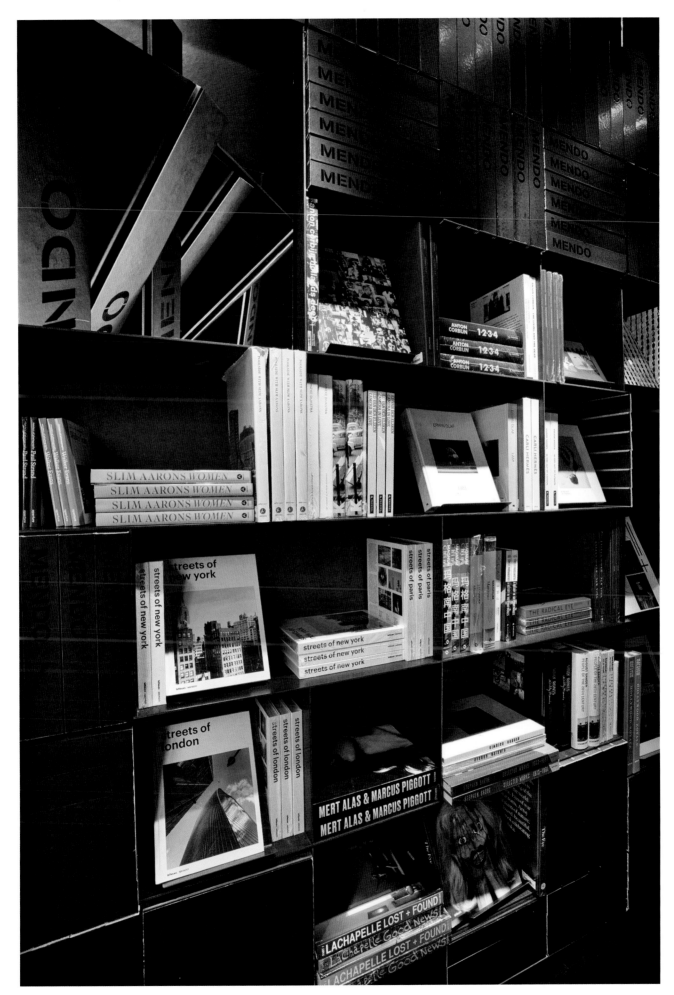

MENDO — AMSTERDAM

Boekhandel Dominicanen

TON HARMES

This was the first Gothic church built in the Low Countries, in the thirteenth century, but it was deconsecrated six centuries later. It's since been a boxing arena, a car show venue and a storage facility for bicycles. Children's carnival was also held here, so a lot of Maastricht's citizens experienced their first dances and first kisses here. Sentimentally, it's a place that means a lot to the local people.

When we converted the church into a bookshop, we put in these massive steel bookcases, which enhance the Gothic surroundings, and a pair of huge doors in Cor-ten steel in the shape of a book; a portal that lets you know what's inside, with the word "books" printed on them in twenty-seven languages. Tourists start coming here just before 9 a.m. to see the opening of the doors. It's acquired a kind of ritual aspect.

We get a million visitors a year, with many coming for the concept. Our challenge is to turn visitors into customers. It helps that we were called "The World's Most Beautiful Bookshop" in *The Guardian* in 2007, and that Instagrammers do our worldwide marketing for us. You also have to walk through the interior to get to the staircase, which encourages browsing, and, once you're up on the second floor, the fact that you have a better view of the Baroque ceiling paintings, and that you're eight metres closer to heaven, may also inspire a purchase. There's a lot of love for this place; when the owners of the shop went bankrupt a few years ago, we raised 100,000 euros through crowdfunding within a week in order to keep it going. We're now entirely independent.

We uphold two principles of the Dutch constitution here: freedom of speech and freedom of print. You'll find ideas and opinions from across the spectrum, and you're free to make up your own mind. We also organize around 200 events a year, where authors and others discuss any subject from any point of view. It's more important than ever to have a space where that can happen, and this environment – contemplative, reflective – seems to make people uniquely receptive. That's why people are paying more and more attention to the physical spaces in which books are sold. They can be places of refuge, but also of inspiration.

Would the saints give us their blessing as they look down on us? Well, when you look up at the ceiling, you see three bishops, with the Bible open in their hand, at the first sentence of the first chapter of Saint John: "In principio erat Verbum" – in the beginning was the Word. We are dealing with the word all day, and carrying it forward, whether that's about politics, poetry, travelling, gardening or teaching children how to read. So I think they'd approve, yes.

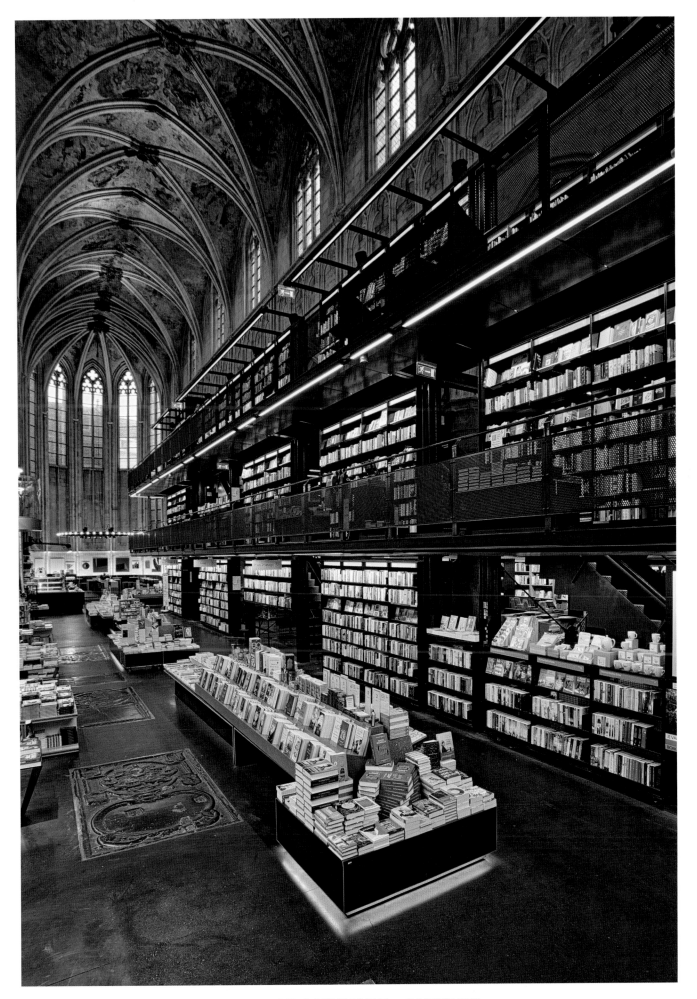

BOEKHANDEL DOMINICANEN — MAASTRICHT

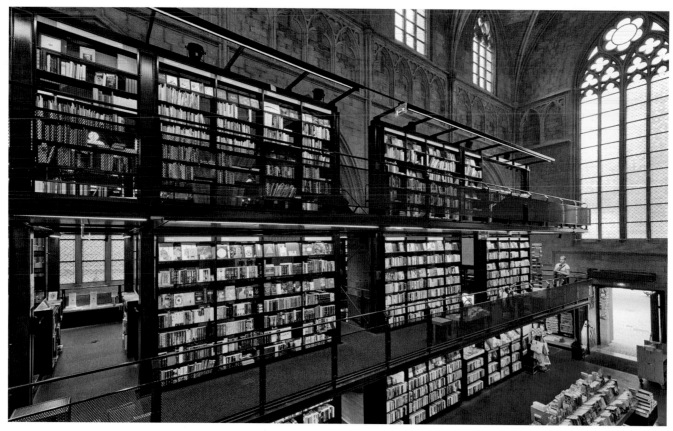

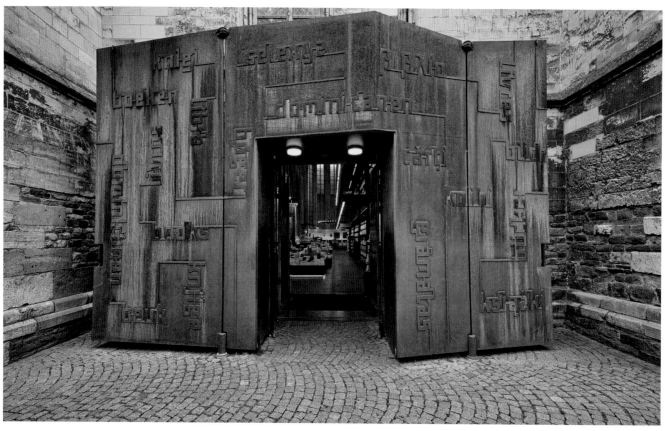

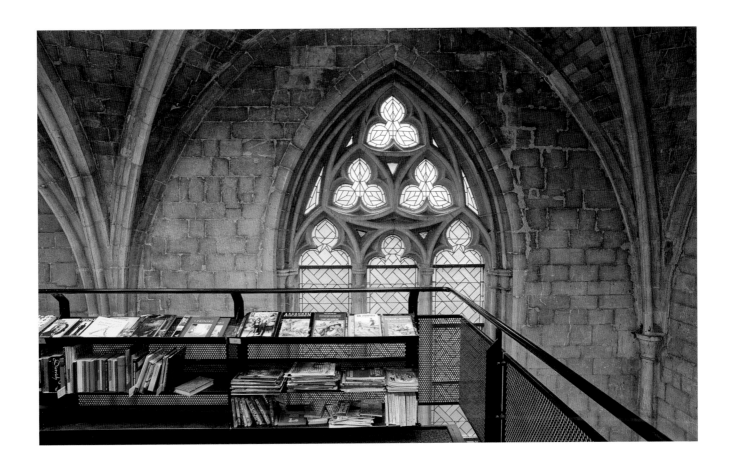

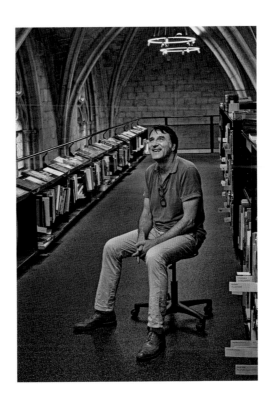

TON HARMES — BOEKHANDEL DOMINICANEN — MAASTRICHT

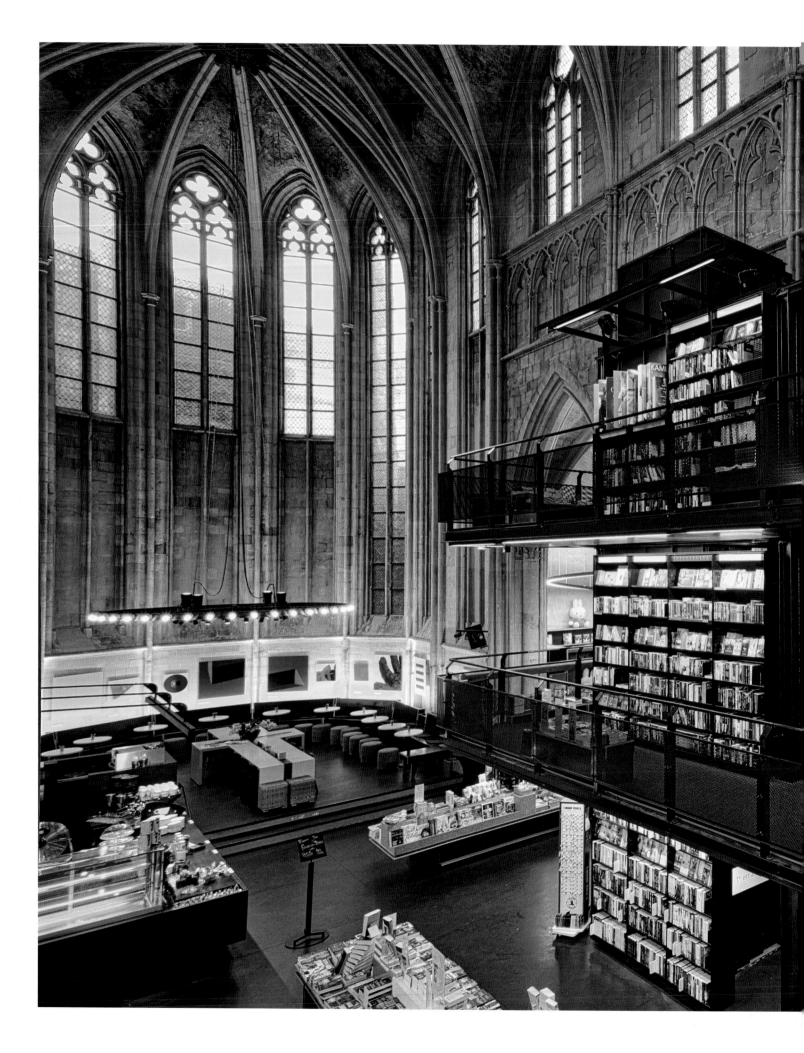

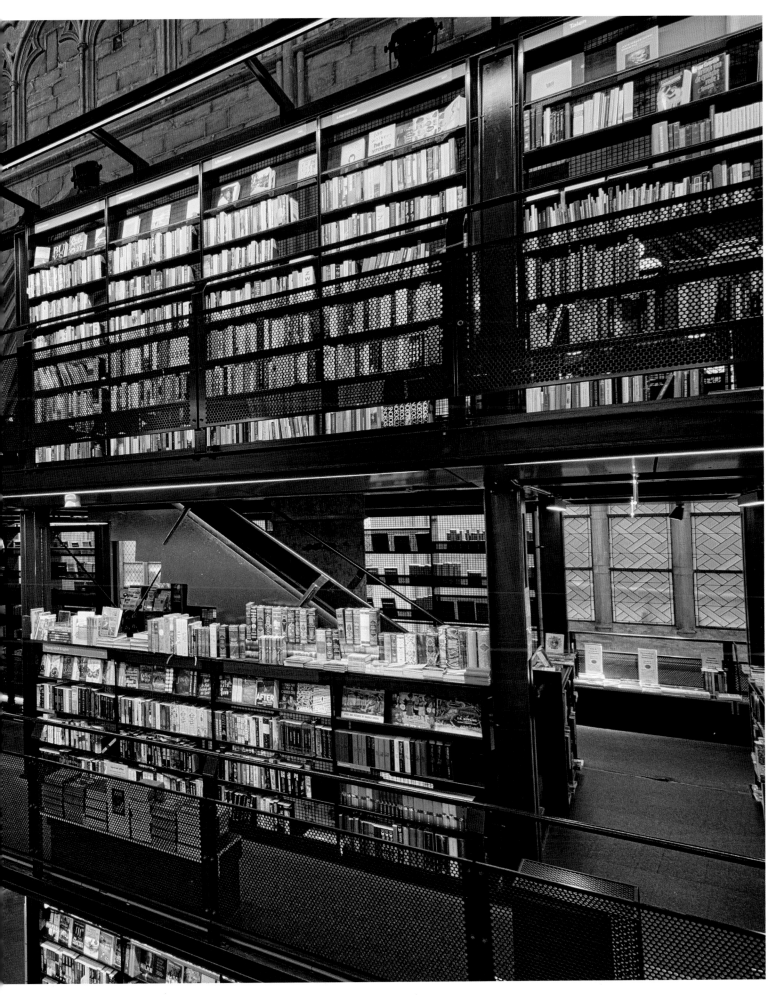

BOEKHANDEL DOMINICANEN — MAASTRICHT

Bouquinistes

There are 240 bouquinistes along the Quais of the Seine. We grew out of the tradition of peddlers – the *libraires forains* – who'd sell their pamphlets along the banks and the bridges in the sixteenth and seventeenth centuries. Today, you get ten metres of railing each; the boxes you use have to be two metres in length; and they have to be painted in "wagon green", named for the colour of old railway rolling stock. We're only supposed to sell a limited amount of souvenirs amid the books, but some are now going heavy on the baguette magnets and mini-Eiffel Towers to attract tourists.

It's a great job, because we're really free. We can open and close when we like, and a unique statute means we're the only traders in Paris who can work on the pavement without paying tax. The internet has impacted on us, but you can still occasionally find extraordinary bargains and rarities here. It's been a while since a first edition of Baudelaire's *Les Fleurs du Mal* showed up on the quays, but we've had it here. It's a place of surprises and discoveries, and emotions.

There's talk of granting the bouquinistes UNESCO World Heritage status, which might help safeguard our future; the boxes are constantly being tagged, we've been asking for ages for decent lighting – we have to close up pretty early in the winter – and there's no public toilet for us, though the neighbourhood cafés are kind enough to let us use their facilities.

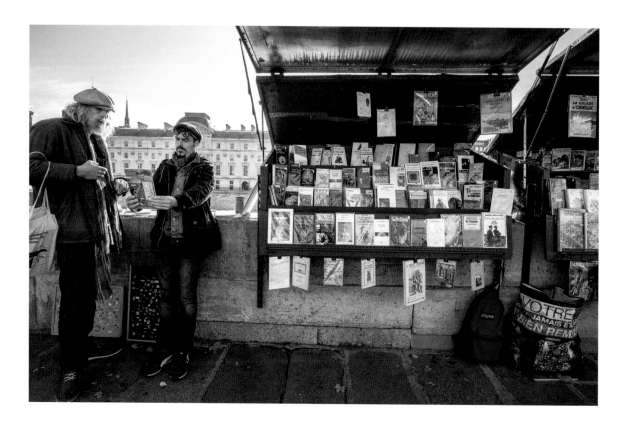

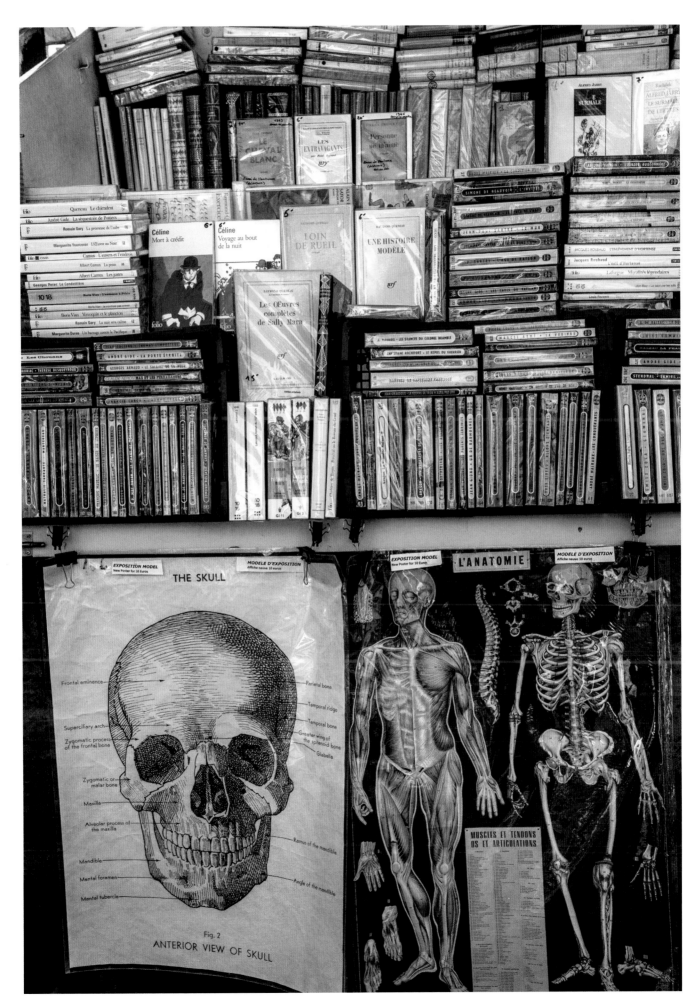

BOUQUINISTES – PARIS

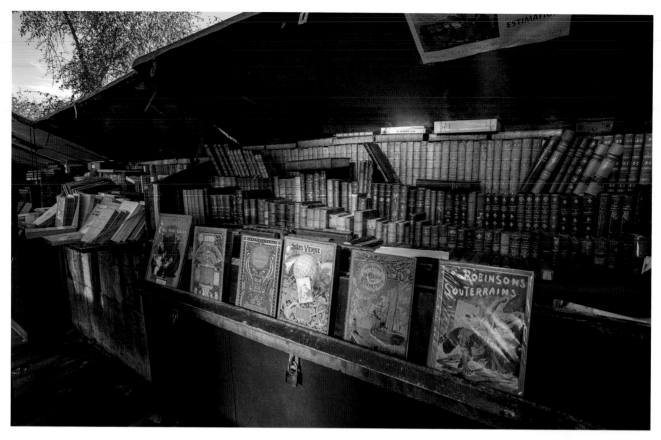

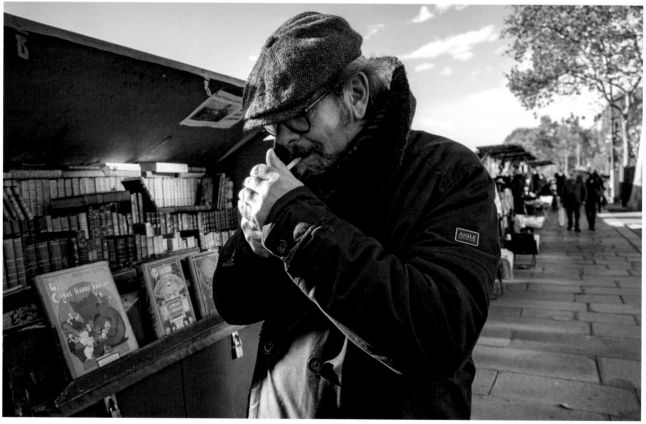

BOUQUINISTES — PARIS

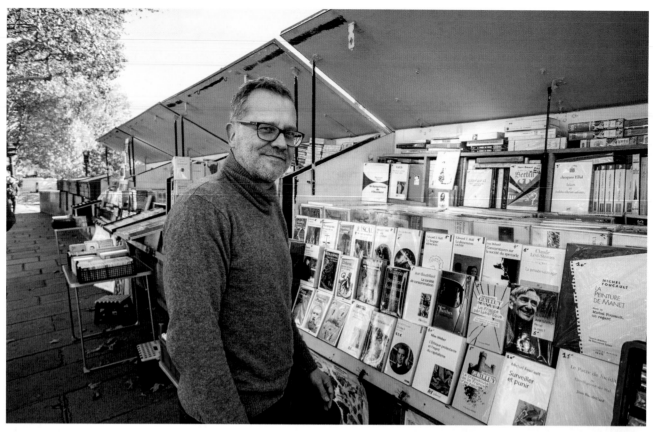

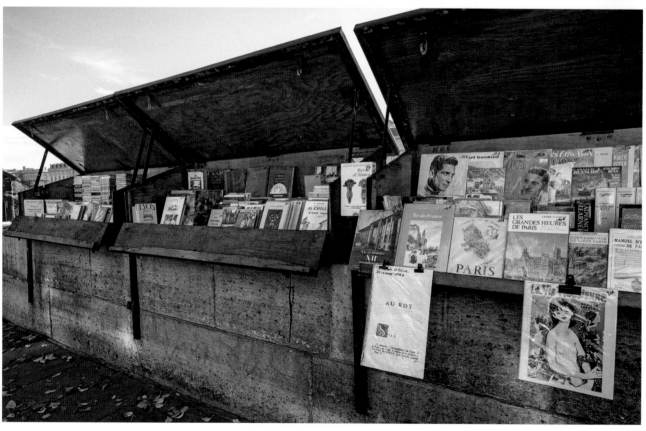

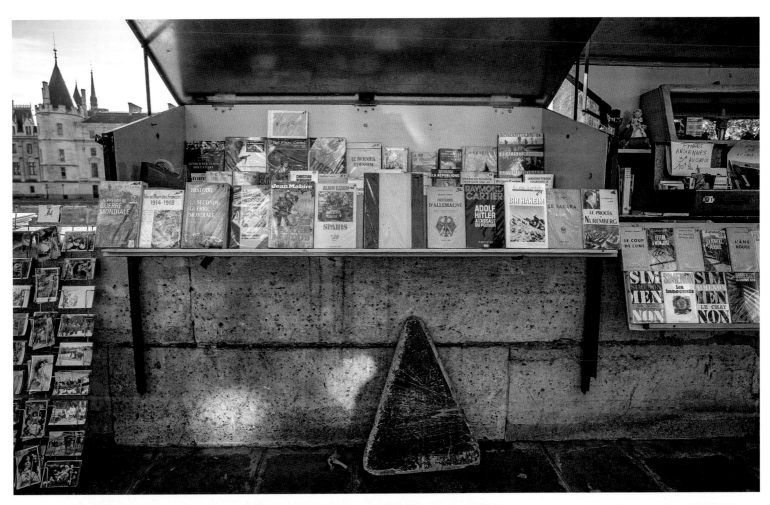

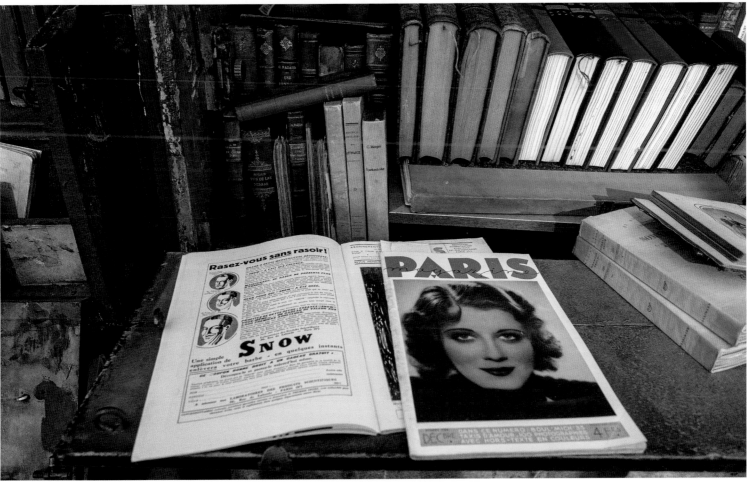

BOUQUINISTES – PARIS

Librairie Auguste Blaizot

PAUL BLAIZOT

I'm the fifth generation of booksellers in my family. Auguste was my great-grandfather, and he used to run a combined bookshop/salon on the Boulevard Haussmann. We moved here, to an old boulangerie on Rue de Faubourg Saint-Honoré, in 1910. There's a beautiful Art Deco window by Jacques Grüber in my father's office.

My grandfather collected autographed manuscripts, while my father collected books. I was more drawn to autographs when I was growing up; I love Napoleon, and one masterpiece I received early on was a letter of his. But then I did an internship at the Librairie, cataloguing the books. I came across a signed volume by Guy de Maupassant and wanted to buy it, but of course, at 12, I couldn't afford it. Then, when I passed my Baccalaureate at 18, my father offered it to me. He had kept it for me all that time. I think that's when I lost my heart to books.

Every *librairie* has a speciality; ours is bookbinding, first editions and illustrated books. Most people come here looking for the best, rarest or most beautiful editions of the classics. We know all the other dealers – we have a WhatsApp group – and that network is very important in helping us find books. The internet was difficult for us at first – it was like the Wild West, and price wars broke out everywhere – but now the market has established itself, and it's brought us a lot of big customers from the United States, China and Japan, which we didn't have before.

We're on the same street as all the government ministries, and presidents and prime ministers have always shopped here. We usually get no warning, they just appear in our doorway. One time my father received a certain president who wanted to see a particular book; they disappeared out a back entrance to our other shop without telling his guards. They were gone for an hour and we had no idea where they were. There was a big alert – "The president is missing!" – but eventually they came back and the guards were like, "OK, he's alive! Let's go!" Should I say which president it was? OK, it was Mitterrand.

The environment in which you buy a beautiful vintage book is very important, and the Librairie is a rich treasure house, representing decades of scholarship and erudition. It's a fabulous place to work, because you discover something new and interesting almost every day. I was recently going through a massive library someone had sold to us. It took us a year to go through all the books, and in the last box I found a book of poems by Guillaume Apollinaire, an original that had been presumed lost for decades, worth maybe 100,000 euros. It was like finding a Caravaggio in a box of flea market paintings.

It's beautiful to know that all the books that surround us here have survived, and will outlive us. No one really owns them, but we can hold them in trust and pass them on. It's like that Maupassant book my father gave me, which was dedicated to his friend: "I think it's good, but I'd like your opinion." It touches me, because it was touched by him. It's history, but it still lives and speaks to the next generation.

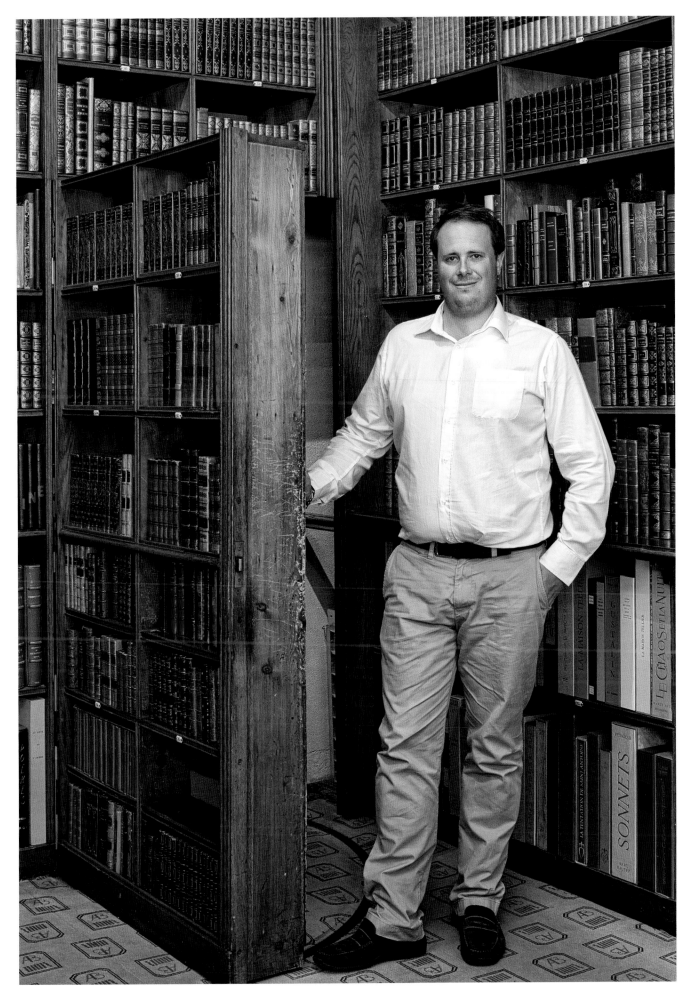

PAUL BLAIZOT — LIBRAIRIE AUGUSTE BLAIZOT — PARIS

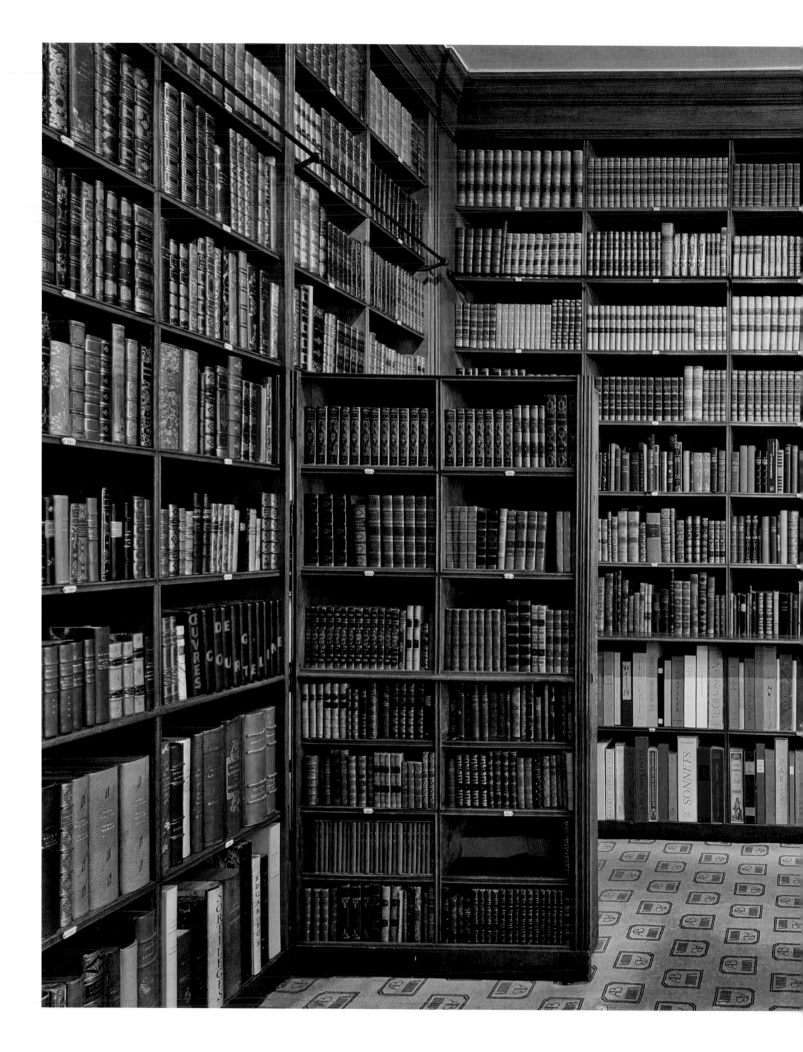

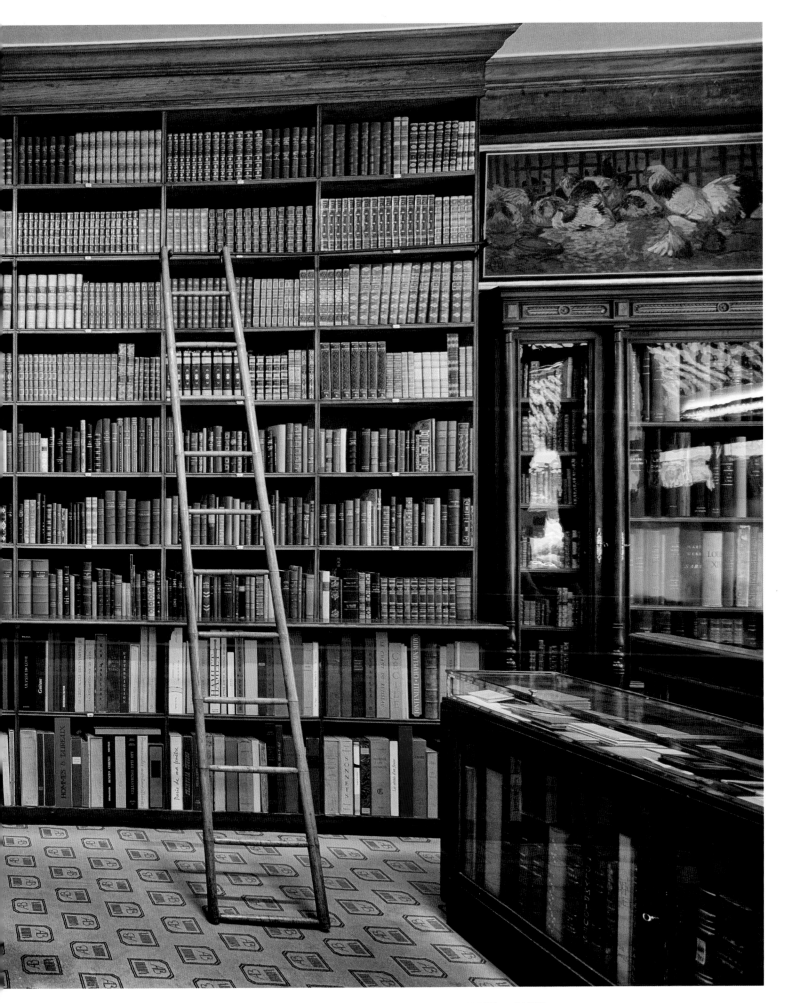

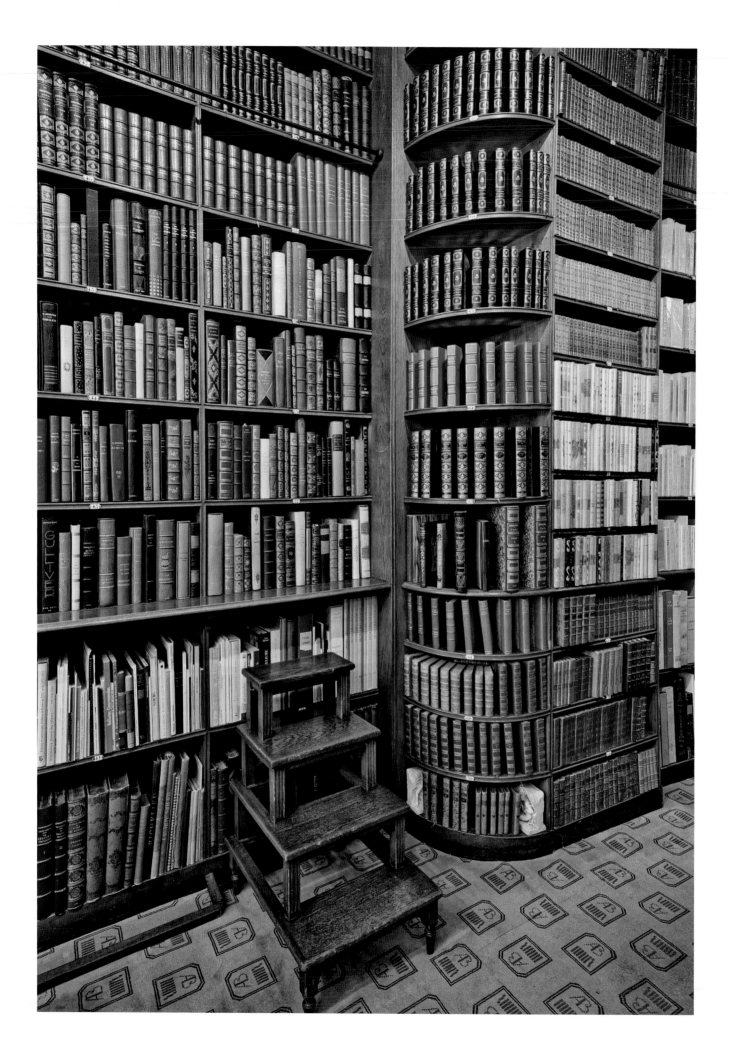

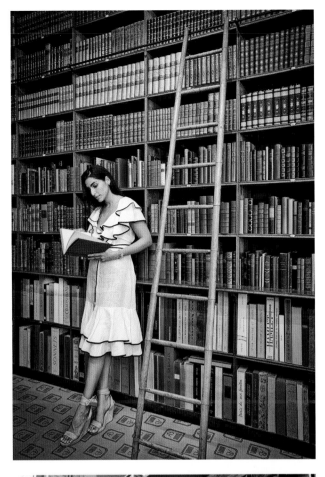

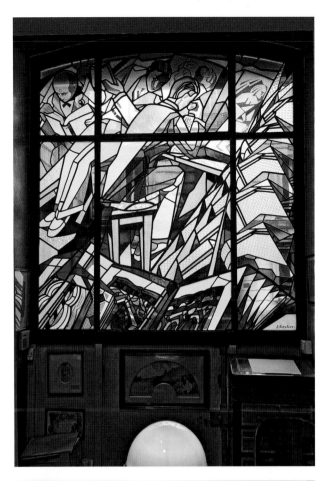

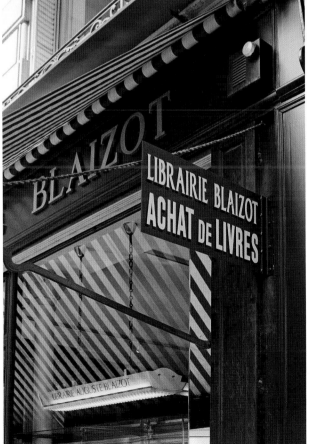

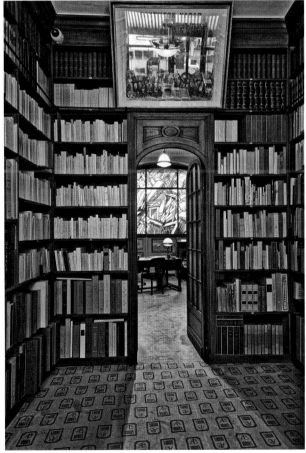

LIBRAIRIE AUGUSTE BLAIZOT — PARIS

Shakespeare and Company

SYLVIA WHITMAN

I was born above the shop. My father George founded it, and named it after an earlier English-language bookshop in Paris that had provided a haven to expatriate writers like Hemingway in the years after World War I. And he named me after its proprietor, Sylvia Beach. She was much more than a retailer – she pushed her shop to the brink of bankruptcy in the 1920s in order to publish James Joyce's *Ulysses*. My father was a similar idealist – he'd hitch-hiked and train-hopped across America during the Great Depression on what he called his "hobo adventure", and was met with the kindness of strangers everywhere. In opening the shop, he wanted to replicate the generosity he'd experienced on the road. He called Shakespeare and Company "a socialist utopia masquerading as a bookshop."

From the beginning, George invited people to sleep here, a tradition that carries on to this day; you'll find the beds among the bookshelves. The only stipulations are that guests help out around the shop and they read a book a day. We've had 30,000 tumbleweeds, as we call them, blow in and out over time, and more than 100 marriages have occurred through people meeting here – including my own. My father started the shop with 1,000 books from his personal collection, acquired under the GI Bill, but he would lend out as many as he would sell – he was never interested in making money. He was interested in creating a space where people could mingle, exchange ideas and get inspired. Our first floor remains a dedicated library space where you can read, write, reflect, meet other people – we have a bulletin board called The Mirror Of Love, where you can leave messages or poems – or just play the piano, pet the cat or look out the window at Notre Dame. You're actively encouraged to linger. It's really a space to dream.

We've experienced our own moments of literary history here. The Beats arrived in Paris in 1957, and Allen Ginsberg read from *Howl* in the shop, during which he felt moved to strip naked. William Burroughs gave the first reading of *Naked Lunch* the same night; George said that people didn't know whether to laugh or be sick. Samuel Beckett was a regular, and once had dinner with my father; he told me they sat in almost complete silence, appropriately. Readings and events are just as important to us today; the nice thing is that authors like Jeanette Winterson, George Saunders and Karl Ove Knausgård tend to stick around after the official event and give encouragement and advice to the tumbleweeds and other aspiring writers. There's a kind of alchemy that happens here – maybe it's George's spirit; he liked to say he created the shop like a novel, with each room opening up like another chapter, a magic world of mystery and romance.

Since I took over seven years ago, we're a little more organized – the books are now alphabetized, and we have an Instagram feed, a Twitter account, and a café, because coffee and books go so well together – so we're managing modern expectations, but I hope we're retaining the freewheeling, bohemian spirit that was established here in the 1950s. Many people are emotionally invested in this place and have a strong personal connection to it. Have the internet giants changed things? Well, it's not a level playing field, but the indie stores are on the rise again, and the physical book is far from dead. (Didn't Jung say it was the most magical object?) And to me, this place is like a lighthouse, a beacon for readers, where they can be alone together and they don't have to buy or believe. It's an immediate community – real, not virtual – that anyone can become part of.

I never expected to be running my dad's bookshop, but now I can't imagine doing anything else. It's endlessly stimulating – I can walk through the shop and take something at random off the shelves, and find myself plunging down a new rabbit hole. Sometimes I say that it actually feels like Shakespeare and Company is running me, though in the best kind of way.

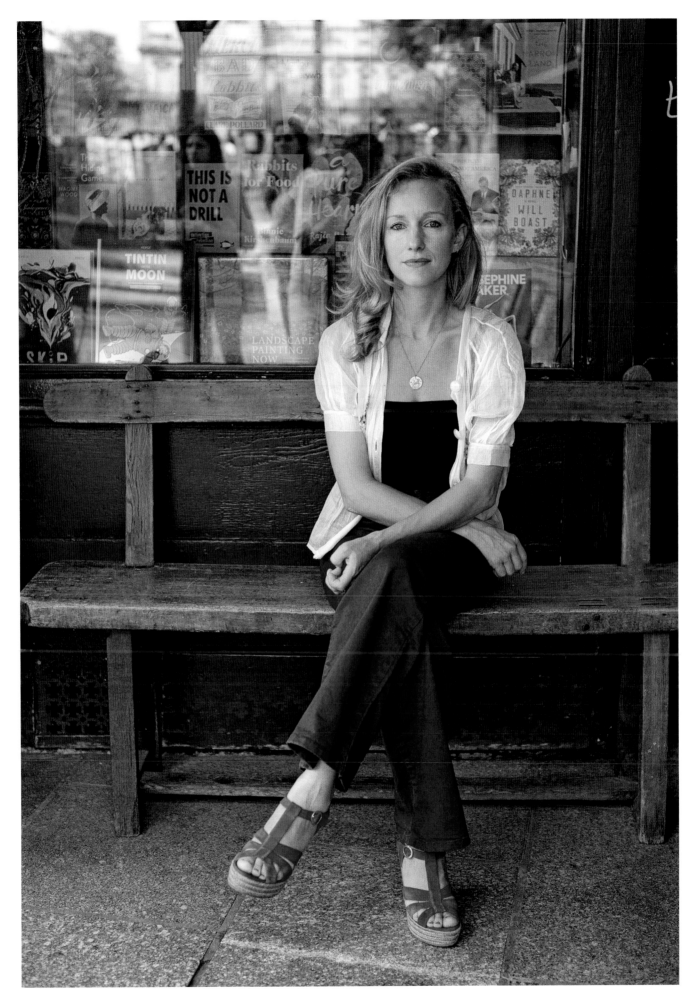

SYLVIA WHITMAN — SHAKESPEARE AND COMPANY — PARIS

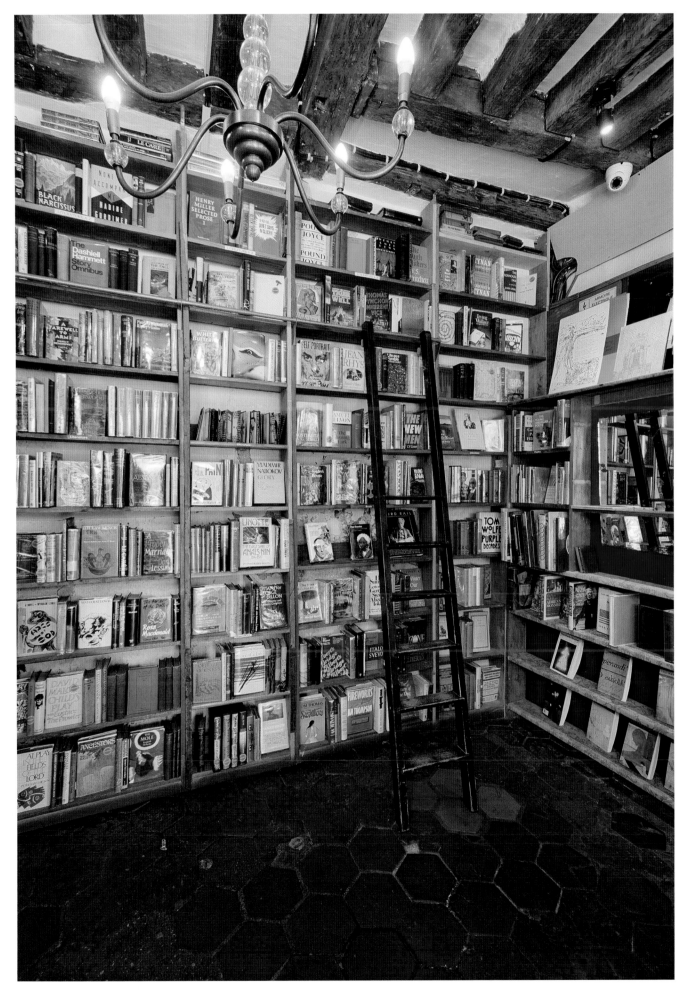

SHAKESPEARE AND COMPANY — PARIS

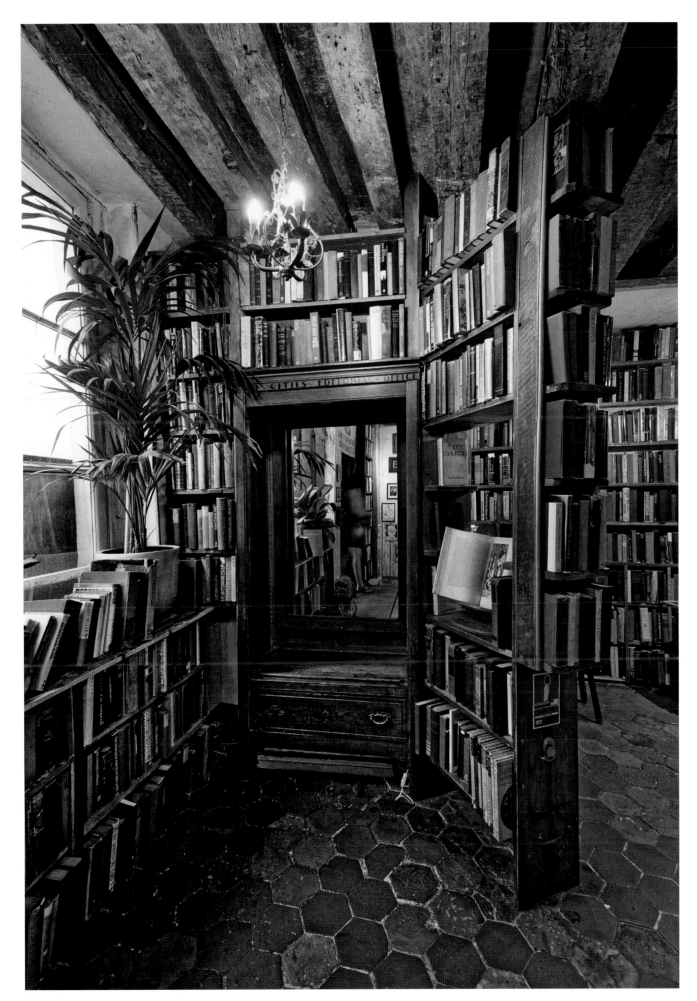

SHAKESPEARE AND COMPANY — PARIS

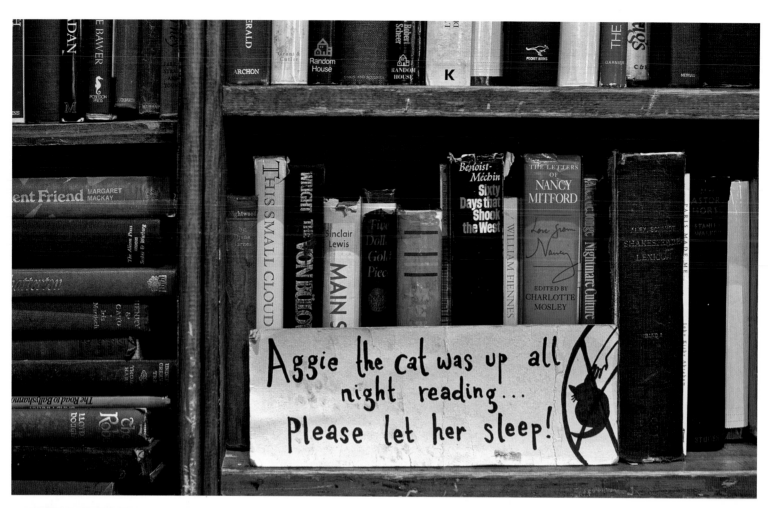

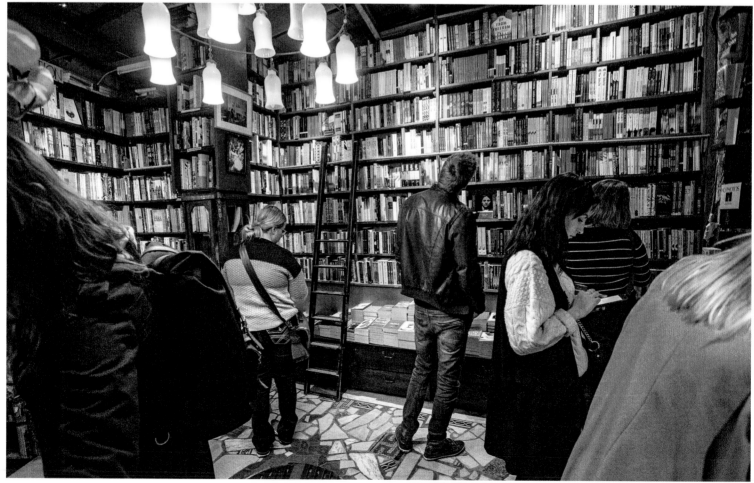

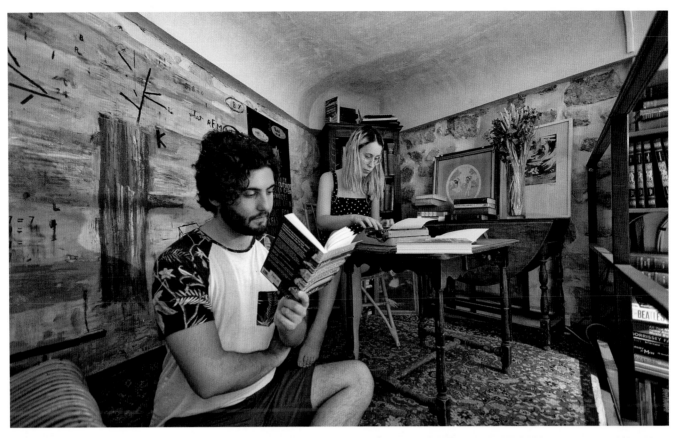

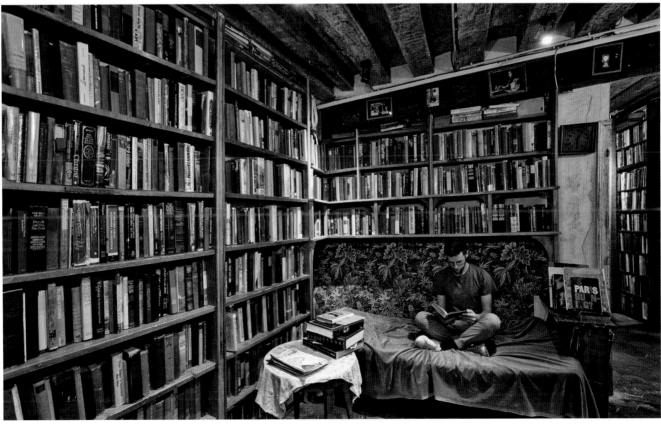

SHAKESPEARE AND COMPANY — PARIS

Buchhandlung Walther König

WALTHER & FRANZ KÖNIG

WALTHER KÖNIG: In 1968 my brother Kaspar, who was living in New York at the time, and I founded a publishing company, Verlag Gebr. König Köln – New York. The opening of the bookstore followed in early 1969. It was the hour when Pop art was born. The mainstream was receptive to art. The concept of the book itself as an autonomous work of art was gaining increasing acceptance.

FRANZ KÖNIG: At that time Cologne was the centre of the German art scene.

WK: Many Cologne galleries were working with German, British and American artists. This scene revolved around our bookstore. Everyone came to us. It was a space without political boundaries, and a little bit like a post office, too. Artists left letters and notes, and sometimes just tips about restaurants, for colleagues who were due to come to the city a few weeks later.

FK: Others stayed longer and published art books with my father. There is a photograph of Gilbert & George standing in our shop window and presenting the entire print edition of their artists' book *Side by Side*, which we published. At the edge of the photo I can be seen, a little baby crawling around on the floor. I grew up surrounded by books and have spent my whole life in their company.

WK: In 1981 we moved into the present building. At first we had one and a half floors, but in the meantime we have expanded into a labyrinth over several levels. More than 3,500 metres of shelves are accessible to customers. All of our profits go back into books. A hopeless habit. When customers ask us for a book about Picasso, we say, "Which would you like? We have about 280 in our range." The first two hours of the day are an almost sacred act: everything that has been delivered is laid on the big table, and we take decisions title by title.

FK: It's a kind of ritual. In this way we get a feeling for a book. As soon as we hold it in our hands, we know where we can present it and how we can sell it.

WK: I have been doing it like that for over fifty years. I love to hold books in my hand, as objects. I would spend all of my time here if I could. I am 80 years old now, and I have passed on my desk at the centre of the store, and the whole company, to my son. The customers who have grown old with me can now find me all day in my tiny office on the first floor or in our second-hand store.

FK: It was always about presenting and introducing to others the things that we were most interested in ourselves. We do this not strategically, but instinctively.

WK: We now have several shops all over Europe, but our concept is still traditional. When you enter a König bookstore, first of all you see a large table, crammed full with monographs and catalogues that straight away give you a view of what is happening in art at the moment. You won't find coffee or merchandise items in our stores. For us, it was always about books, and that's how it will remain.

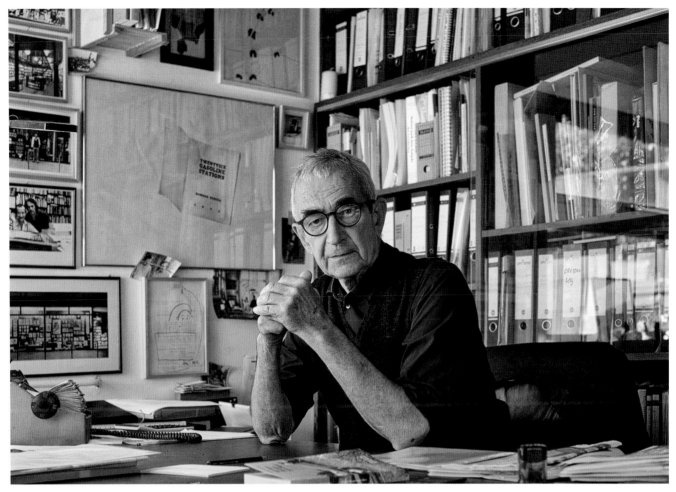

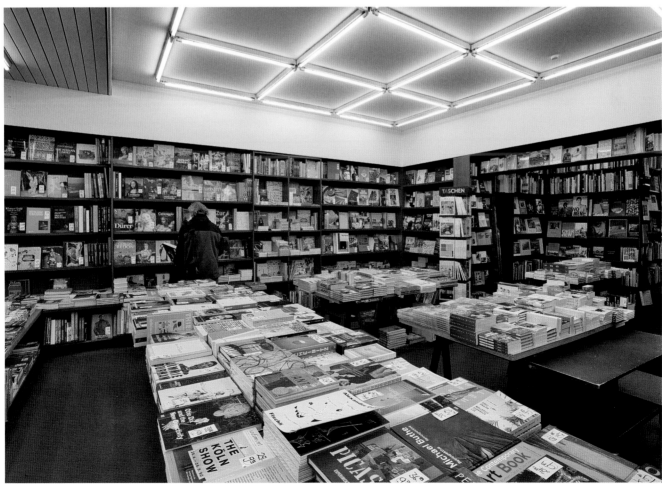

WALTHER KÖNIG — BUCHHANDLUNG WALTHER KÖNIG — COLOGNE

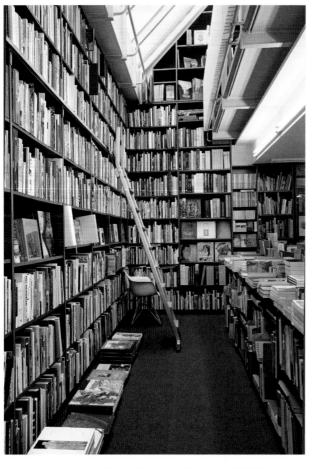

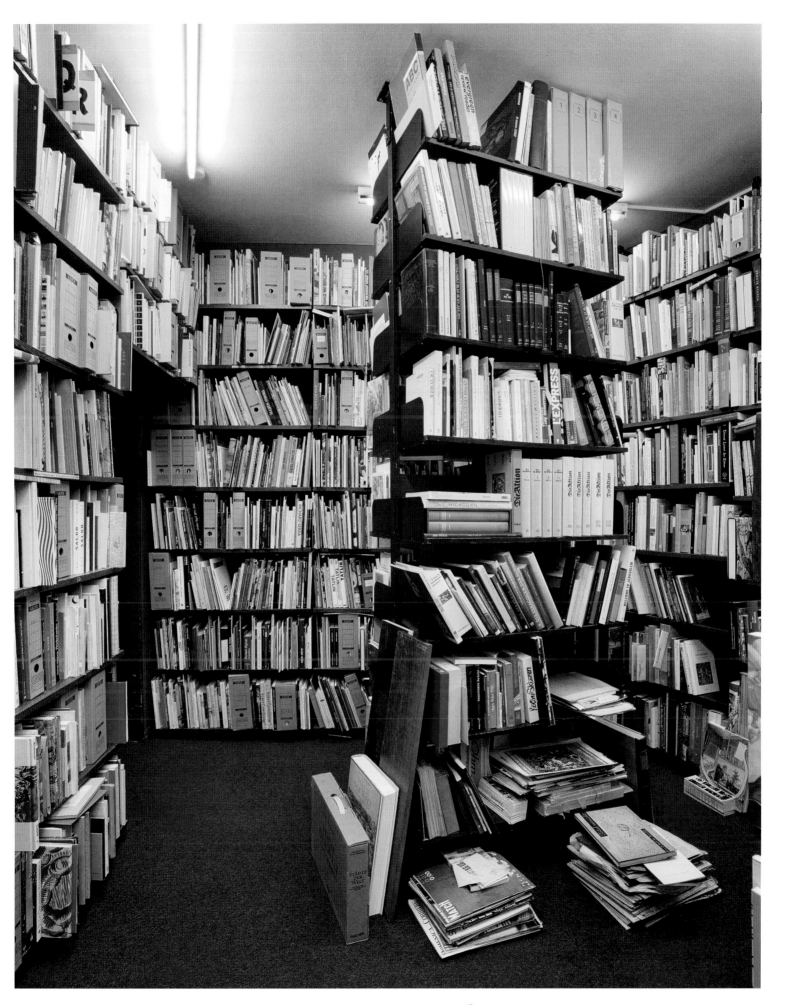

BUCHHANDLUNG WALTHER KÖNIG — COLOGNE

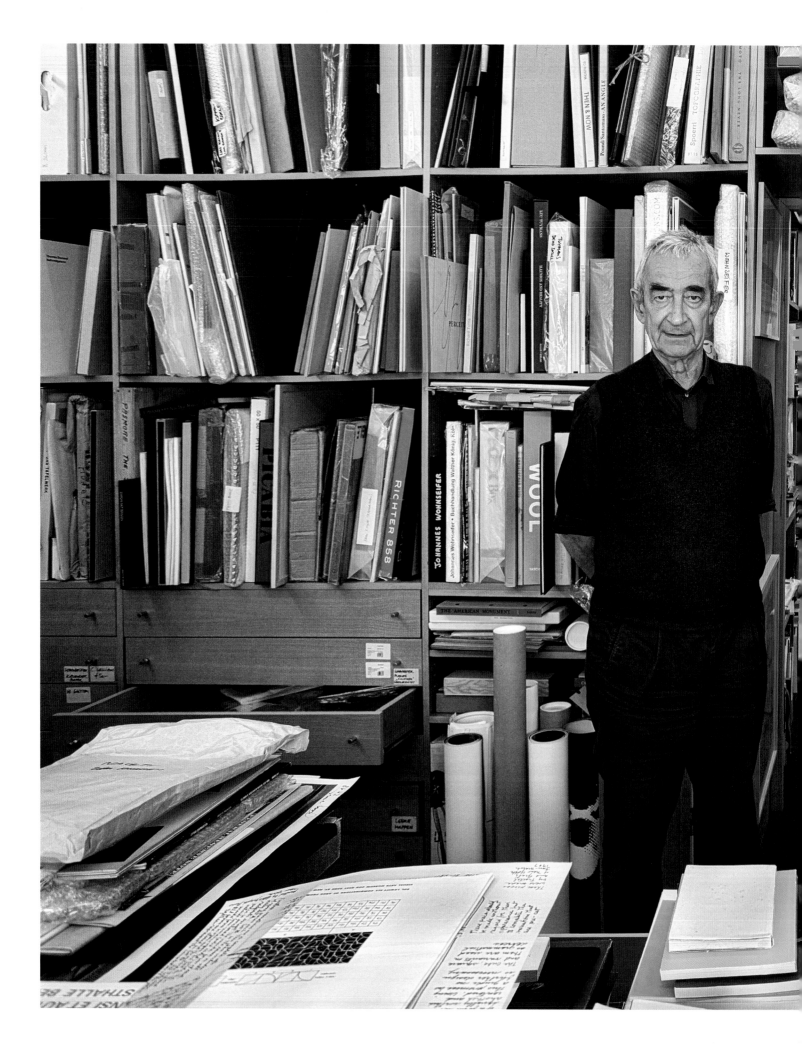

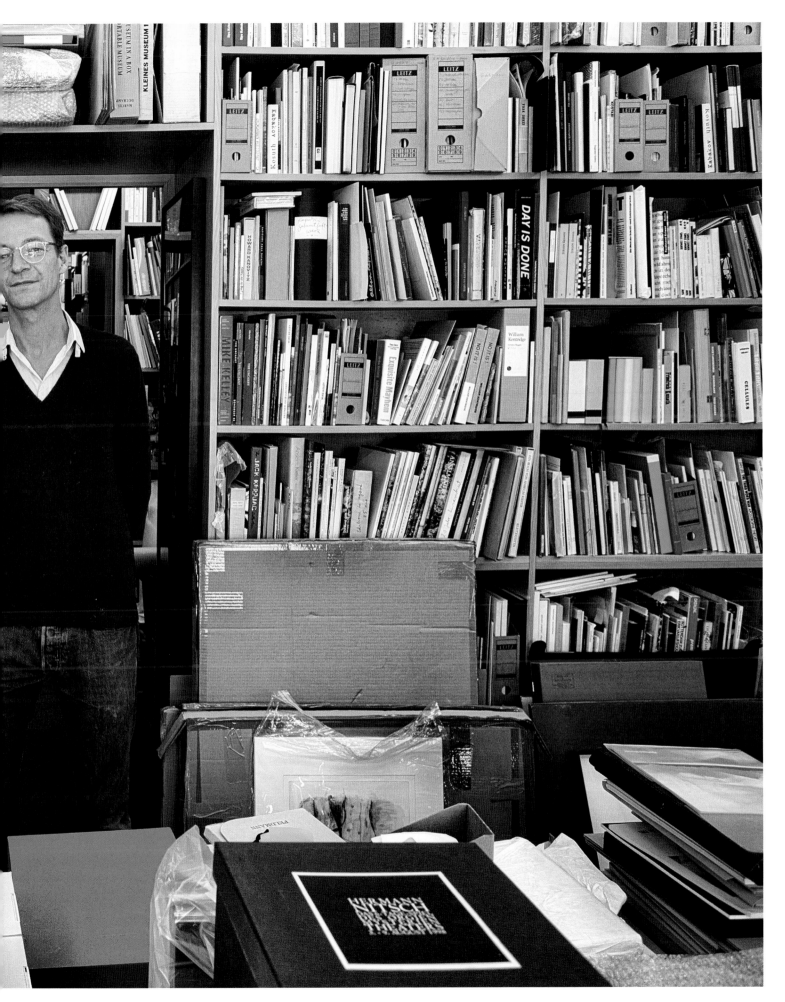

WALTHER & FRANZ KÖNIG — BUCHHANDLUNG WALTHER KÖNIG — COLOGNE

Booxycle

MARCUS MÜLLER

This all started when I saw someone throwing a whole box of books into a trash bin. It was so sad, I couldn't bear to see it, so I rescued them. Gradually I became known as the person who takes in old and unwanted books. Eventually I had a cellar full of them. Then I found this space, which had been a kiosk that sold cigarettes. I also have a transport business and a stationery shop, but the books take up the most space. I sleep here during the week, in the back room, between piles of books.

Do I regard books as sacred objects? Well, in Germany we have a history of burning books, and I think they're essential for the development of culture and civilization. We're in a situation now where children are always on smartphones and tablets, but books are better vehicles for the imagination and for learning how to think. That's why I have a "pay what you want" system here. I would like to encourage them to turn pages instead of swiping screens. And it means that people who haven't much money can still have access to good literature.

My reward for doing this? Just to keep books in circulation. When I read a book, I touch the thinking of the person who wrote it. It's a direct link to them, a transfer of mind and spirit.

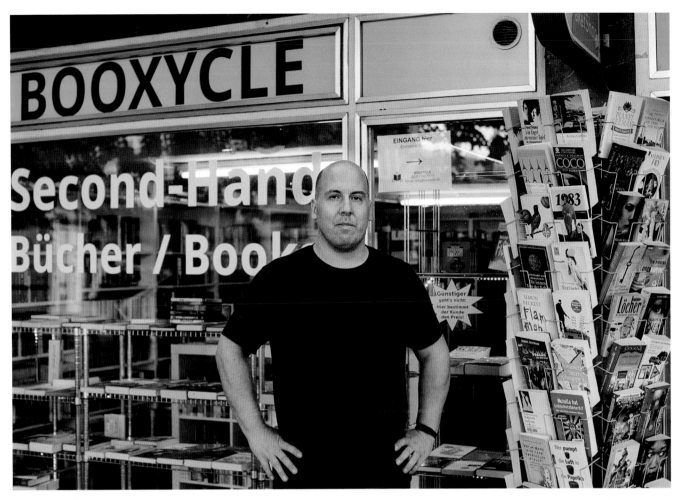

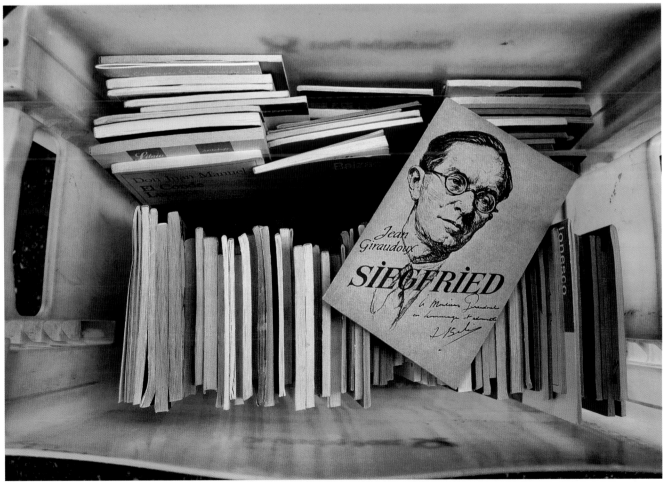

MARCUS MÜLLER - BOOXYCLE – DÜSSELDORF

artes liberales

CLEMENS BELLUT

I never intended to open a bookshop. When I came to Heidelberg in 2012, I originally wanted to establish a small private institute for philosophical studies. Before long, however, I noticed that a certain kind of bookstore, familiar to me everywhere else, was missing: a receptive space, an assortment for alert curiosity, for well-made books, for finding without seeking and for meeting remarkable people.

We are in a newly renovated, wonderfully beautiful building, 300 years old and situated on the finest square in the old quarter of Heidelberg. Here we were able to create a "chamber-music space", as it were, which can therefore restrict itself most favourably to its area of only twenty square metres - invitingly extended by a large display window, which is usually open. The airy, artistic and surprisingly arched shelves - announced by the designer Laurenz Micke even at the planning stage as "the ship's hold of Noah's Ark for the books of artes liberals" - hold hardly more than 2,000 books, many of them in the original language, selected and maintained according to the store's own areas of focus: ancient, medieval and Arabic writings, philosophy and poetry from early modern times and the eighteenth century to the present day, scholarly works on ethnology, economics,

design and architecture, music and art... Of course this institution is supposed to earn its keep, even though the people who enter are regarded and treated primarily as visitors, and not from the outset as customers. They are scholars, professors, students, residents of the town, children, learned travellers from other cities and other countries, sometimes immersed in lengthy perusal or conversation on the reading chairs.

In this way, as if by accident, a small, distinctive centre has evolved in the city, a living rebuttal of the culturally pessimistic view that "young people" no longer have a mind for books and reading. In a trade that is economically highly precarious, even on difficult days a lovely, fine-spun conspiracy and warmly tuned resonance convey the pleasant feeling of having had a wonderful day. It is a place for countless remarkable encounters, for example with French philosophers associated with Bruno Latour from Paris, for whom there was only one thing wrong with this bookstore: it was not in Paris. Or the old, bent but beaming woman who came in one Christmas Eve shortly before closing time, browsed, beamed even more at all her discoveries, and cordially called out as she departed that she had already received this year's Christmas gifts.

168

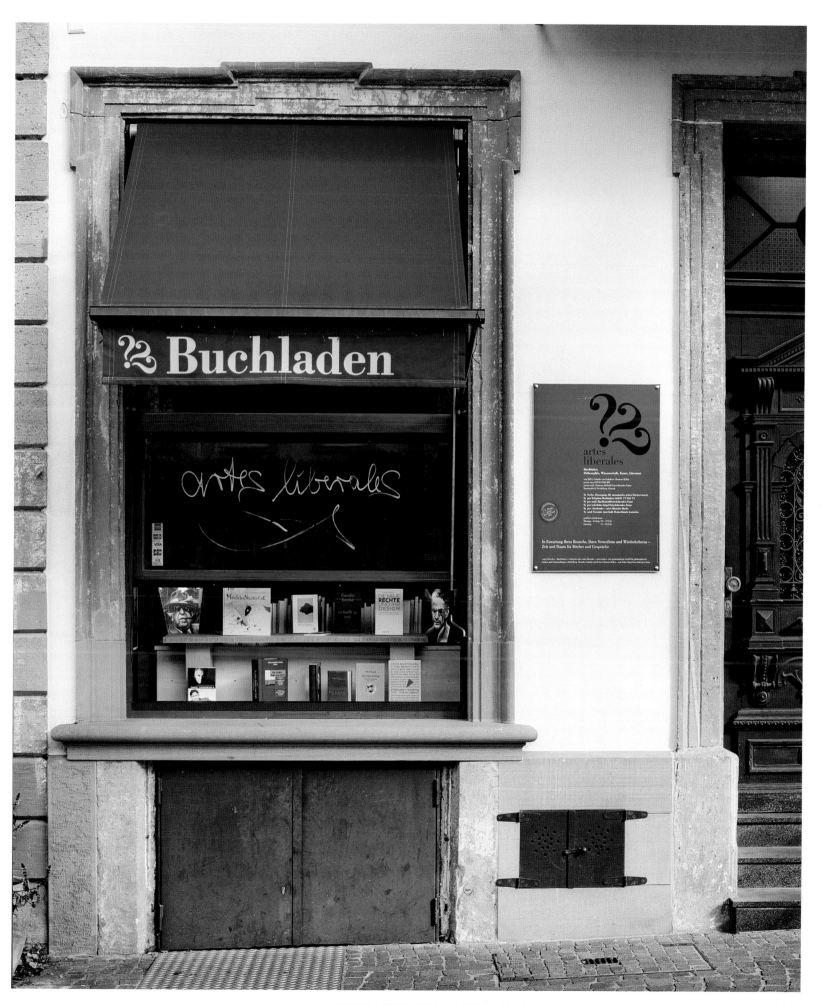

ARTES LIBERALES – HEIDELBERG

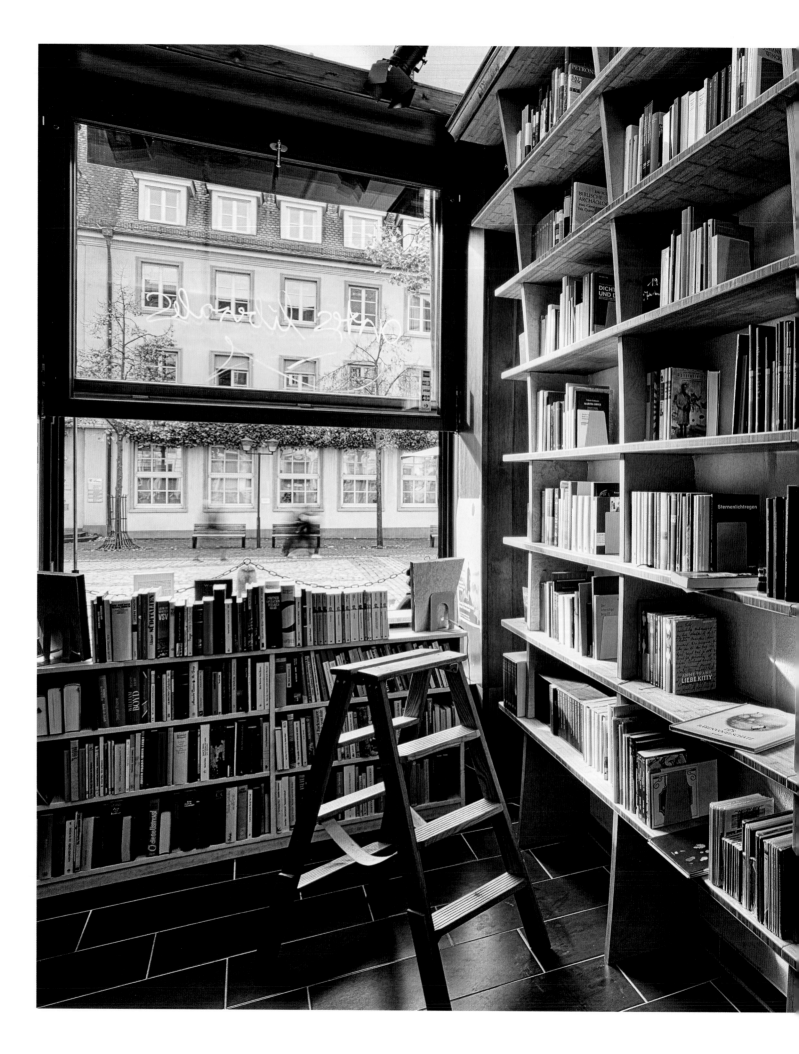

Felix Jud

MARINA KRAUTH

For me, our bookstore continues to epitomize the values that were important to Felix Jud. He opened the shop in 1923, when Germany was going through a turbulent period. Felix Jud believed in a better future for the country and believed in literature, and called this "a place to care for good and beautiful books". As a result of his activities for the White Rose, he was arrested by the Gestapo in 1943 and spent the war years as a political prisoner in the Neuengamme concentration camp. In 1948 Felix Jud was able to reopen the shop. Wilfried Weber became his partner in 1962. It was he who employed me.

Felix Jud is a cultural institution in Hamburg. A lovely place in Mellin Passage on Neuer Wall, the city's oldest shopping arcade. It has always been an open, free meeting place for authors, artists and generations of readers.

We specialize in contemporary literature and classics, and sell important first editions of nineteenth-century and twentieth-century literature in the second-hand department. A special aura surrounds old books.

When you leaf through a bibliophile work, the spirit of a whole era can be evoked directly. With a signed edition by Thomas Mann or James Joyce, or a graphic work signed by Otto Müller, the presence of the authors and artists is almost tangible.

Even as a child, I loved illustrated books. After my apprenticeship as a bookseller I studied German literature and art history in Munich.

We hold readings and art exhibitions, catering to art collectors and book lovers equally. Meeting authors, artists and customers gives me great joy. Karl Lagerfeld, for example: we delivered books to him for decades. I think they were a major source of inspiration for his genius. He told a German magazine that our bookstore is his intellectual delicatessen, without which he would starve. In that respect he was typical of our clientele. In a seemingly confusing world, we would like to offer orientation and inspiring encounters to our customers.

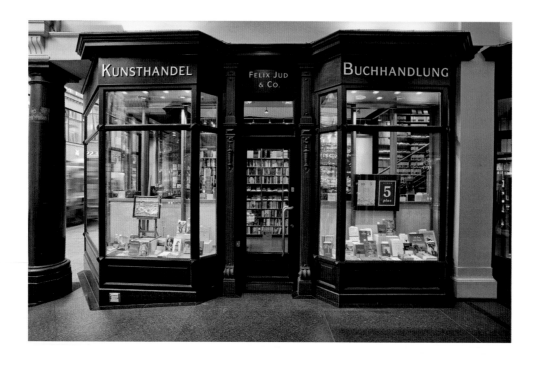

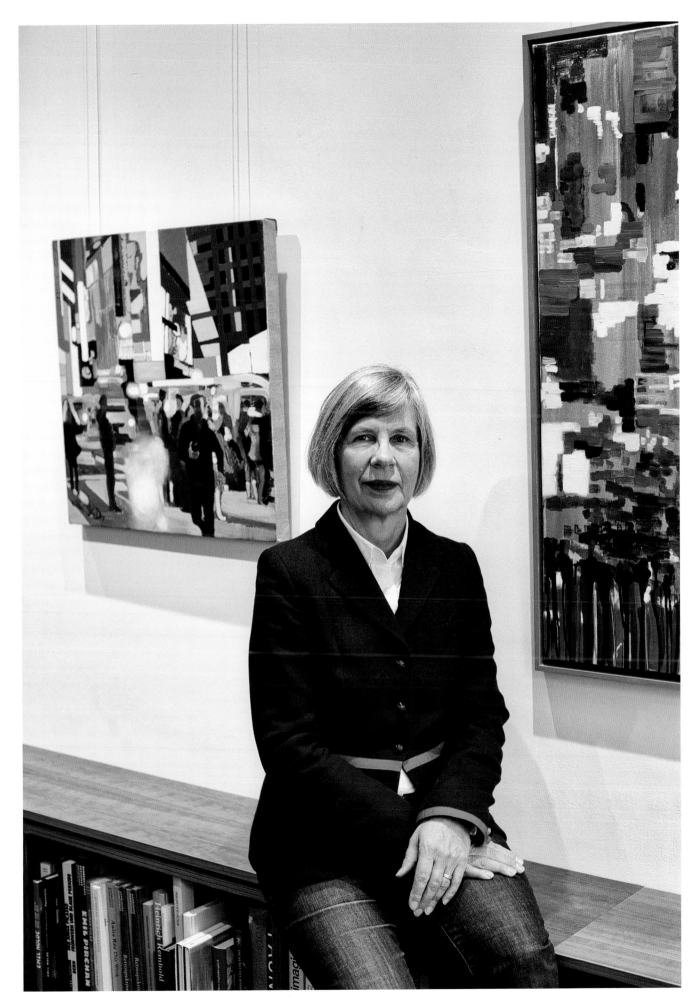

MARINA KRAUTH — FELIX JUD — HAMBURG

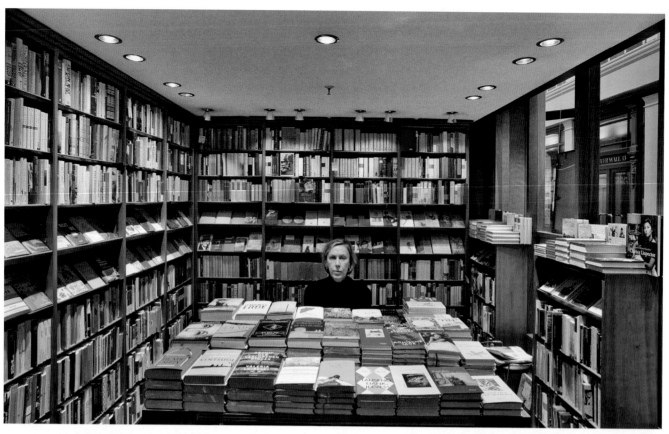

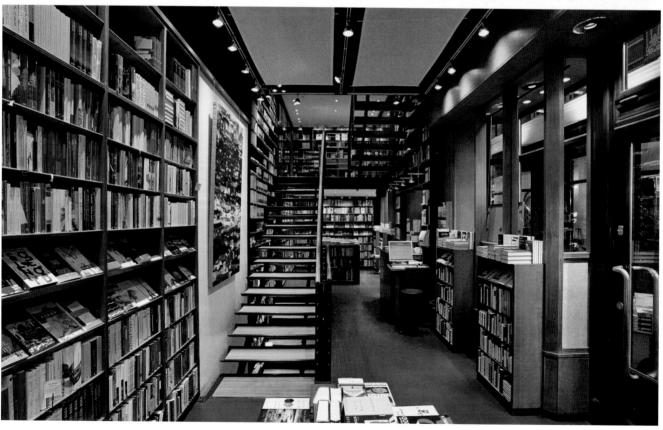

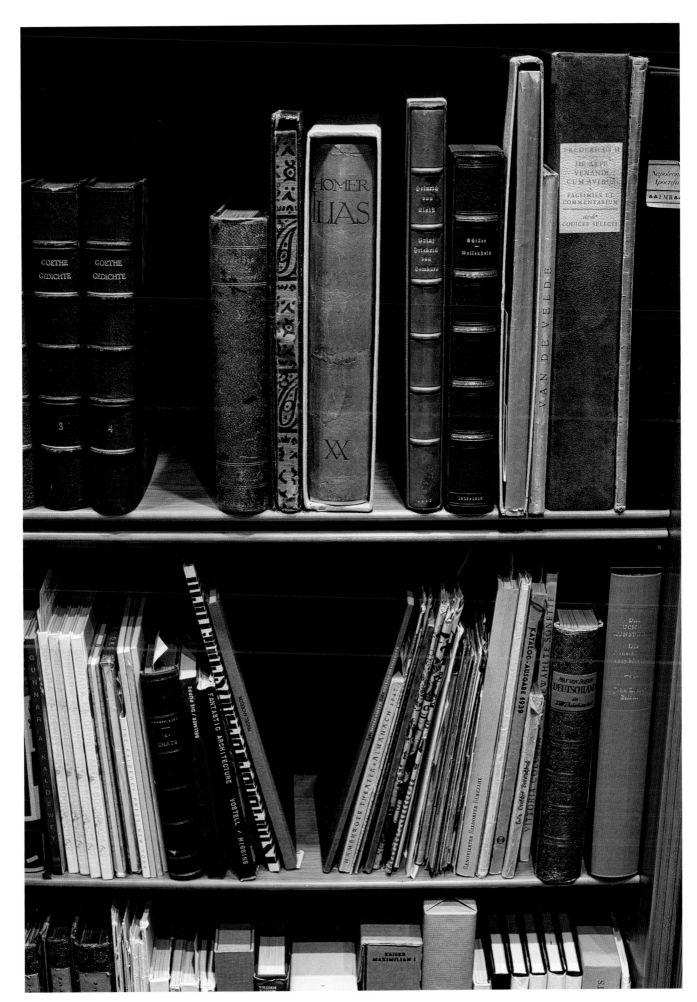

FELIX JUD — HAMBURG

stories!

ANNEROSE BEURICH

In the place where I grew up there was no bookshop; books were sold in the toy shop. So the decision on what to spend my pocket money on was very difficult. But books tended to win out. We talk a lot about the "third place" in our society – the place that has relevance in everyday life next to home and work. I'd like to think that stories! is such a place.

For me, bookselling is the most beautiful profession in the world. stories! is the sum of everything I've learned over a lifetime of working in the book trade. When I was finally able to open my own bookstore, I wanted to combine the best of both worlds: the individual shopping experience in the corner shop with the service and professionalism of larger chain stores. We present our books in a very modern, clean atmosphere; stacks suggest arbitrariness. The white frames draw attention to the individual book, arouse curiosity and inspire. Even our regular customers, who often come in several times a week, have the impression that there's something new to discover, because we can redesign the entire store in no time at all.

What can you get here that you can't on the internet? Smiles, passion, enthusiasm, coffee and cake, individual advice, entertainment, talking to like-minded people at the bar... none of that can be digitized. For our 10th birthday, the store was flooded with people who brought us letters, cards, flowers and gifts. That really touched and overwhelmed us all.

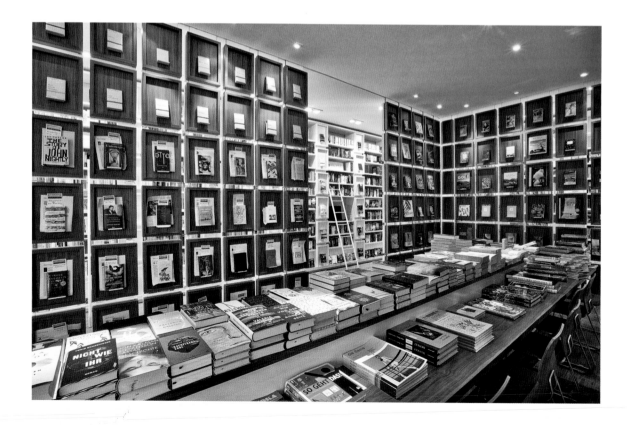

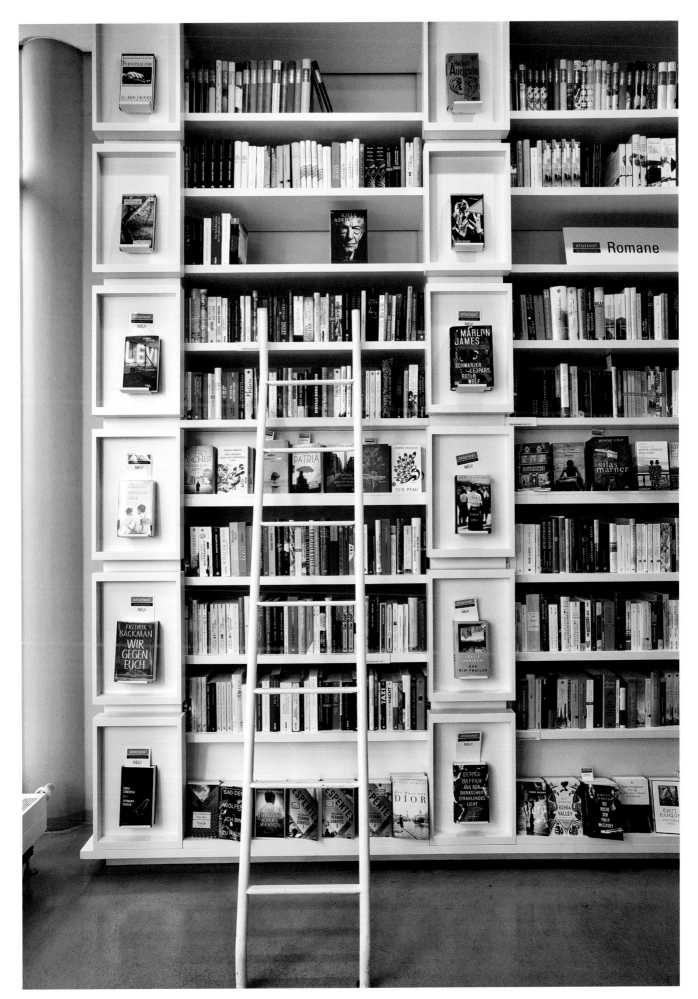

STORIES! — HAMBURG

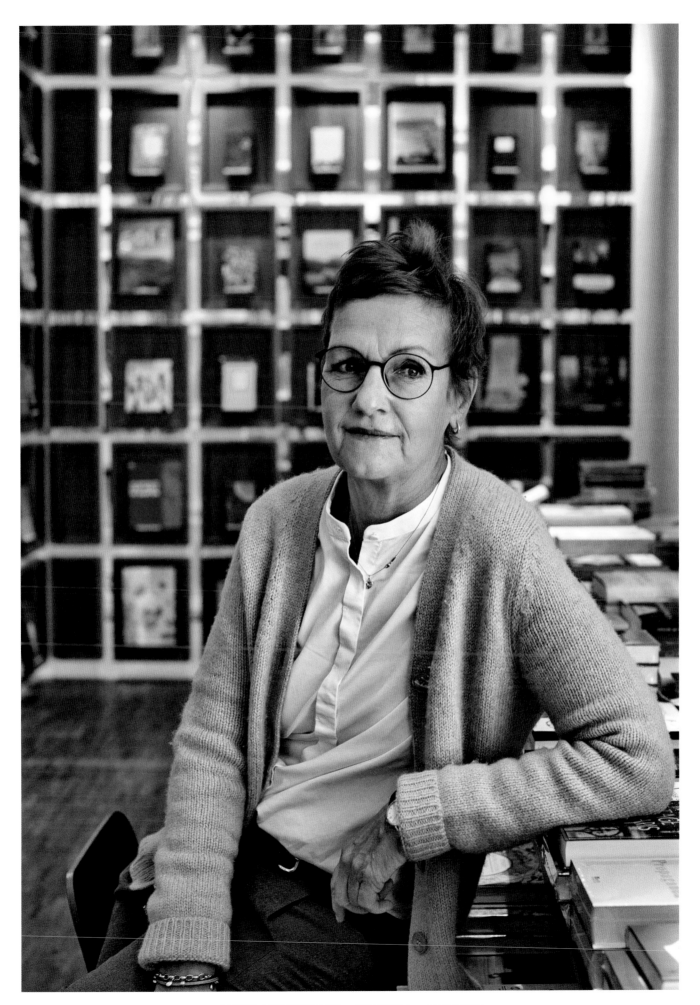

ANNEROSE BEURICH — STORIES! — HAMBURG

Bücherbogen

RUTHILD & WANDA SPANGENBERG

RUTHILD SPANGENBERG: Here, below the rail tracks, there used to be a car repair shop. However, to us it seemed to be the ideal place for our bookstore. Back then, when we opened, the area looked completely different...

WANDA SPANGENBERG: There was only a restaurant, and Savignyplatz was a hang-out for hookers, their punters, and the customers of Eisen Adolph.

RS: At that time, people thought we would hold out for three years and no more. They said we could become taxi drivers after all if the store didn't take off. (And I couldn't even drive...) So I had to get the shop going. Bücherbogen [Book Arch] opened in one and a half arches. A few years later we had the opportunity to rent one more arch, because the florist next door retired. So we extended the shop.

WS: In 2006 we were able to add an arch that had not been converted. Finishing the new arch was the occasion for an all-round renovation. We stripped the paint from the walls, the brickwork was exposed, the old wooden flooring gave way to a coating of poured asphalt, and the windows, which had become leaky, were renewed. My father, the architect Gerhard Spangenberg, took on the rebuilding. He invented our now-famous red strip, a close relative of the red carpet, and developed our lighting system, subject to the considerable technical limitations of that time. Neon strips that cross at the centre of each barrel vault created the impression of a groin vault. Gerhard Spangenberg wanted to give the books a place that was something between an industrial building and a church.

RS: We worked very hard to make the interior match the quality of the art, design, architecture and fashion books that we specialize in, so that each supported the other. At times it was a hard struggle to implement this, but I never thought of giving up. I love the personal dimension of things that can give people contact to authors, artists and designers. I started out as a bookseller in a small north German town. The bookstore's stocks were tailored to a clientele that was able to feel enthusiastic about these books and appreciate them. Bringing people and books together makes me happy. Without this communicative level, I would not be interested.

WS: Many customers who come to us for the first time are delighted with the space and with the fact that they can move from one arch to another, to a different area. Some say they would not like to work here because of the noise from trains. We got used to this backdrop of metropolitan sounds long ago.

RS: And to compensate we have a pretty park right on the other side of the road...

WS: What do we do better than other shops? As we are a specialist bookstore, it is difficult to compare us with those that have a general range. We too can order any book that is deliverable, and ones that are out of print. But it is important to us to stock titles from small publishers, institutions and individual artists. We are a special place for cultural dialogue. We support this by giving advice, by research for unusual customer enquiries, and through numerous events that complement book sales. We have customers from all strata of society. While I was still at school, helping out with the Christmas sales, Karl Lagerfeld once walked in unexpectedly. I just thought, "What if he asks me something?" But he was simply very friendly. My mother got to know him better, and sometimes went for a meal with him. He always said that Bücherbogen was his favourite bookshop – a big compliment from a man with a library as impressive as Lagerfeld's!

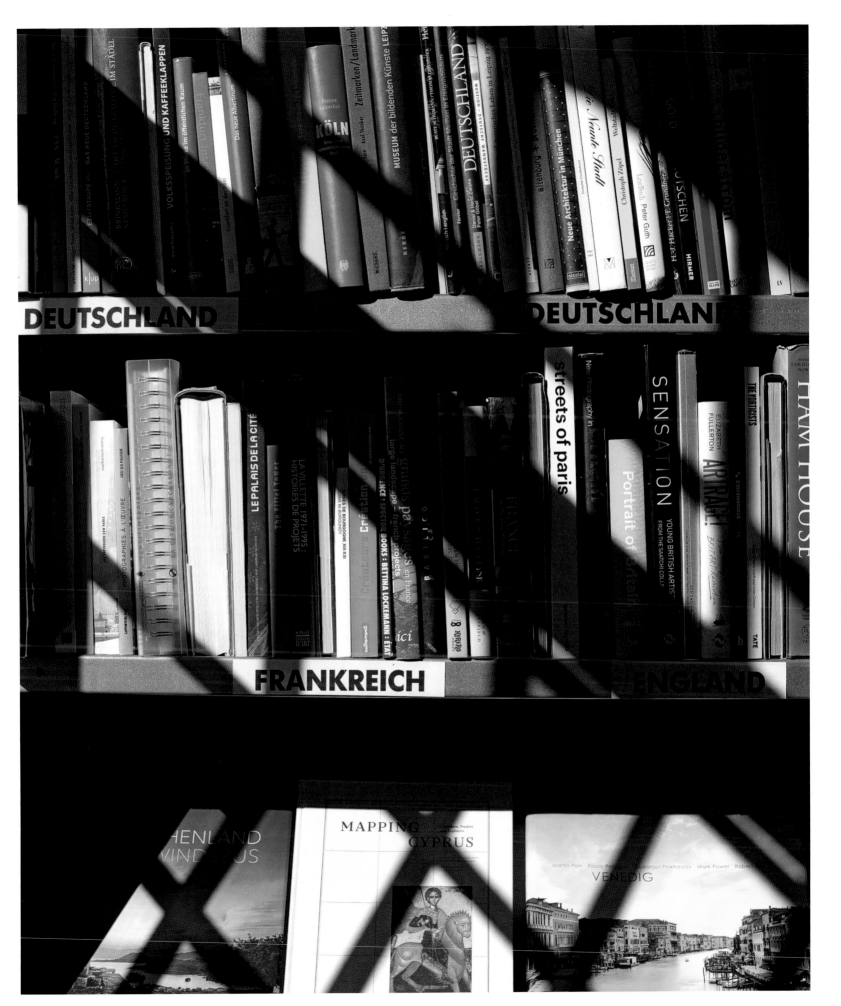

BÜCHERBOGEN – BERLIN

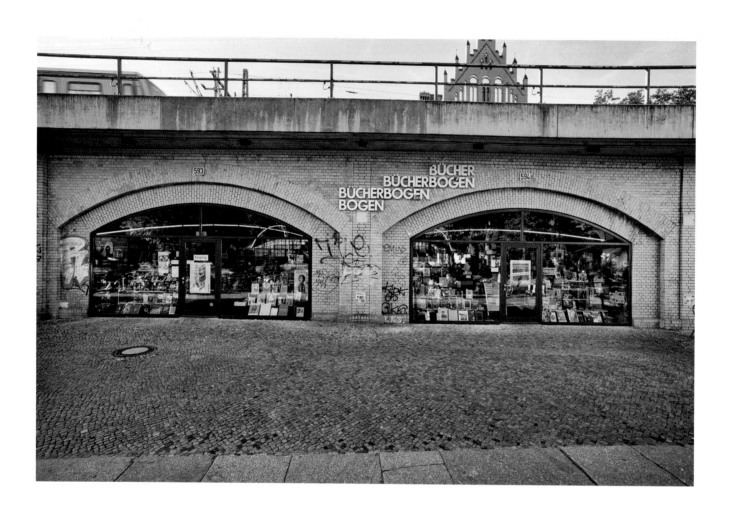

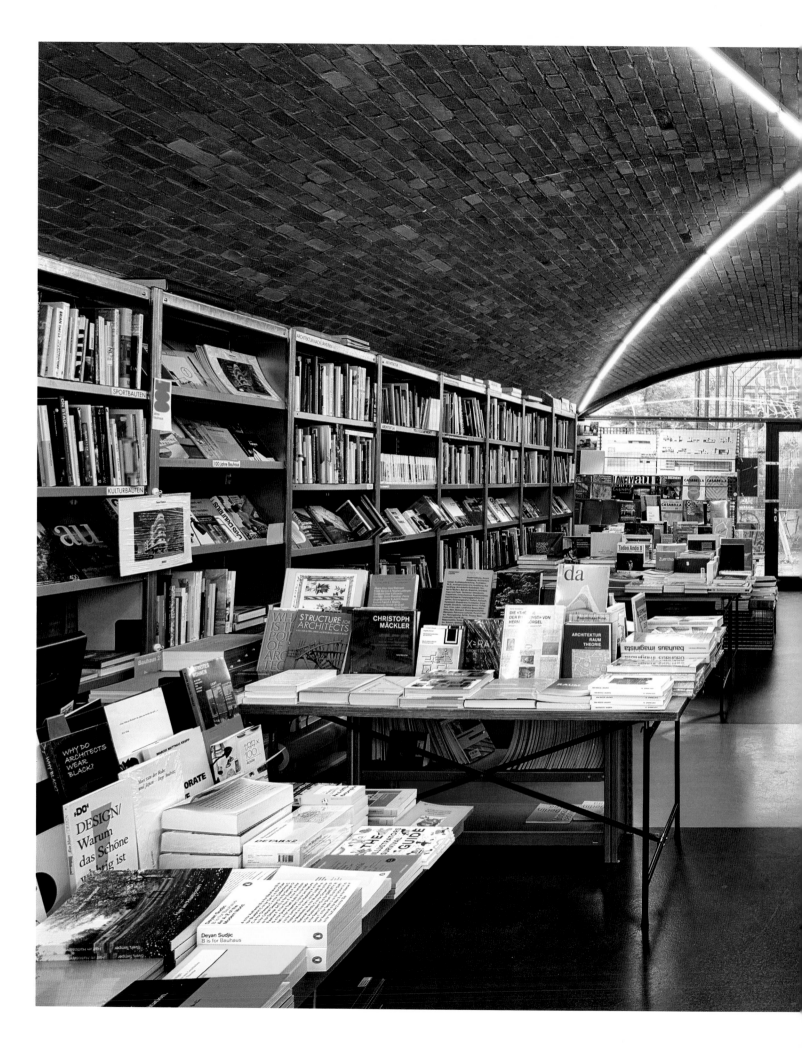

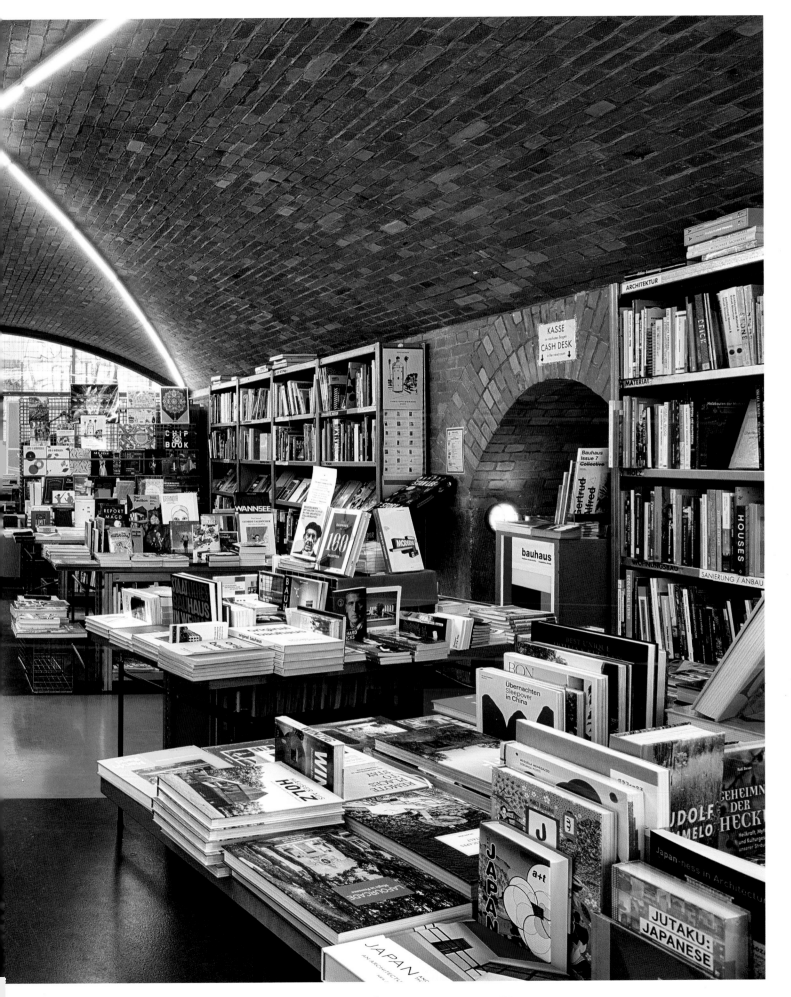

BÜCHERBOGEN – BERLIN

Pro qm

KATJA REICHARD

Twenty years ago, Berlin was in a ferment; there were many collective, artist-run spaces being opened up in Mitte, where all these old industrial buildings were standing empty. I started this place with my friends Jesko Fezer and Axel J. Wieder; none of us were from a book background, but from architecture, design and art history. We were reading about urban theory and the processes of gentrification, and we thought why not have a space where we can stock books about urbanism, and hold exhibitions and discussions around these issues? It was less about retail, more a kind of laboratory for ideas about how this newly opened-up city could evolve. There was a real sense of possibility here at the time. Twenty years on, we still hold presentations every fortnight, on housing issues, urban planning or climate change. So yes, times change, but our critical view prevails.

The space? Jesko is an architect, and he lives in collective housing that's very flexible. We wanted the same feeling of freedom here, to be able to move things around and accommodate everything from magazines on various Berlin subcultures to special events. I remember one notable occasion when we had The Fall's Mark E. Smith singing from a balcony and Michael Clark dancing on a staircase.

My favourite section? That's like asking me which of my children I like best. We have so many strange hardcore super-nerdy titles. I have a soft spot for utopian architecture projects from the 1970s.

What would I like the shop's legacy to be? That people discovered something they wouldn't have if they hadn't been here, and it maybe changed them in some way. We've worked with people who've since become politicians responsible for different aspects of urban planning, so on our best day we could say that we've had our part to play in the development of the city.

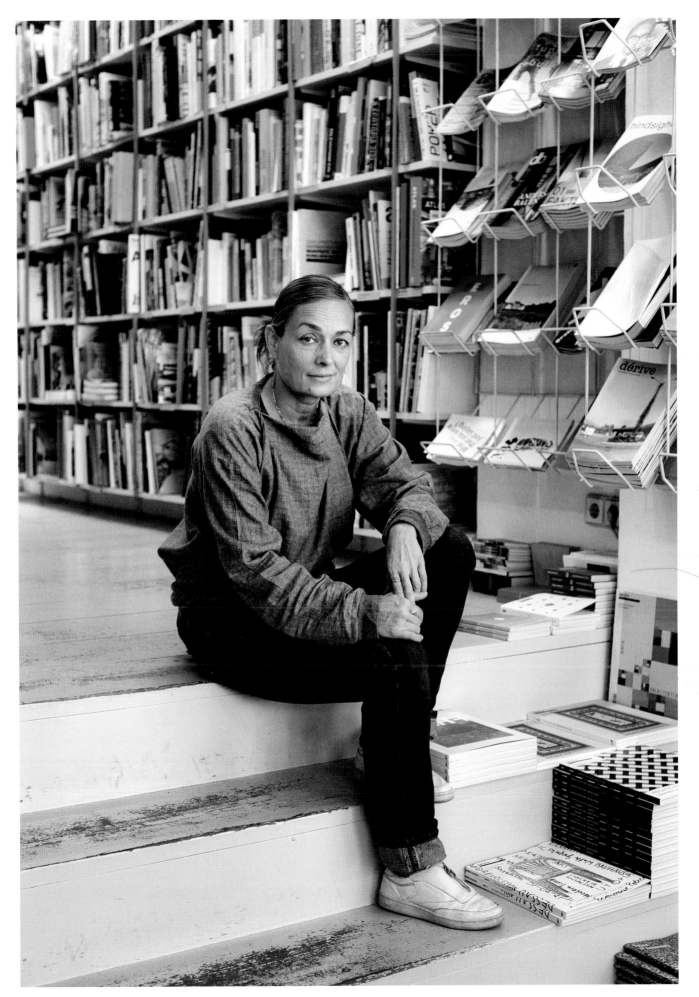

KATJA REICHARD — PRO QM — BERLIN

PRO QM — BERLIN

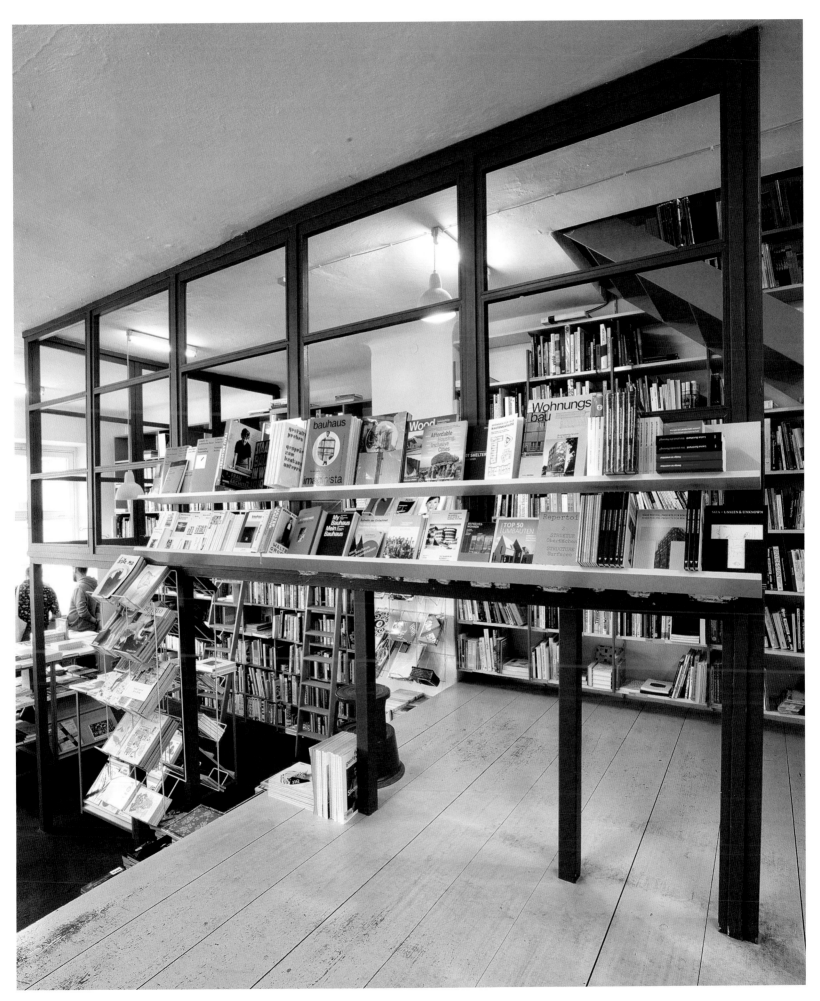

PRO QM — BERLIN

do you read me?!

MARK KIESSLING

There wasn't a space like this in Berlin, dedicated to magazines, when we opened. I run a design studio, and my business partner Jessica worked at Dussmann, the big Berlin bookshop. We both loved magazines, so we thought, why not? This is very much our vision.

What's the role of print in people's lives now? Well, there's been no decline in interest. And that's gone along with the fact that it's now so much easier to produce your own print product. So while the mainstream magazines have really suffered, there are all these specialist titles that look amazing and that don't have to chase revenue. Some of them have teams spread all over the world – an editor in Berlin, a designer in Australia – and some move to different cities for different issues, embedding themselves in the life of a place. So you see people coming in and really engaging with these different viewpoints. Print still fulfils a deeper need. You're always distracted if you're trying to read something on your phone, with hyperlinks and other things popping in and out. It's not so great for absorbing or understanding. Here, time slows down and people sometimes stay for hours. There's even a magazine called *Delayed Gratification*, which picks up topics that may have been in the news cycle a while ago and writes about them in depth. And we've got a thorough selection of books that pick up on some of the themes in the magazines – design, fashion, music – so you can explore further.

Lots of people have been inspired to start their own magazines after seeing this space, and we've ended up stocking them. It's a kind of virtuous circle. And we get new titles in all the time, so the character of the whole place changes from month to month, which keeps people coming back and keeps things fresh for us. We've often thought about expanding, and have had some good offers. But there's a lot to be said for keeping a place unique and special.

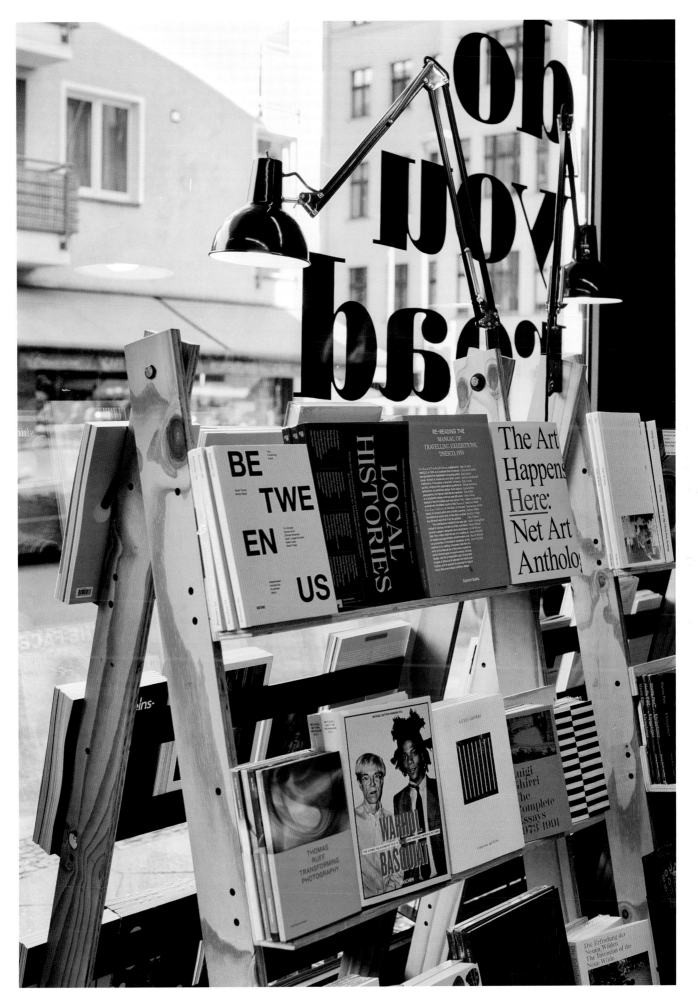

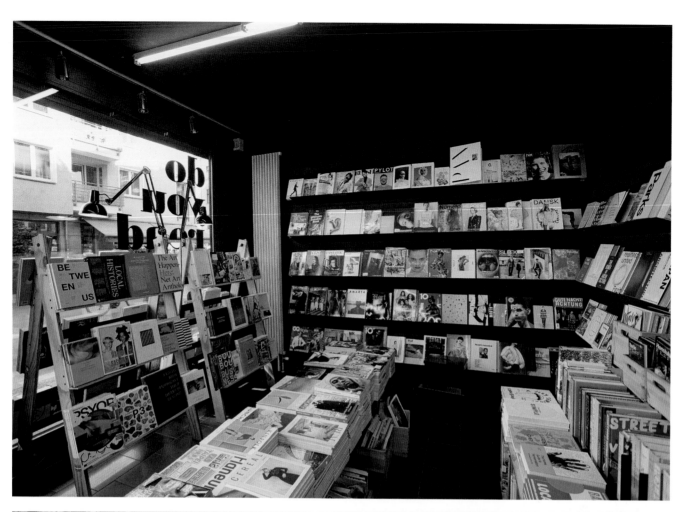
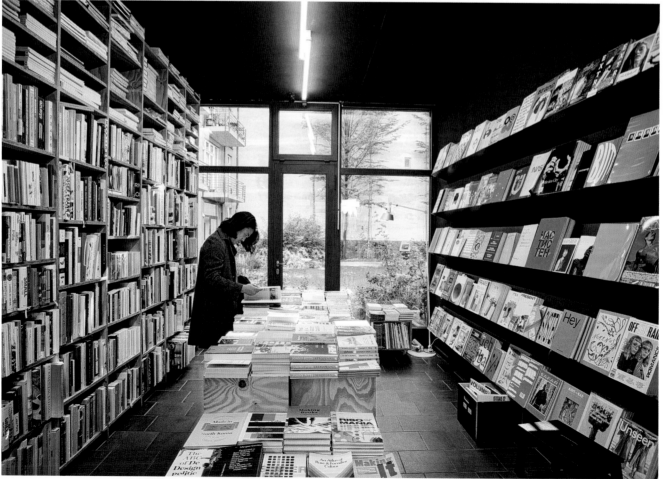

Bildband

JOE DILWORTH

I've had many lives – I've been a drummer for various bands including Stereolab, and I've been a photographer for a long time. But you'll never make a living from playing the drums, and being a photographer makes for a solitary life, so it was nice to start a photography bookshop and gallery space. I did it with Thomas Gust, another photographer; we showed at the same gallery, and we'd curated shows together, so we thought we'd bring it all together, see what we could do with no money but a lot of enthusiasm.

We've tried to create a welcoming environment for people to come and hold books in their hands, because it's a tactile medium. We also try to go beyond the mainstream and find things that have been forgotten or passed over. It's really nice to see people discover stuff that hasn't necessarily become famous or even widely known, as well as self-published stuff that people have brought in. We'll give those things as much weight as a new monograph by a well-known name.

We've seen four bookshops close in this area in the past five years. You've really got to have something to say now, a personality, in order to have a chance. And our kind of insider's view on what's out there is our selling point. I mean, I'd have loved to have found a space like this when I was starting out as a photographer. What do I like best about it? Getting people like Dayanita Singh to come here. We just asked, and she came, you know? Hearing people talk about their work is so magical, it brings the place alive for us.

Books always keep coming back, no matter what. There's always something new to say in photography and in publishing. If someone comes in here and wants to make a book, you can pull ten different alternatives and approaches off the shelves, from mass-produced zine-like things to beautifully produced limited editions with special bindings. There are all these different ways and none of them are more "right" than another. So I think it's actually an incredibly exciting time for the art book.

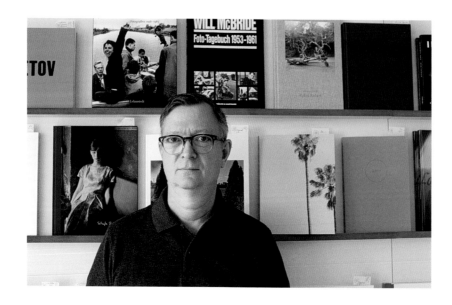

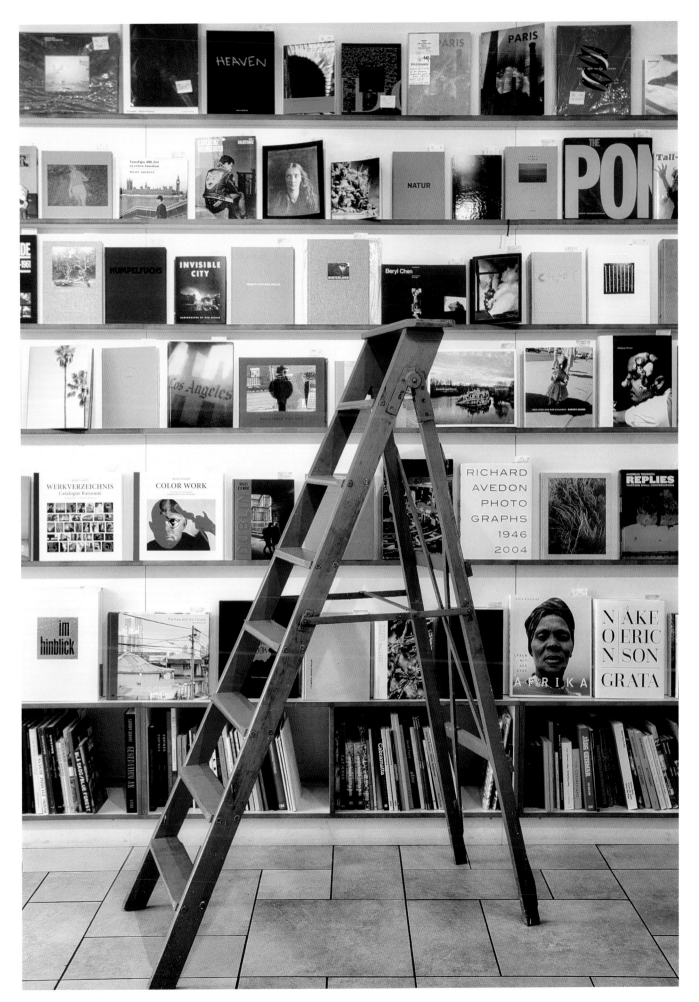

BILDBAND – BERLIN

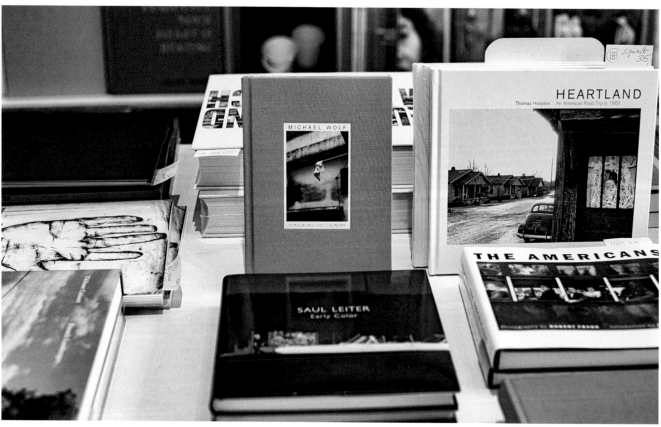

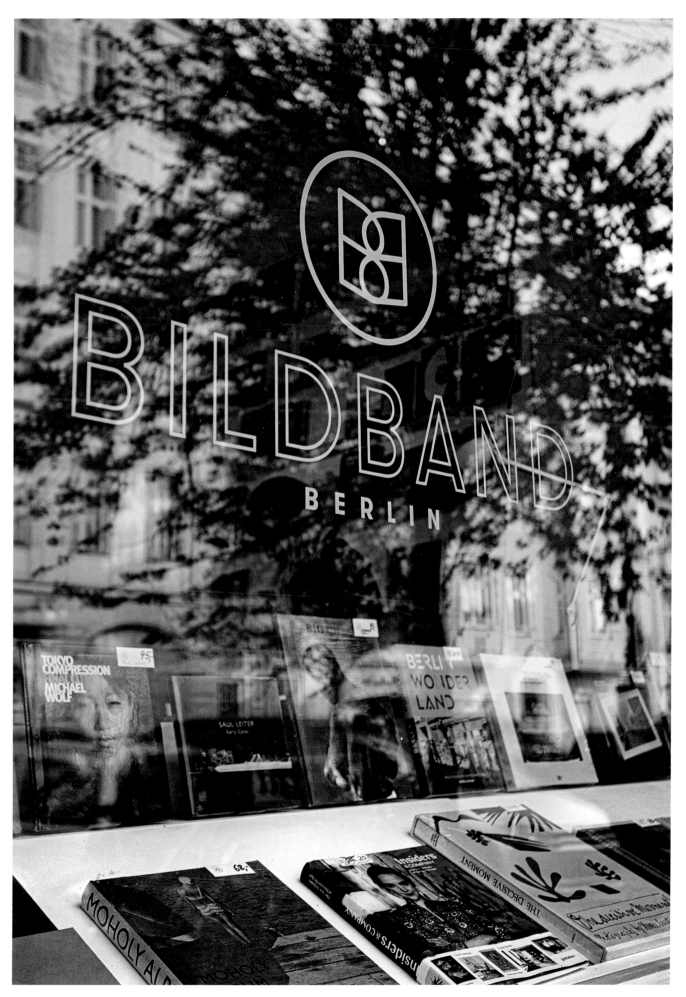

BILDBAND — BERLIN

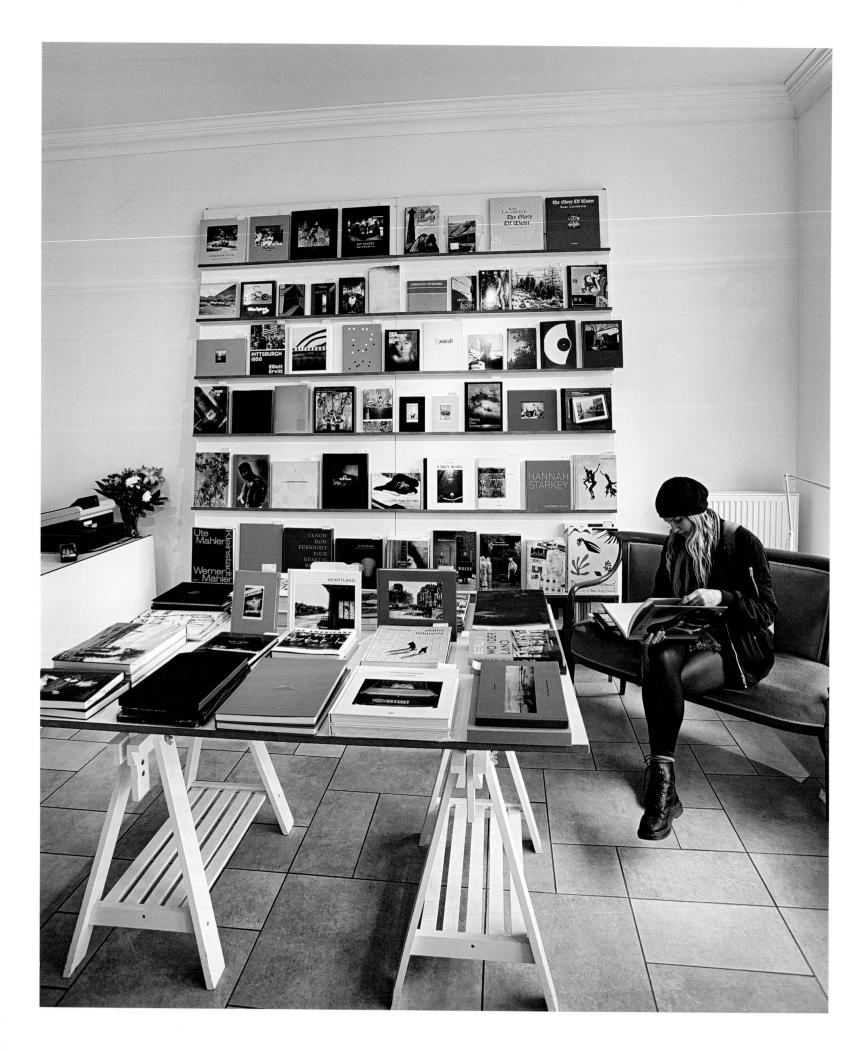

book of the week

MUNICH
OPENED: 2004

soda

SEBASTIAN STEINACKER

I studied fashion design at Central Saint Martins in London in the late 1990s, and I discovered magazine stores like Magma through my college research and became a bit of a fetishist of their style. I felt that Munich needed something similar.

In the past ten years, mainstream magazines have really suffered, but niche magazines have exploded – you've got titles dedicated to plants, or queer food journals. I try to balance the best-sellers, like *Monocle*, with the more esoteric offerings.

More and more people are interested in print. They like to have something to hold and pages to turn. It's a counter to the internet, where things come and go, and there's nothing to hold on to. Print has a beginning, middle and end, and you can put it on your shelf and go back to it, refer to it. We, as humans, quite like the satisfaction of finishing something, I think.

Clean was the keyword when it came to the design of the store. The magazines are like small works of art, so they need the space to express themselves. I wanted it to feel like your best friend's bookshelf, where you go to their place and you find something you weren't necessarily looking for. Maybe a designer will arrive looking for a design title and leave with something about architecture or food. I love the notion of cross-pollination, of ideas feeding into each other.

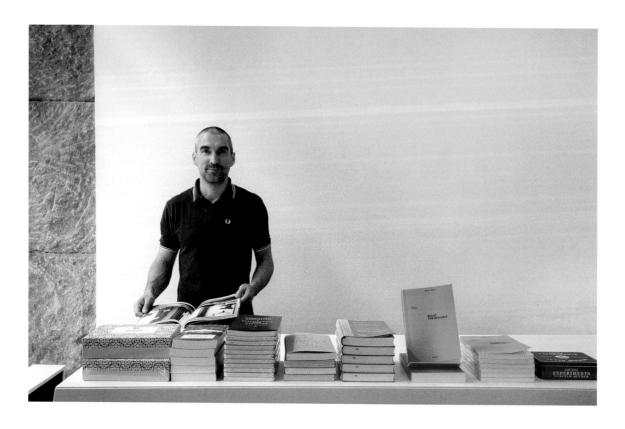

202

soda

ART+
DESIGN
BOOKS+
MAGAZINES
sodabooks.com

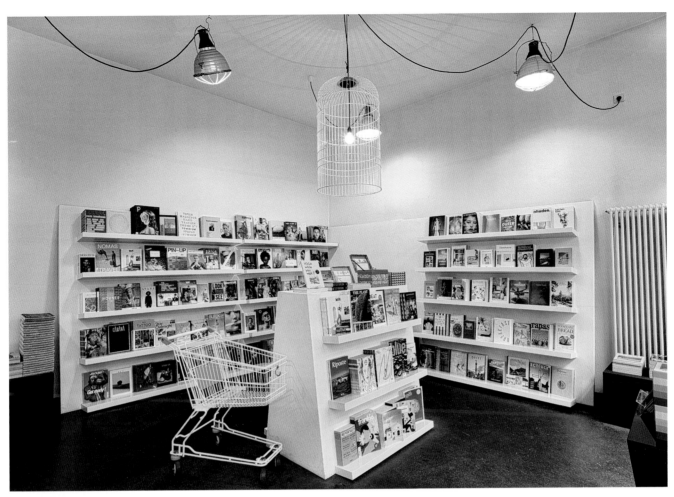

SODA — MUNICH

Literatur Moths

REGINA MOTHS

If you ask about good bookshops, the venerable, traditional, sometimes slightly enchanted ones are usually recommended: ravines of shelves that reach the ceiling, well-modulated chaos – the bookworm's nose twitches... But there are other kinds of enchantment.

I did not want a bogus vintage idyll, a fake romantic world of books. I wanted a space where the book comes into its own and where people find themselves, find inspiration on the walls and the shelves: a stage for bibliophilia; for literary, political, graphic debates and consensus – a place of satisfying enrichment.

For the interior fittings I took my cue from Donald Judd's minimalistic style: openness with clear lines, a combination of loft and gallery, backlit walls, a mobile ballet of shelves – a mood of expectant tranquillity. Harmony of space and book can only be attained, however, if the range of literature can be shown and maintained with the same degree of concentration and care. We study reviews, look at previews, listen closely to our customers and read, read, read. We keep out of the way of the noise around best-sellers and enervating mediocrity, and we are not interested in the esoteric. We draw the literary margins into our circle, give strength to neglected lyricism, and encourage finely sifted culinary work.

As soon as we open the door, the shop buzzes – customers and their wishes, illustrators and artists with their portfolios, publishers and their authors. Every day, the store bestows an audience of well-wishers (including a tribute from Denis Scheck, a kiss from Yotam Ottolenghi, a visit from J. K. Rowling). And so we are constantly surrounded by beneficent spirits.

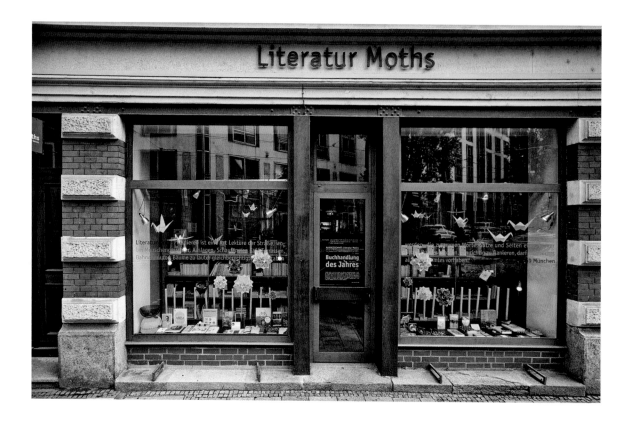

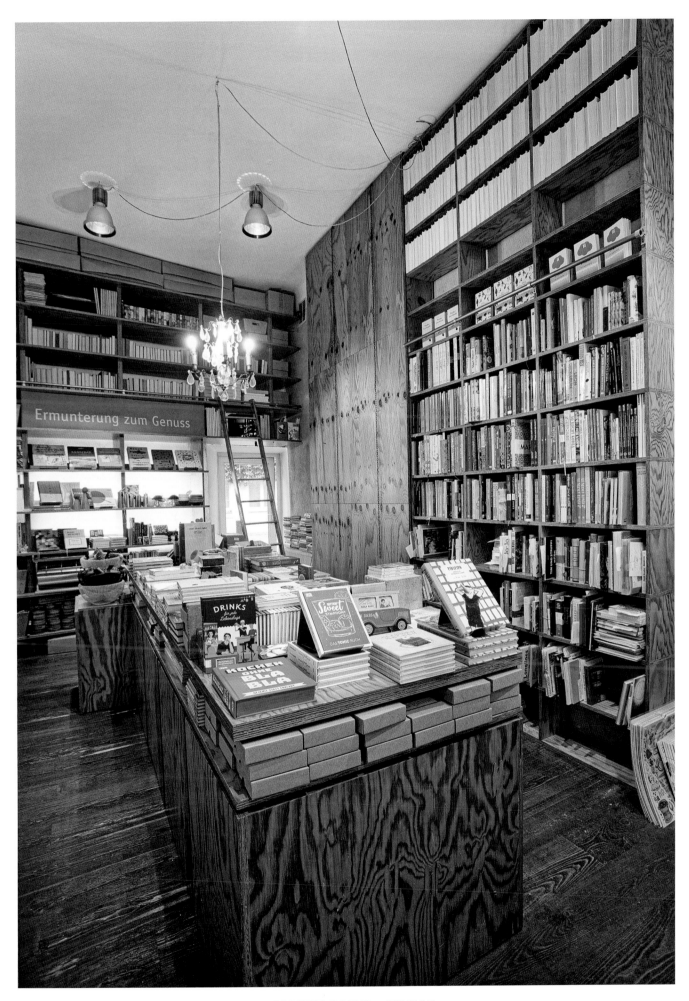

LITERATUR MOTHS – MUNICH

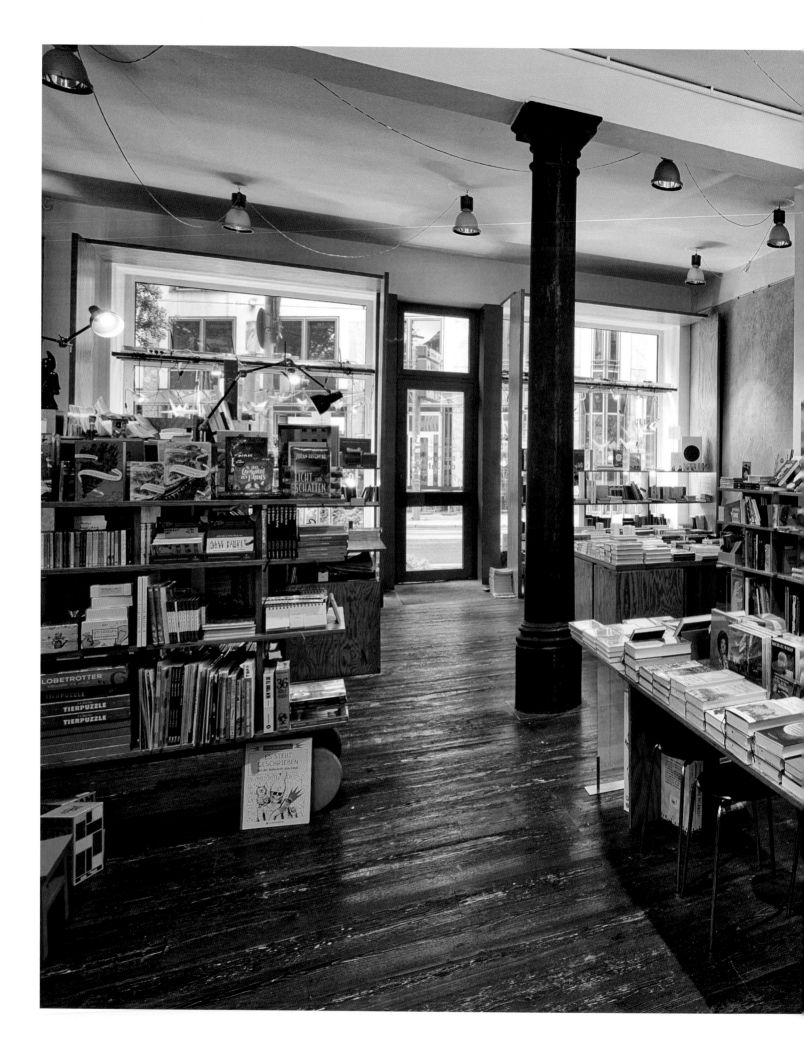

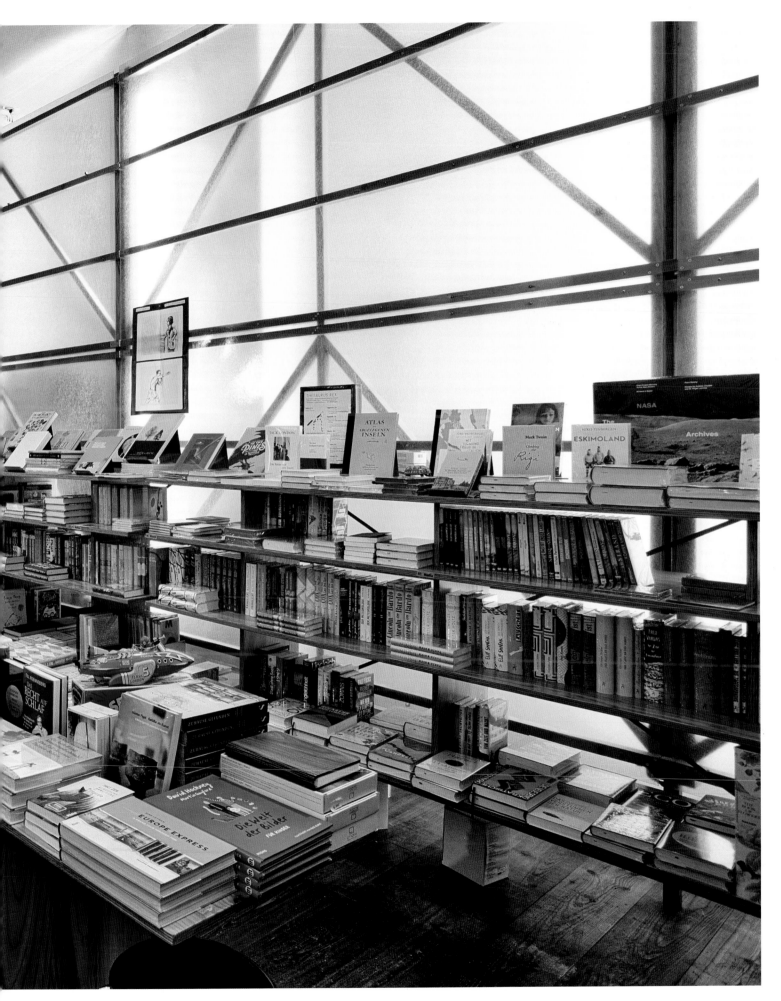

phil

CHRISTIAN SCHÄDEL

I used to work as a journalist, reviewing movies, concerts and TV shows – and books. But it became more and more unsatisfying to me to criticize works of art in which people had invested all their energy and heart. So I went travelling in South-East Asia for a few months looking for an idea. I found it in Luang Prabang, in Laos, while I was on a bus – or it found me: a bookshop /café hybrid in Vienna. Phil opened a year later.

Are books and all-day breakfasts a natural combination? I think so. I wanted to create a "living room" ambience, where books were always integral to the concept, alongside great food and drink, soft lights, and sofas to browse on; a home away from home. The atmosphere changes through the day; when the breakfast dishes are cleared, the beer, wine, and gin and tonics come into play. We're open till 1 a.m., and reading is encouraged any time, day or night.

We have a quote on one of our shelves – "Don't classify me, I'm a book, not a genre" – that represents our philosophy. We do a lot of research on what to stock and take recommendations from social media and our visitors, but we like to mix things up, so that people might stumble across something that they wouldn't ordinarily encounter. There are sections that have found their place for eternity – the English-language books, for example, or what we call the "brain department", where we keep the non-fiction mind-expanders, everyone from Nietzsche to Naomi Klein – but we hope to continue surprising our customers and ourselves.

Phil is not the internet, it's real life. And it's instant gratification, meaning you get smiles along the way when you order a coffee or buy a book. You don't have to wait for the parcel to arrive. And as well as a bookshop, we're a place for birthday parties, Tinder dates or family reunions, sometimes all at once.

Phil is the best thing that ever happened to me, and I'm not generally given to saying things like that. It's a Vienna institution now. But the smile from someone as they're leaving, and saying "I'll be back"? That never gets old.

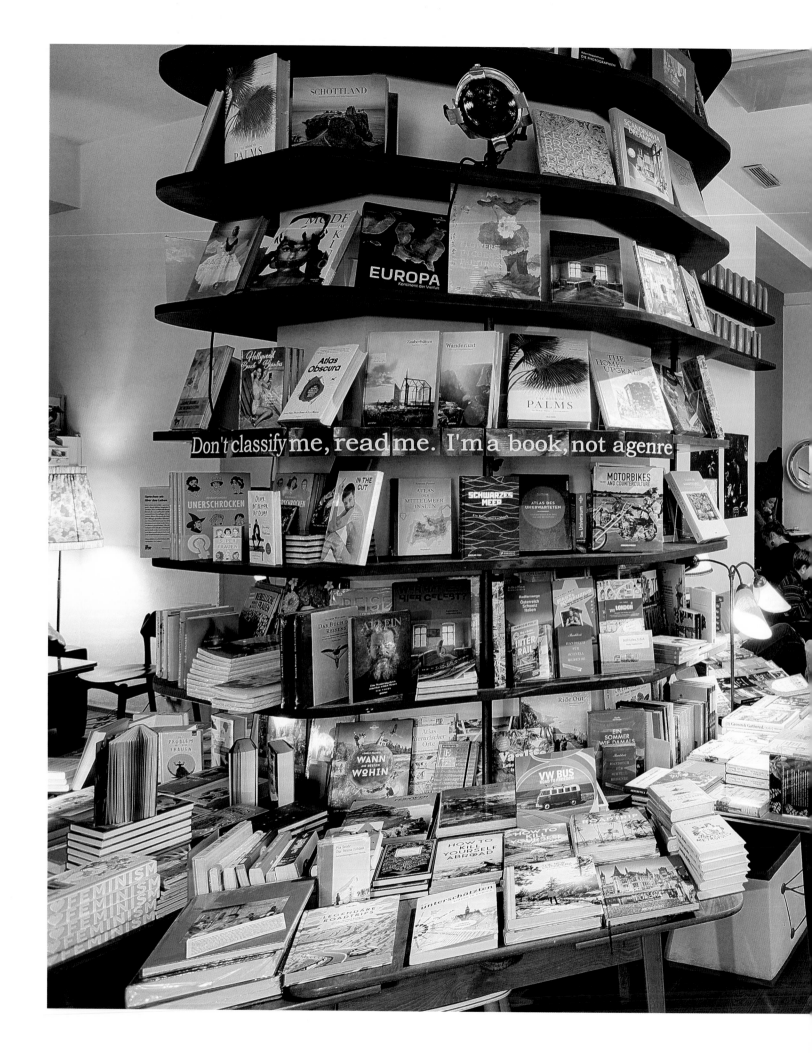

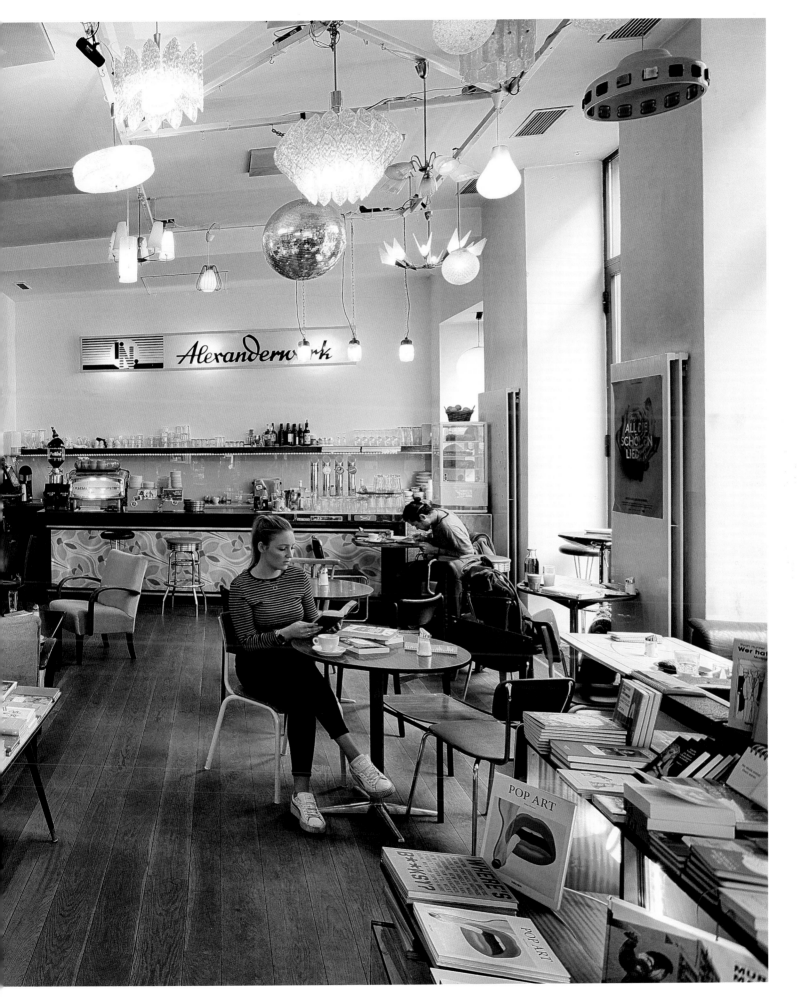

Hartliebs Bücher

PETRA HARTLIEB

For me, books have always been a way to escape everyday life, or to make sense of it; to travel without boarding a plane; to immerse myself in other worlds. In my hometown there was a library bus that came once a week, and we were allowed to borrow as much as we could carry. I carried a lot.

My husband Oliver and I used to live in Hamburg, but we spent our holidays in Vienna. We noticed that a small bookshop in the 18th district had closed down. And then our fantasies and dreams began. The rest of our vacation was taken up with number-crunching and viewing the premises. We sent in our offer weeks later, and it was accepted. We'd bought a bookshop!

With this place, we've brought our fantasy bookshop to life. It has floor-to-ceiling shelves, so you are immersed in books, and it stocks poetry and rarities alongside bestsellers. We wanted to present an old-fashioned front, so we look like a sort of classic bookshop, while all the workings – the inventory management software, the fast service, the webshop with delivery throughout Austria – are as modern as we need them to be. We have a great team that looks after each other as well as our customers; we create jobs, we pay taxes, and we do our bit to keep our district alive.

I love it when young people come to us and seek advice on what to read. We've known many of them since they were babies, and we've played our own small part in shaping their taste in reading. We're also a lifeline for a lot of elderly people, and a way for them to stay engaged with the world, which I find equally touching. Yes, it's a business, but there's this intangible quality to what we do that I think is so vital – now more than ever.

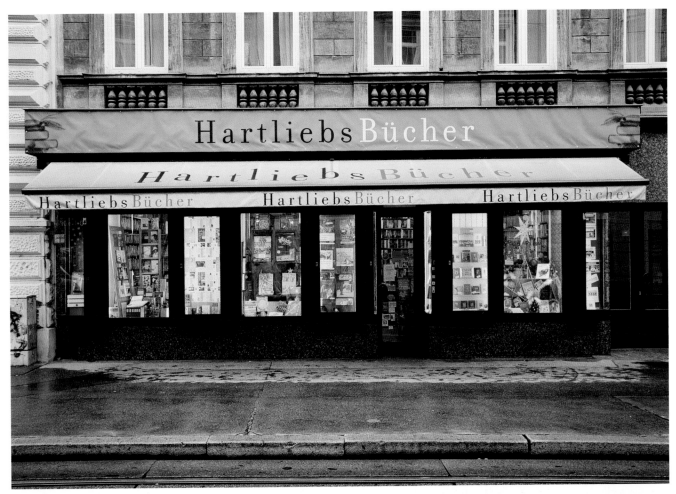

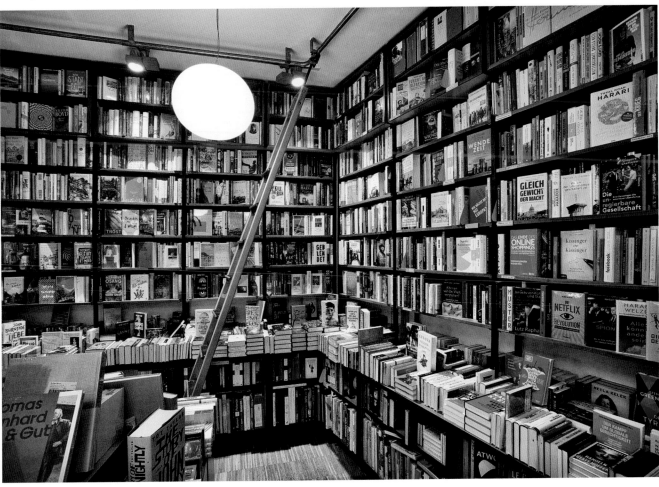

HARTLIEBS BÜCHER – VIENNA

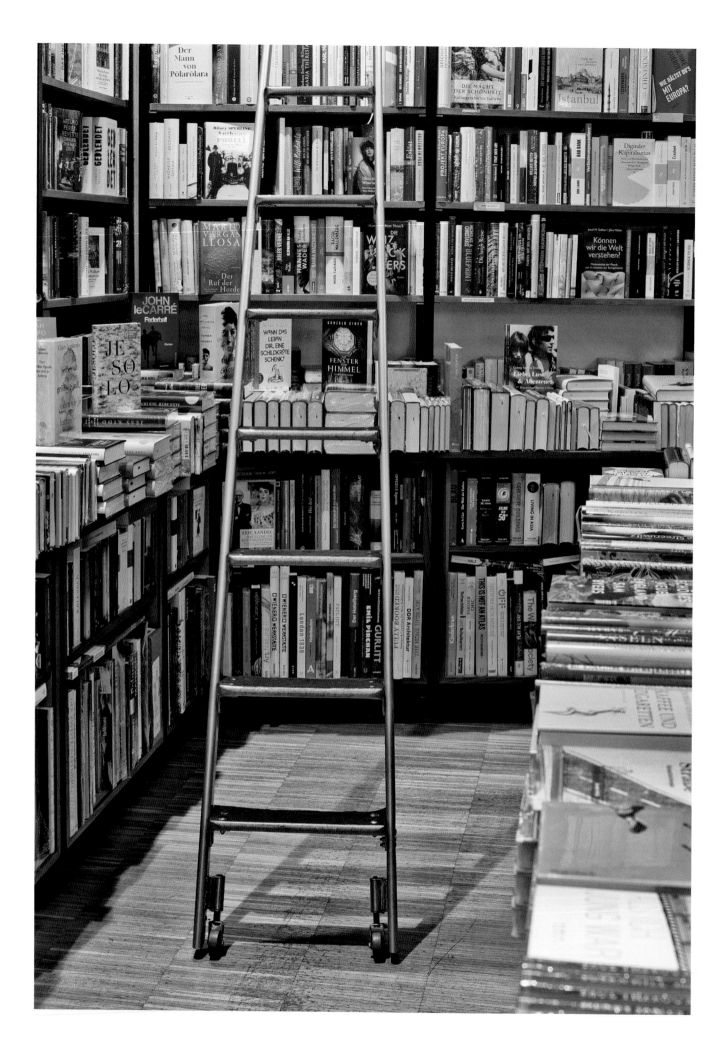

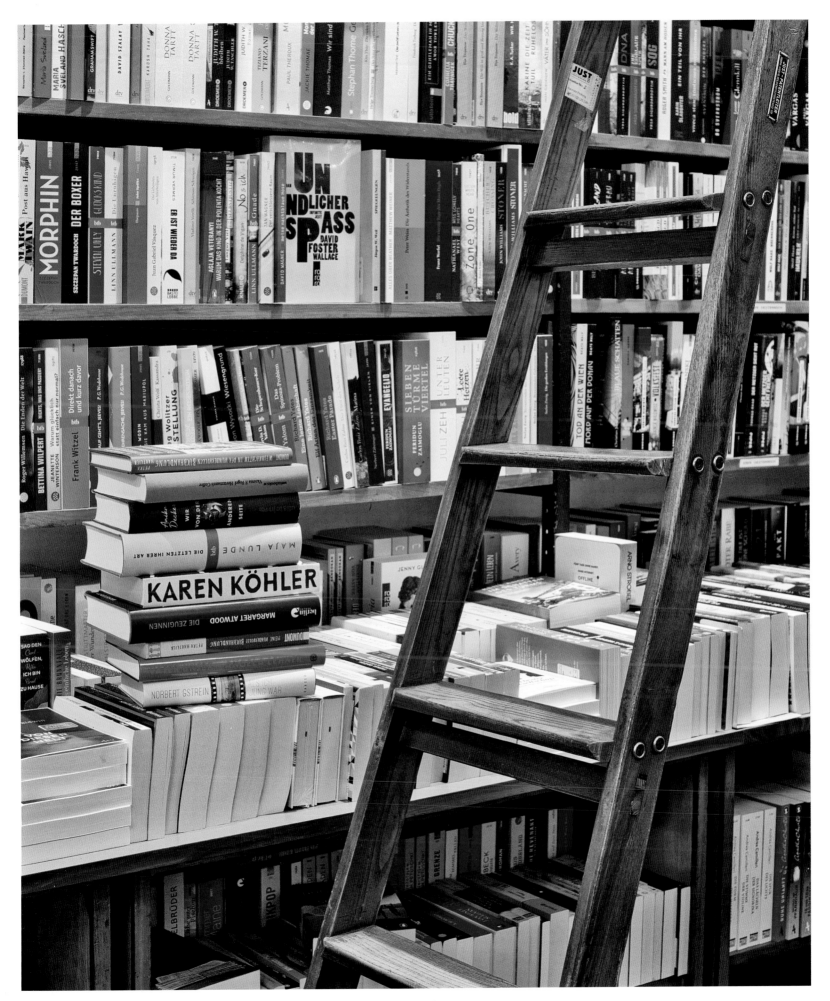

HARTLIEBS BÜCHER — VIENNA

AnzenbergerGallery

REGINA MARIA ANZENBERGER

I've been collecting photobooks since I was 20 years old. I eventually started my own photography agency and gallery, but it was after an exhibition with Martin Parr in 2011 that I decided to open what I called a "book-lounge". In 2012 we moved to a former bread factory – it was actually the biggest bakery in Europe a century ago – which gave me space to extend the bookshop and organize workshops and master classes with artists, critics and publishers like Martin Parr, Roger Ballen, Corinne Noordenbos and Michael Mack. I think people who visit the bookshop appreciate the bright, clean, utilitarian feel and also the depth of our titles; a lot are self-published or small editions which sell out fast and quickly become rarities. We have around 2,000 titles from around the world, even South Africa, Australia, China and South America. Since 2011 I've also been running a photobook collectors' circle called "Bring Your PhotoBook". There are about thirty of us. We meet once a month and everyone presents one or more photobooks they've discovered.

I started the bookshop because not everyone can afford a piece of art. The book is a more democratic medium. It's art for everybody, but it's also an education. People come and look at our long table of books and get inspired for their own life or work. I think bookshops are fascinating, because they're places where time seems to stand still somehow, yet they always take you forwards in terms of knowledge and inspiration. You also discover yourself in the books that you read. I moved through Sartre, de Beauvoir and Camus in my teens, and through the Latin and South American writers like Isabel Allende and Gabriel García Márquez. Today I love biographies of women – and photobooks, of course. When I travel I always visit the best photography and art bookshops. I want to see everything I can. Sometimes I stay for hours. I've found it's better to travel with friends who also like books.

We've found that the audience for photobooks in Vienna is big, and it's also young. You can easily self-publish a book these days, because you can print it yourself and distribute it through the internet, promote it on social media, and sell it at book markets around the world. It's a really vibrant scene. I love to show new and surprising works by artists, and they love this place, because we can give a lot of space to their prints and their books, and we have a quantity and quality of titles that you can't easily find anywhere else. I met Martin Parr in Paris recently, and he introduced me to a woman from the Tate as "Mrs Photobook Austria". I thought that had a nice ring to it.

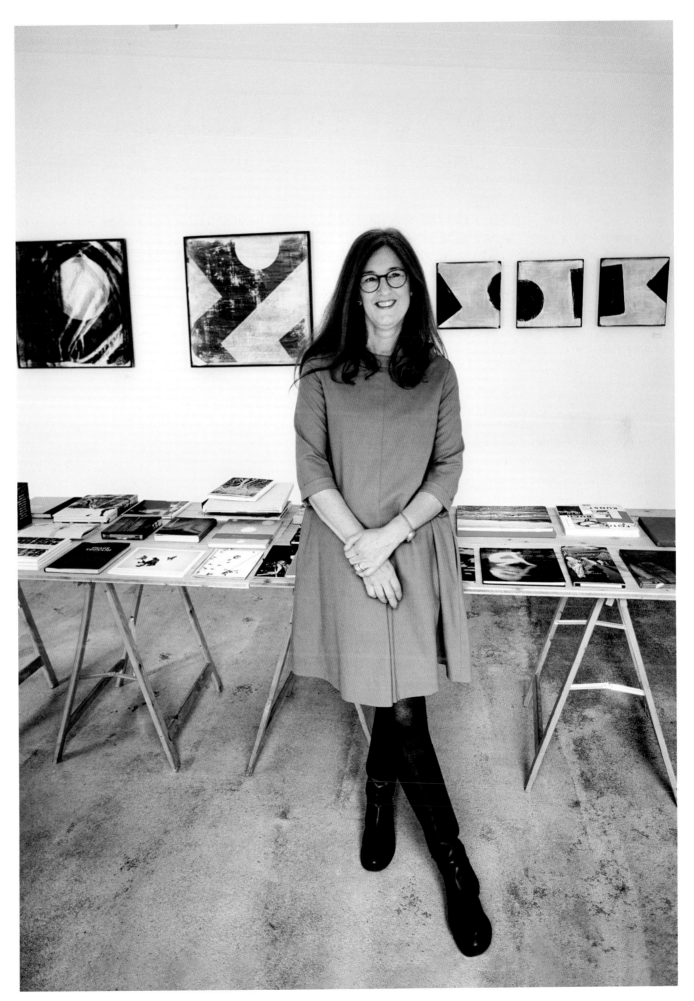

REGINA MARIA ANZENBERGER — ANZENBERGERGALLERY — VIENNA

Anna Jeller Buchhandlung

ANNA JELLER

I came here by chance, actually. But the very moment I entered the room, I was so impressed that I immediately felt the wish to become a bookseller myself: the books in the metres-high shelves seemed to be breathing. I soon became a regular customer, and six months later I began to work for Herr Halosar, who was the owner of the bookshop at that time. After his death in 1985 I made the leap to self-employment and took over the business. I was 26 years old at that time.

I wanted and I still want to preserve the special atmosphere of this place. Here, the books must have the space that they deserve. This is reflected in, for one thing, the choice of titles: I would like to sell books only with pleasure and a clear conscience. The ones that are not found on bestseller lists are particularly important to me. Books that are not in the spotlight, and books from smaller, independent publishers. I want my customers to discover things here that they cannot find elsewhere.

For me, a bookstore is a lively place, somewhere for people to meet, to get advice, to talk about literature and other matters. No algorithm can do that. I would like my customers to take away with them not only books, but something of the spirit of the bookshop.

It is a privilege to have been able to turn my passion for reading into my profession and vocation. Every day I learn something new – from the literature and from my customers. Recently, someone put it like this, "This bookstore is a place of cultural happiness!"

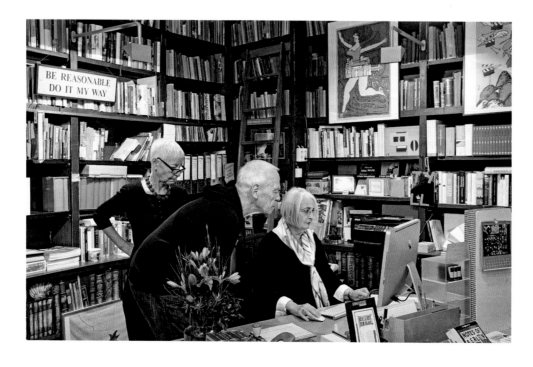

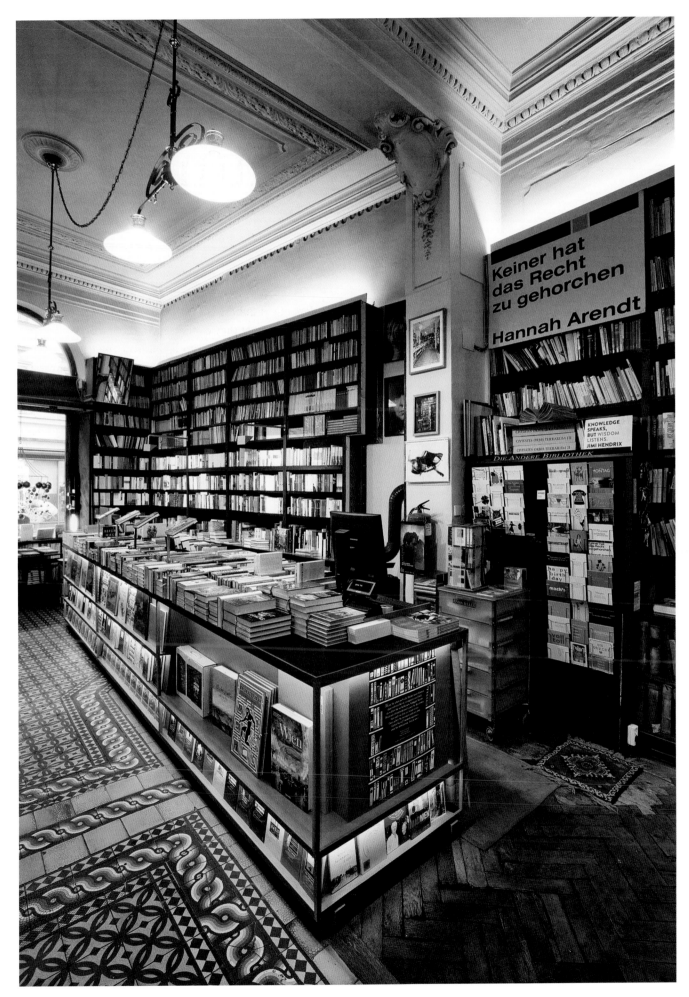

ANNA JELLER BUCHHANDLUNG – VIENNA

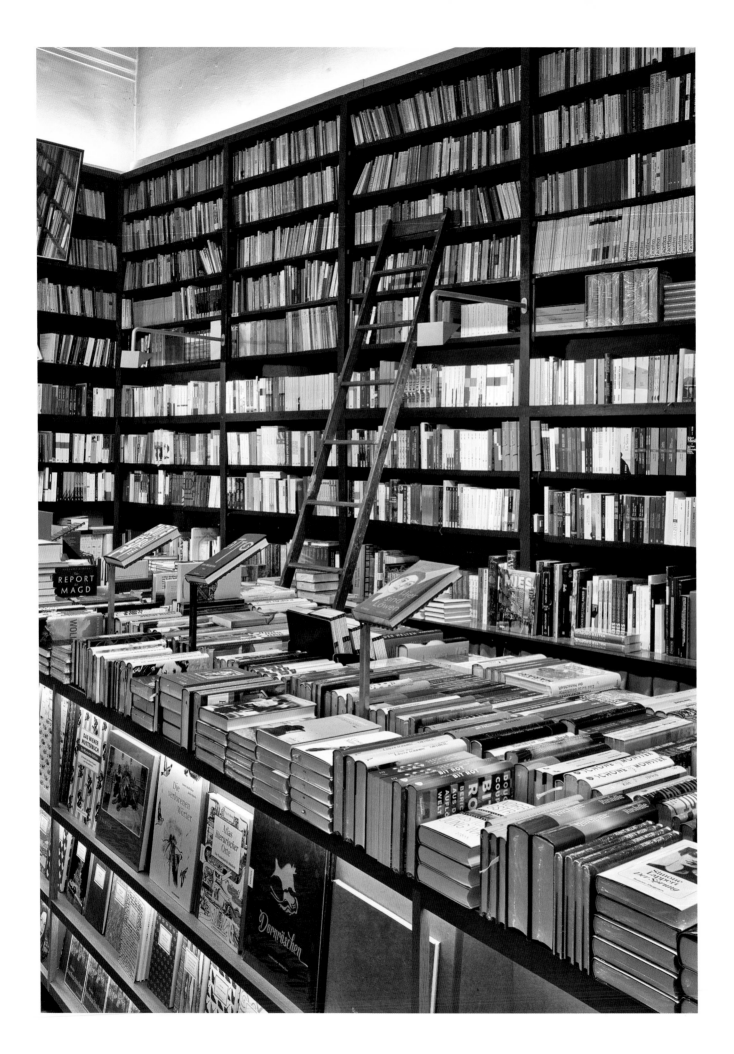

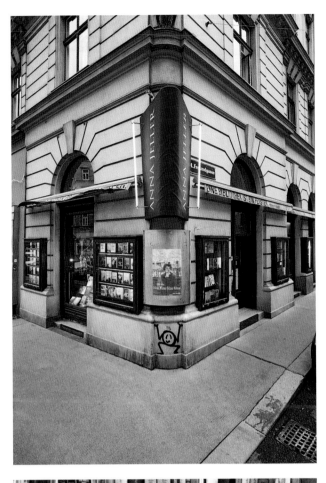

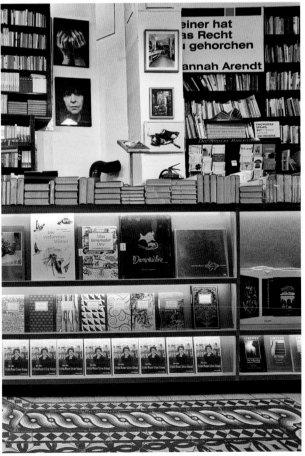

ANNA JELLER BUCHHANDLUNG — VIENNA

Buchhandlung Bernhard Riedl

BERNHARD RIEDL & SANDRA RAČKO

There has always been a bookstore on this site since 1889. When we took over the business, we wanted to preserve its old-fashioned style and the cosy atmosphere in the sales area, which many regular customers had known since childhood, while bringing the whole organizational side in the back room right up to date. For us, the smell is one of the best things about real bookshops. It is that blend of the scents of paper, wood and an unfathomable secret ingredient that creates this special feeling of well-being.

However, the spotlight is on the subject of literature and exchanging ideas about it. Both of us are passionate and critical readers, and in reading we continually discover books beyond the mainstream and the best-seller lists. As our customers greatly value personal recommendations, we publish a small journal each year with our current favourites. In conversations and discussions we find out what meets readers' wishes, quite differently from the way algorithms do this. This occasionally leads us to advise against buying a book if we have the impression that it is not suitable for the reader in question. Sometimes we have completely different views on a book. One of us loves it, while the other thinks it is too sad. After reading it, customers tell us whether they agree with Sandra or Bernhard.

This can go further than purely literary exchanges. For example, if we recommend a city guide on Rome, we can chat about a few restaurants that we liked on our own visits and the wonderful shoe shop that happened to be right next door. Later the customers come back with their own recommendations.

One of our nicest compliments came from a customer who works in marketing: "You do everything wrong, really: no marketing or advertising at all, you have no online business, nothing whatsoever. But somehow it all works wonderfully well."

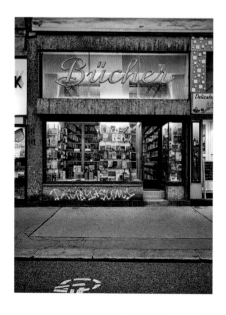

226

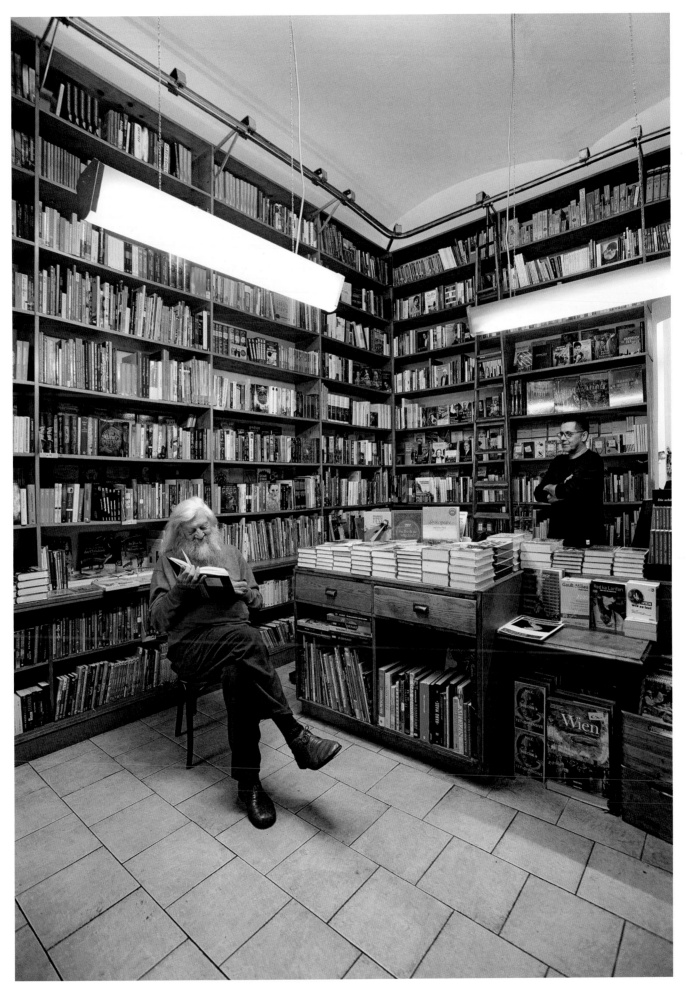

BUCHHANDLUNG BERNHARD RIEDL — VIENNA

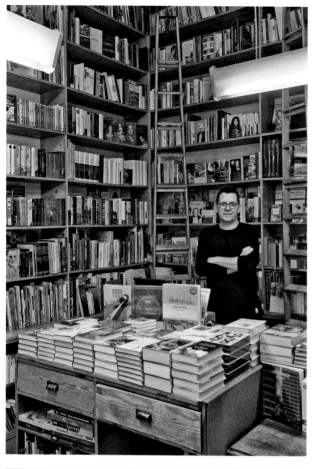

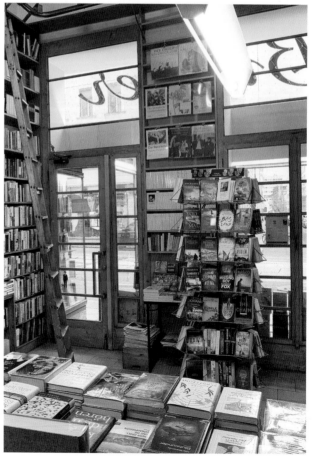

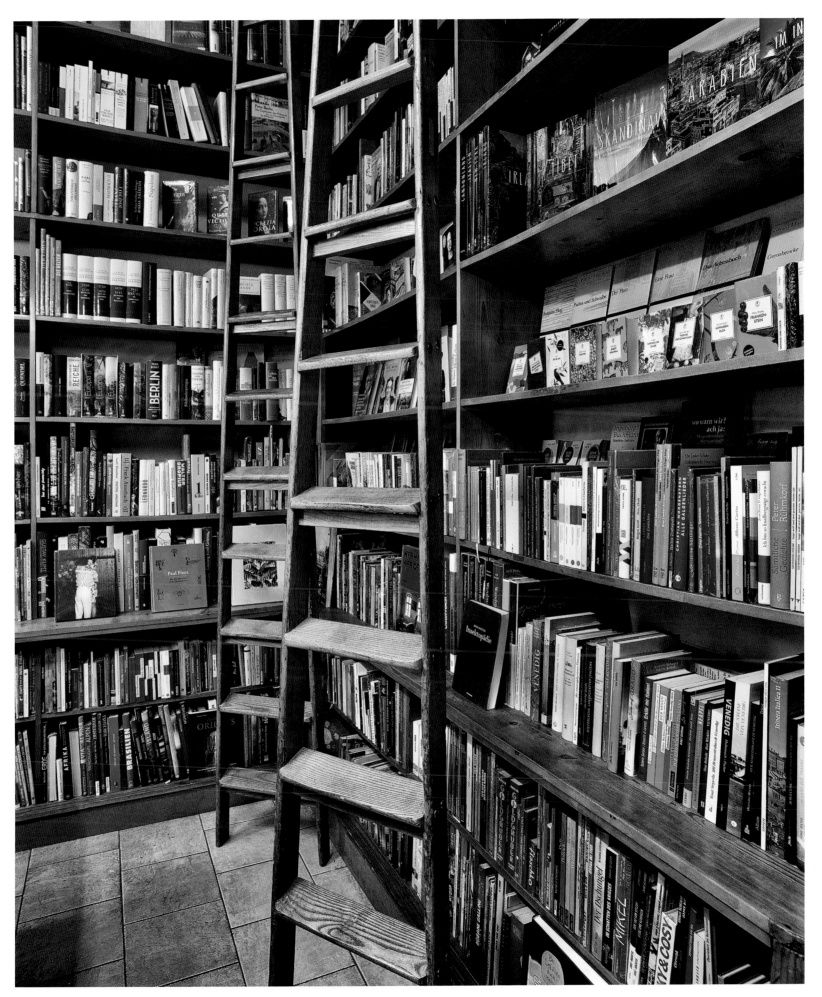

BUCHHANDLUNG BERNHARD RIEDL – VIENNA

Métamorphose

KERSTIN TUMA

Métamorphose isn't like most bookshops. It's a small shop celebrating beautiful and significant books, from beautifully designed and illustrated titles and cookbooks to special editions of the classics. The name is actually a reference to Ovid's classic that's been among my favourite reads ever since school. I'm convinced that certain books can change the way we look at life.

I've been in the bookselling market for about twenty years now, and this place reflects my ideals and preferences. It's designed as a "book gallery", and follows a minimalist approach, giving beautiful editions room to breathe and resonate. Ambience is important here; there's no loud music playing or stressed-out employees. Giving people a chance to get away from a hectic everyday life is among the nicest experiences a bookshop can provide.

Authentic guidance is also essential to me; I want my customers to feel comfortable, and taking the time out to talk to them is key to achieving that.

I'm aware that my stock appeals to a relatively small group of people, but I'm happy with that; they're bibliophiles, a very mixed, open-minded audience who love to discover new things and treasure analogue experience. In fact, I'm finding that more and more people are swinging by to share their experiences with the books they've bought here. They "co-design" the entire space by providing valuable input.

I suppose everyone's searching for meaning, aren't they? And the fact that my customers consider Métamorphose beautiful, special and meaningful really makes my heart leap.

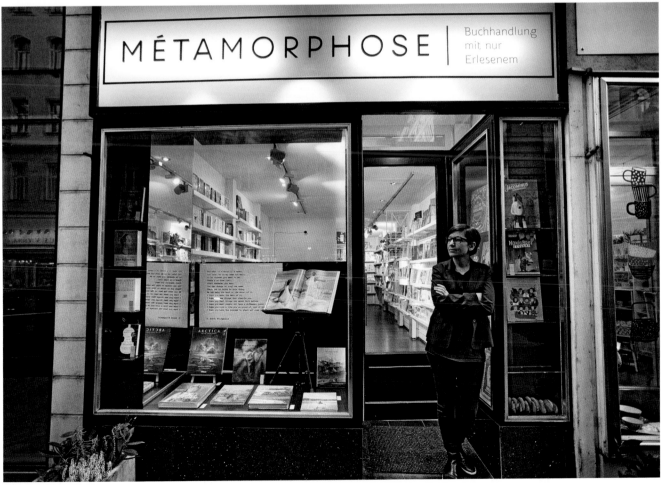

KERSTIN TUMA — MÉTAMORPHOSE — VIENNA

Livraria Ferin

JOÃO PAULO DIAS PINHEIRO

The Ferins were a Belgian family who had a thing for books. Initially, the stock was mainly French, which attracted the intellectuals and politicians who frequented the clubs of Chiado. Ferin also sold notebooks, pencils, wooden alphabets, geological maps, and pictures and engravings. It also had its own printing press, and operated an "Atelier de Reliure", or bookbinding workshop.

It's been in the same premises since it opened, and it's weathered some difficult times – the fall of the monarchy, the establishment of the republic, two world wars, the big fire of Chiado in 1988, which destroyed all the buildings around us, but was stopped right at our walls – but always the family believed that the bookshop was like a light in the darkness, that only with the development of knowledge was it possible to construct a better world, and that books were the perfect vehicle for the exchange of ideas. As well as the store, we have a space for *tertúlias*, or social gatherings, where we launch new books and exhibitions and even stage the occasional fado concert. At a time when social networks are very powerful, we see these as real social networks, places where people can come together in reality. Ferin still has its beautiful bookcases, tables and chairs from its earliest days; the French clock is still there, as well as a wonderful wood-framed barometer, which has never failed to provide an accurate forecast. The smell of books, leather bindings and wood gives this place a special atmosphere, and allows people – whether kings, queens, presidents of the republic, authors, journalists, the young and the not so young, all of whom have patronized the place – to get some pause; a time out from the buzz of the city.

It's also why we've appeared in many novels and movies ourselves. We hope to continue to inspire. As our bookmarks say, "If a single page makes you think, imagine what a whole book can do."

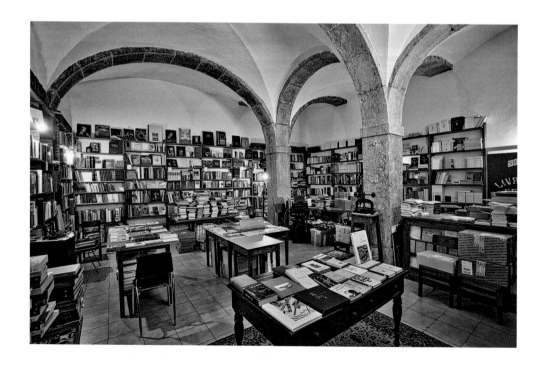

LIVRARIA FERIN — LISBON

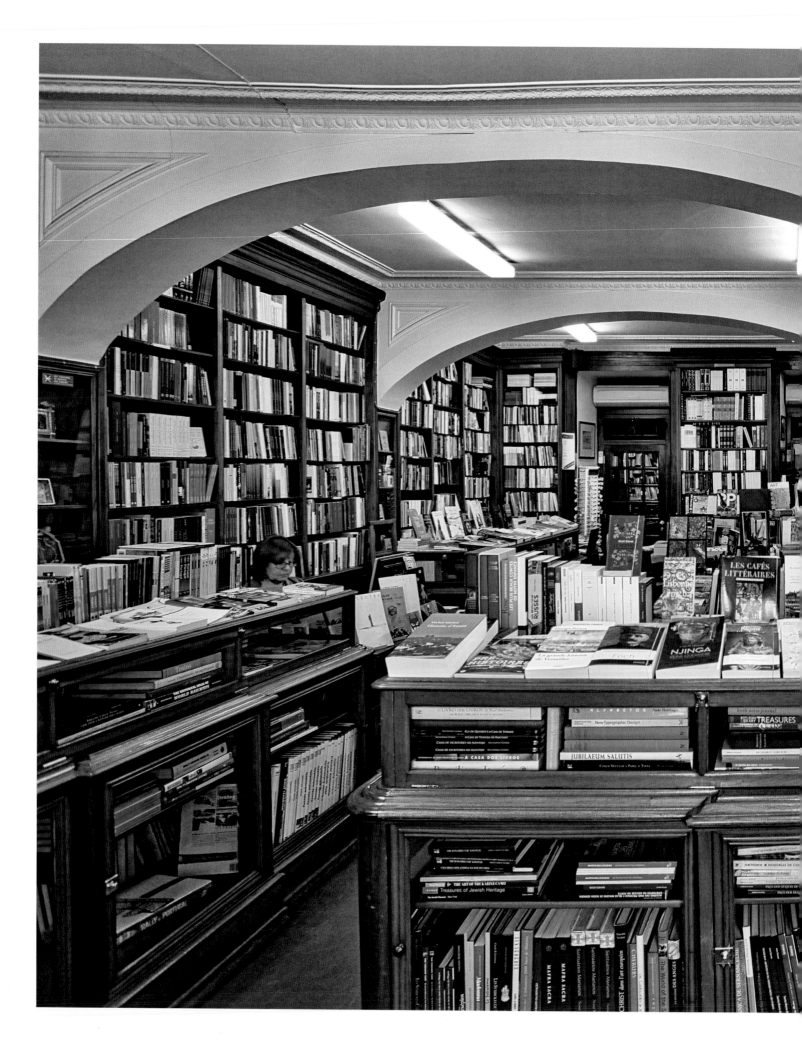

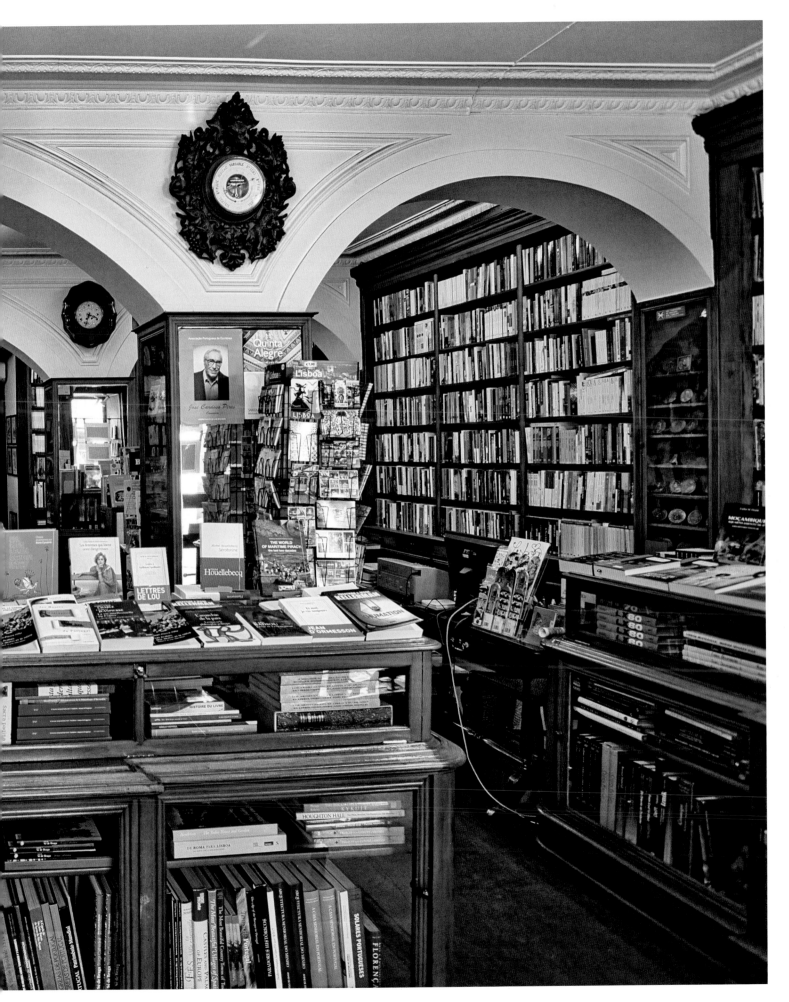

LIVRARIA FERIN — LISBON

236

LIVRARIA FERIN – LISBON

Almedina Rato

EDGAR SANTOS

This is a very special place. It's the former workshop of the stained-glass and mosaic artist Ricardo Leone, which closed in the 1970s, and the idea was to restore, preserve and return to the twenty-first century as much of the character of that space as possible. Hence the books are displayed on old glass manufacturing tables and drawing boards; we've used light wood shelves that marry beautifully with the darker wood of the studio; and there's something to discover in every nook, from the original safe to old paint cans and electrical boards. So the space surprises, the books shine, and we've had people describe it as Lisbon's most beautiful bookstore. I think they appreciate the living history here; it's not bought-in or fabricated.

This is a place where people like to spend time. The book business in Portugal didn't suffer the tremendous shakedown that others did from the onset of online commerce. People still enjoy the physical contact with the book as an object, and the personalized service; often they don't know what they want, or they want to be surprised, or they see a showcase and buy on impulse. It's our job to provide an environment that encourages all of that. A city without bookstores is poor like no other. But we get all kinds of clients, from lawyers and judges to students, families and tourists. And few leave unenlightened.

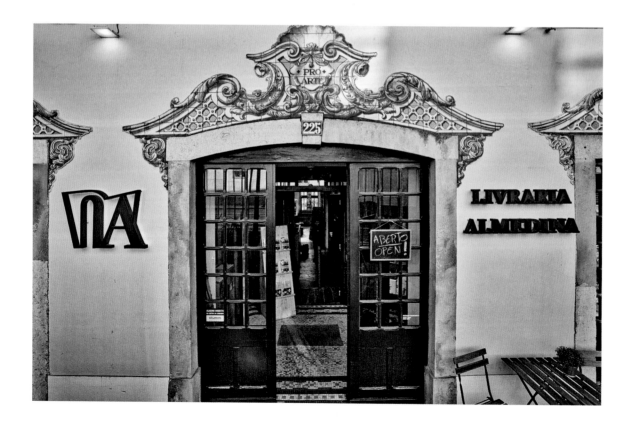

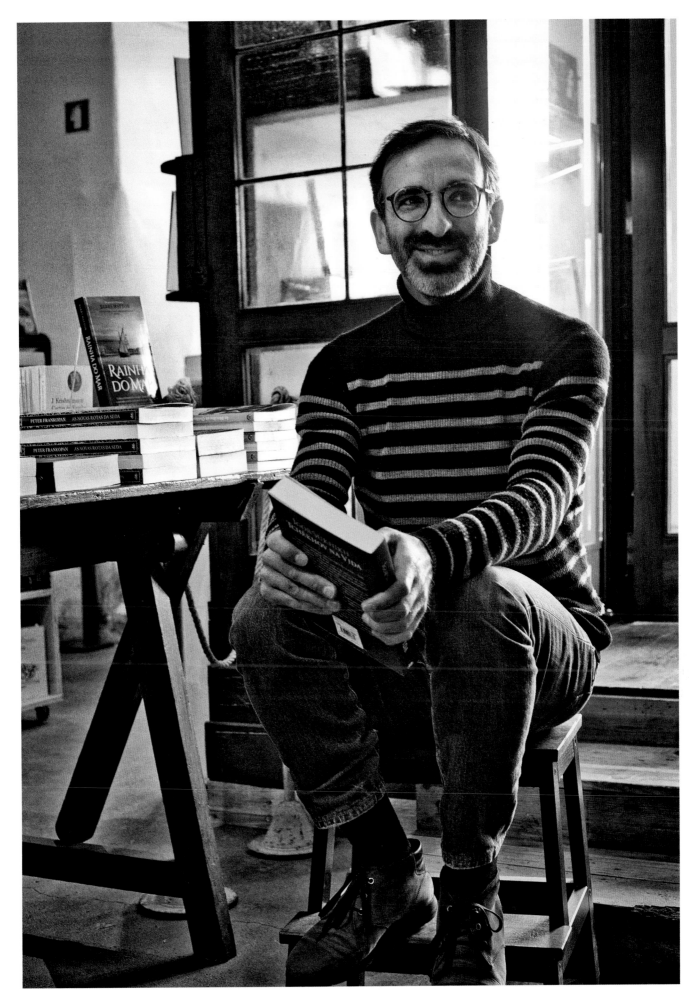

EDGAR SANTOS — ALMEDINA RATO — LISBON

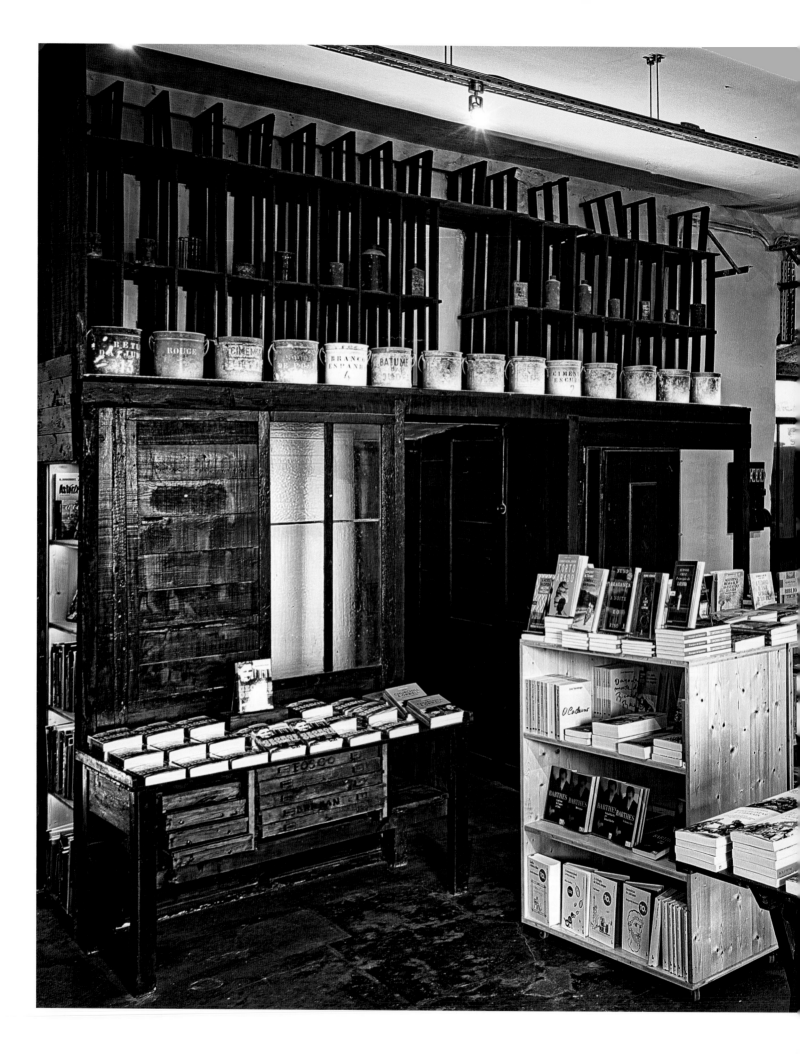

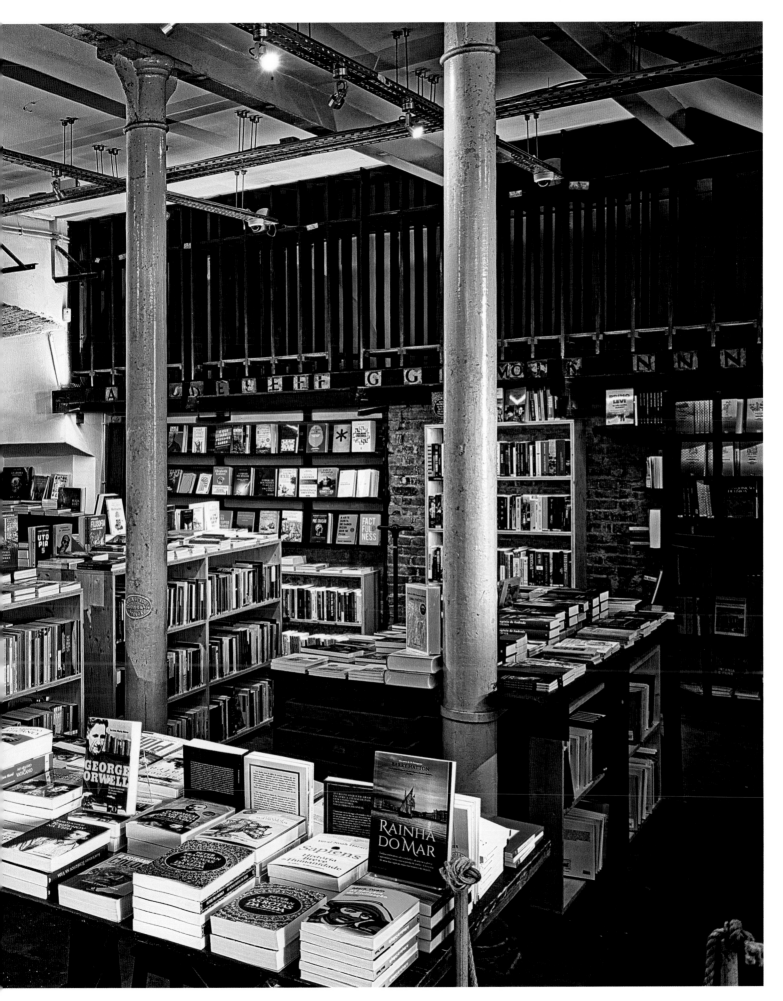

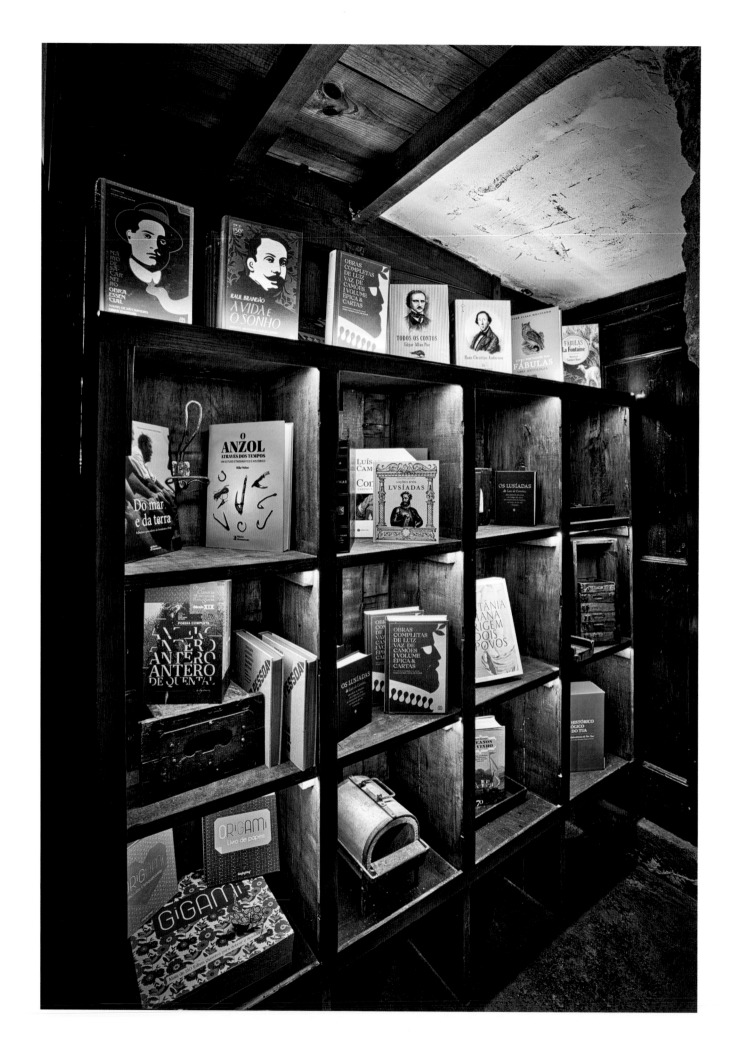

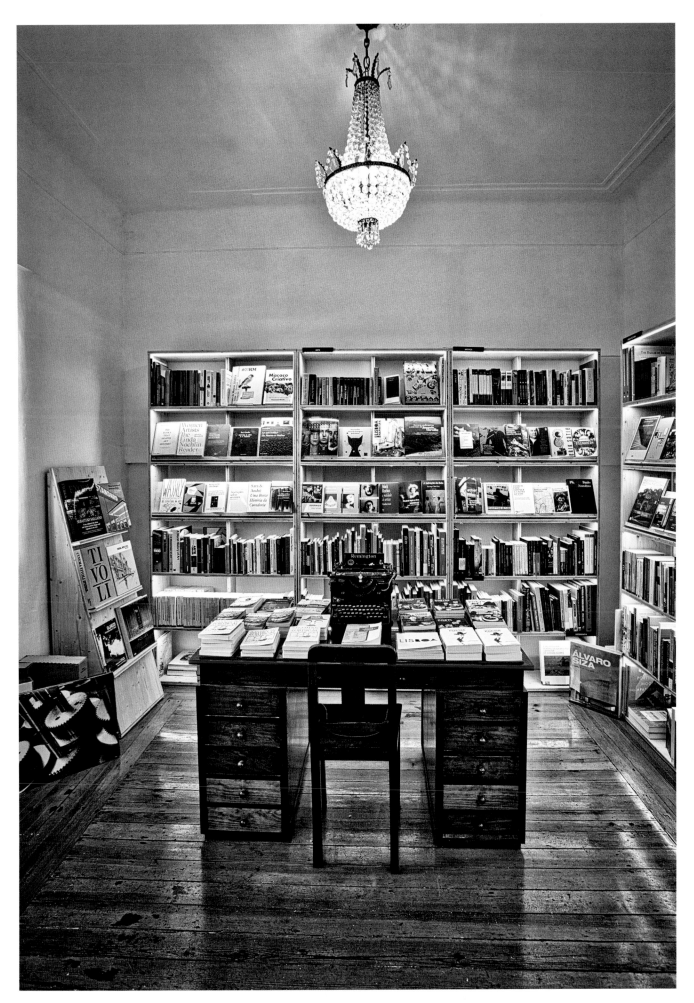

ALMEDINA RATO — LISBON

Livraria Lello

AURORA PEDRO PINTO

Lello was always intended to be a temple to culture in general and reading in particular. The founders, Jose and Antonio Lello, wanted to create a building that would stand out in the city and the world. So the engineer, Francisco Xavier Esteves, created this neo-Gothic building with its stained-glass skylight, ornate wood carvings, forked spiral staircase, bas-reliefs of Portuguese literary figures carved into the pillars, and allegorical figures of Art and Science on its façade. It's impossible not to feel a sense of history and grandeur when you come through the door. Lello was also a publishing house, and a hang-out for the Portuguese literati. To this day we retain a publishing arm, and we host an intense cultural programme with book launches, exhibitions and other events.

In some ways, we're a victim of our own success – in high season, the number of visitors varies from 3,500 to 4,000 a day. Part of this is down to the Harry Potter myth; J. K. Rowling lived in Porto during the 1990s, and visited Lello almost daily when she was writing the first Harry Potter book. Many people claim the interior was the inspiration for Hogwarts, but she's never confirmed or denied that. It pleases us because, as J. K. Rowling inspired a tremendous boom in young readers, so have we. Since we, the Pedro Pinto family, introduced a paid voucher system for entry to the shop in 2015, redeemable with the purchase of a book, we've seen the number of people buying books going from less than 10 per cent to over 50 per cent – that means over 1,800 books a day in 2019 – with our younger visitors leading the way. Through this we're telling the world not only that bricks-and-mortar bookstores have a future – particularly when the bricks and mortar are this beautiful – but also that Generation X, Y and Z love books just as much as their forebears did.

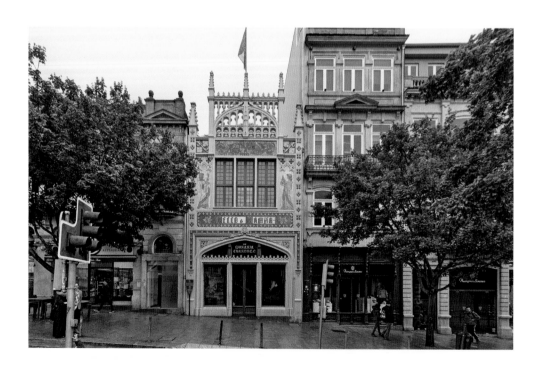

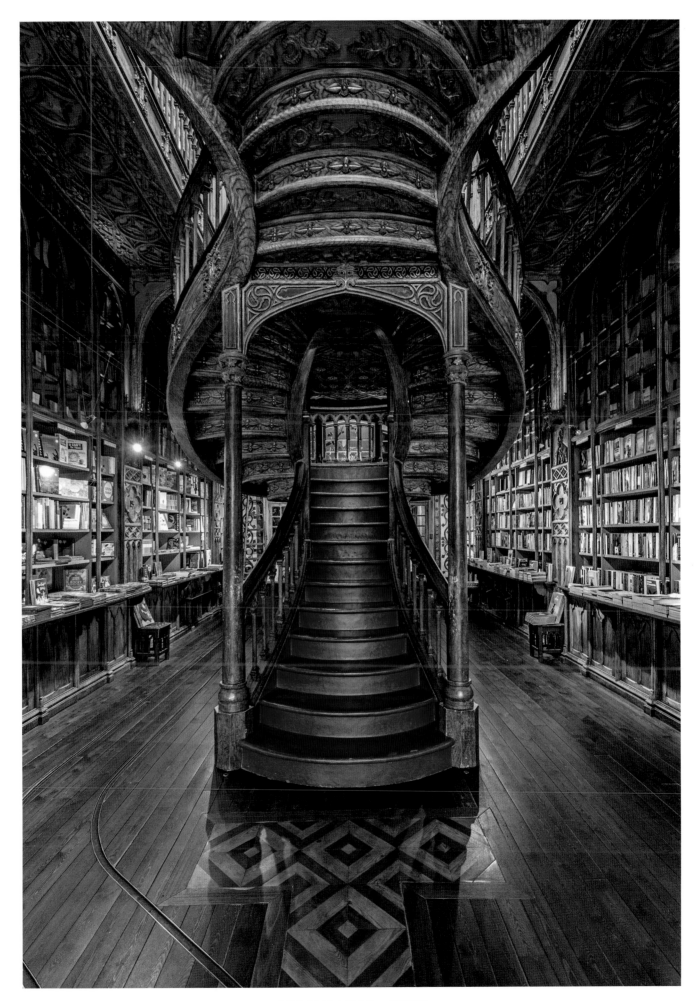

LIVRARIA LELLO – PORTO

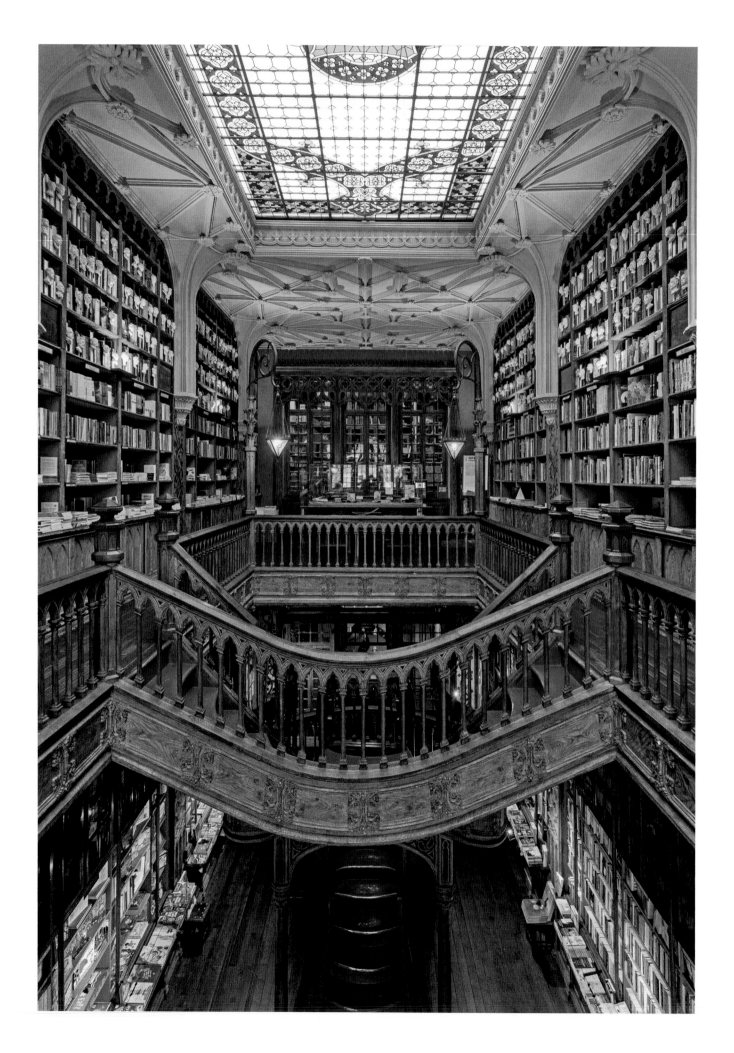

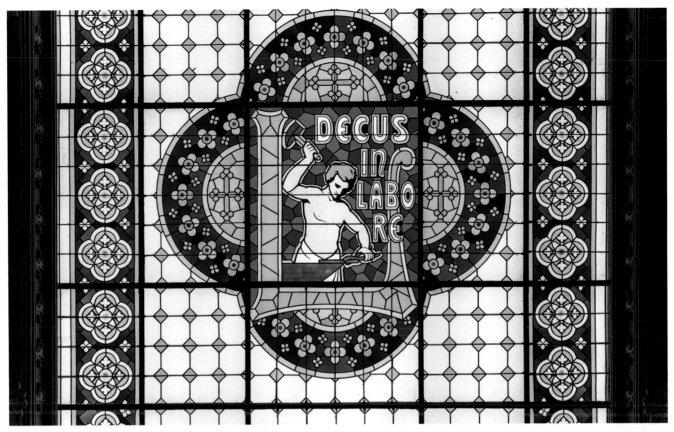

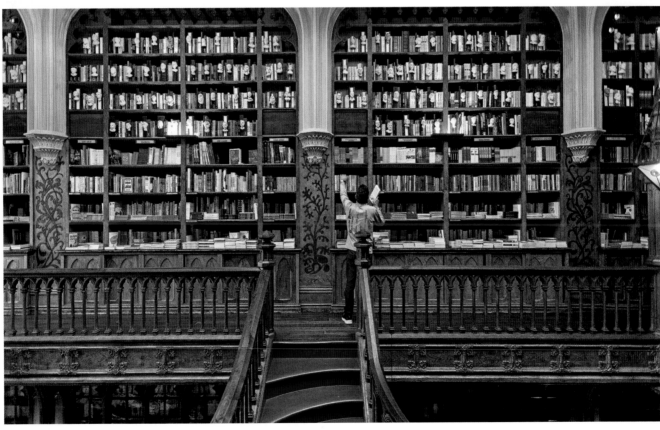

LIVRARIA LELLO – PORTO

Livraria Académica

NUNO CANAVEZ

I came to Porto in 1948, when I was 13, trying to find a job and the means to survive during those harsh post-war years. I saw an ad from Livraria Académica in the paper, and Mr Guedes da Silva, the founder, took me into his trust and taught me everything I know. To this day I have no idea why he picked me.

I've lived surrounded by thousands of books for over seventy years now. The trade of an antique/rare bookshop is quite specific and also magical/whimsical at the same time; specific in terms of finding a precise book that a customer might require, whimsical in that it shows how much you still don't know, and will probably never know. But our merchandise is culture, and, almost without noticing, we're always learning.

My friends presented a plaque to me some years ago, which hangs in the shop and bears one of my quotes: "What a joy to have always lived among books." It's true that I, along with my customers, still delight in the stacks and rows, the beautiful bindings, the way books feel, the way they smell, the details of specific editions. I like to say that we have a bit of everything, like in the pharmacy. And as with the best pharmacies, a visit here will leave you feeling better.

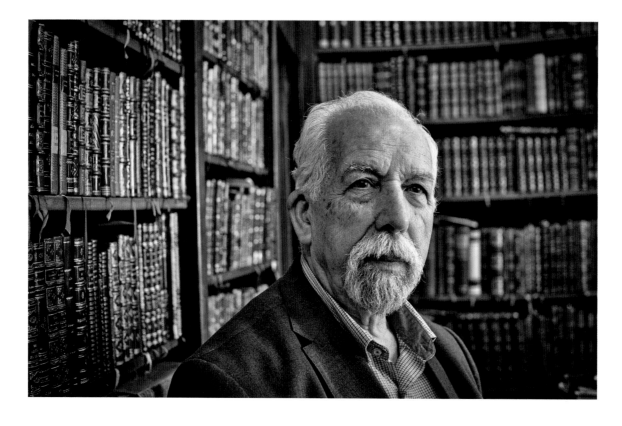

LIVRARIA ACADÉMICA – PORTO

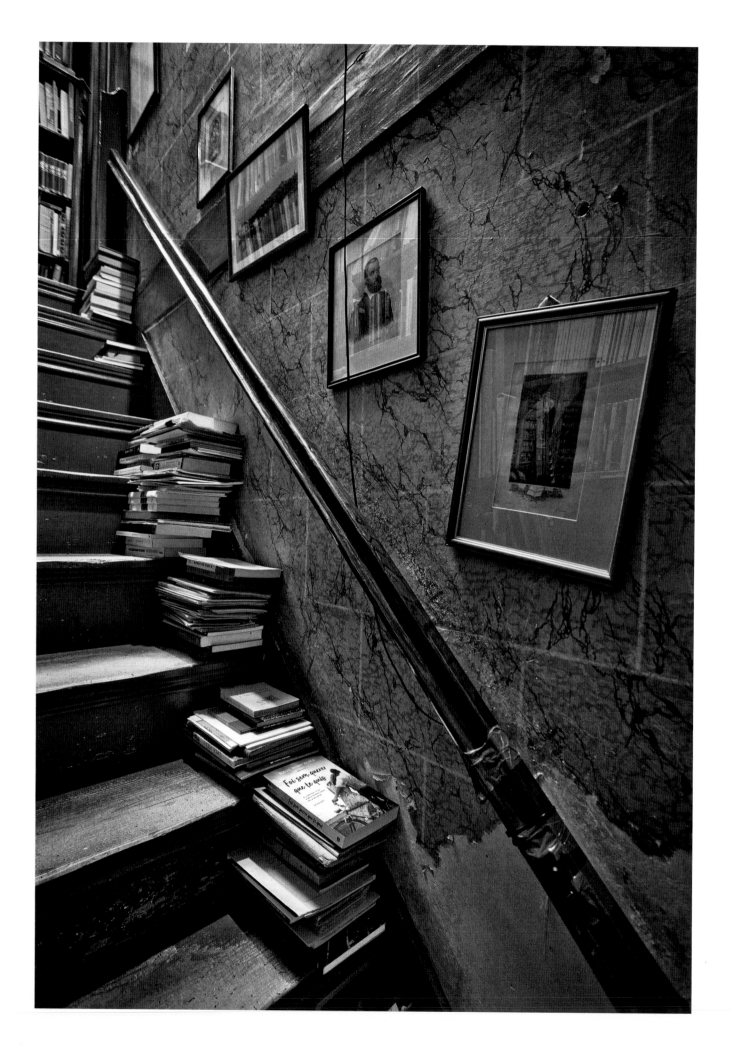

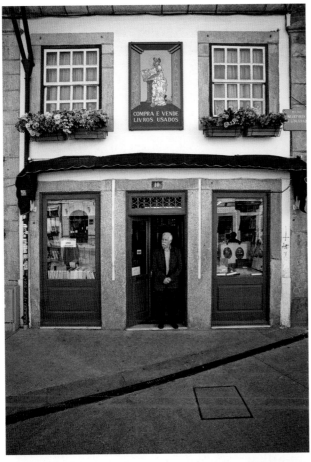

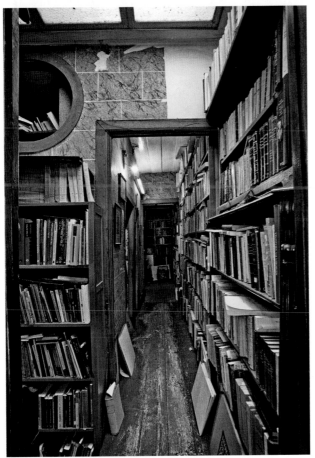

LIVRARIA ACADÉMICA – PORTO

LIVRARIA ACADÉMICA – PORTO

HORST A. FRIEDRICHS

Internationally renowned photographer Horst A. Friedrichs was born in Frankfurt in 1966. He studied photography in Munich and has worked for a number of noteworthy publications including *The New York Times*, *The Sunday Times Magazine*, *GQ* Germany, *Rolling Stone*, *Geo* and *Stern*. He has published numerous books including the best-selling *Cycle Style*, *I'm One: 21st Century Mods*, *Or Glory: 21st Century Rockers*, *Drive Style*, *Denim Style*, *Coffee Style* and *Best of British* (all by Prestel). He is currently based in London.

ACKNOWLEDGEMENTS

This book could not have been realized without the enthusiasm and support of the following people: Nancy Bass Wyden, The Strand; Livia Senic-Matuglia, Rizzoli; David Strettell and Miwa Susuda, Dashwood Books; Jonas Kyle and Miles Bellamy, Spoonbill & Sugartown; Emma Straub, Margaret Myers, Books Are Magic; Kate Razo, Dog Eared Books; Paul Yamazaki, City Lights Bookstore; Kevin Ryan, Green Apple Books; William Stout, William Stout Books; Fred Dannaway, Baldwin's Book Barn; Ed Maggs, Bonny Beaumont and Dr. Titus Boeder, Maggs Bros.; Nicky Dunne and Peregrin Cavendish, Heywood Hill; Johnny de Falbe, John Sandoe Books; Jim MacSweeney, Gay's The Word; Ray Cole, Hurlingham Books; Brett Wolstencroft and Rose Cole, Daunt Books; Claire Harris, Lutyens & Rubinstein; Natalia de la Ossa, London Review Bookshop; Nicola Beauman and Lydia Fellgett, Persephone Books; Paddy Screech and Jonathan Privett, Word On The Water; Simon Armstrong, Tate Modern Shop; Joost Albronda and Joeri Worm, MENDO; Ton Harmes, Boekhandel Dominicanen; Paul Blaizot, Librairie Auguste Blaizot; Sylvia Whitman, Shakespeare and Company; Walther and Franz König, Buchhandlung Walther König; Marcus Müller, Booxycle; Clemens Bellut, artes liberales; Marina Krauth, Felix Jud; Annerose Beurich, stories!; Ruthild and Wanda Spangenberg, Bücherbogen; Katja Reichard, Pro qm; Mark Kiessling and Jessica Reitz, do you read me?!; Joe Dilworth, Bildband Berlin; Sebastian Steinacker, Soda; Regina Moths, Literatur Moths; Christian Schädel, phil; Regina Anzenberger, AnzenbergerGallery; Petra Hartlieb, Hartliebs Bücher; Anna Jeller, Anna Jeller Buchhandlung; Bernhard Riedl and Sandra Račko, Buchhandlung Bernhard Riedl; Kerstin Tuma, Métamorphose; João Paulo Dias Pinheiro, Livraria Ferin; Edgar Santos, Almedina Rato; Andreia Ferreira and Aurora Pedro Pinto, Livraria Lello; Nuno Canavez, Livraria Académica; Norv Bell from The Bureau.

Thank you to all the participants who gave generously of their time, especially Salomé Laloum Gaultier, Stella Friedrichs, Annabell Binder, Kwaw de Graft-Johnson, Farnoush Hamidian, Lauren Johns and António C.A. Sousa Lara. My sincere gratitude also goes to João Vilela Geraldo for his considerable help taking me into the world of bookstores in Portugal. My publisher Prestel has made this a great experience and a deeply satisfying creative undertaking, thanks to the efforts of my editor Curt Holtz and the contributions of Christian Rieker, Michaela Schachner, Pia Werner, Josephine Fehrenz, Corinna Pickart, Andrew Hansen, Oliver Barter and Raya Thoma. A special thanks to my wife Adriana and my two daughters Greta and Zoe, for their love, faith and inspiration. A big thank you to my agent Regina Anzenberger and her team who have always supported my projects and ideas.

I would like to thank Nora Krug for her wonderful introduction as well as the author Stuart Husband for your words and the way you have woven them together. You are the best! And Lars Harmsen from Melville Brand Design, who created the book's concept and design, for his generous work, tremendous enthusiasm and never-ending creativity. The input from both of you during the making of this book, and your enduring friendship, are invaluable to me.

Books are forever!

Horst A. Friedrichs, London 2020

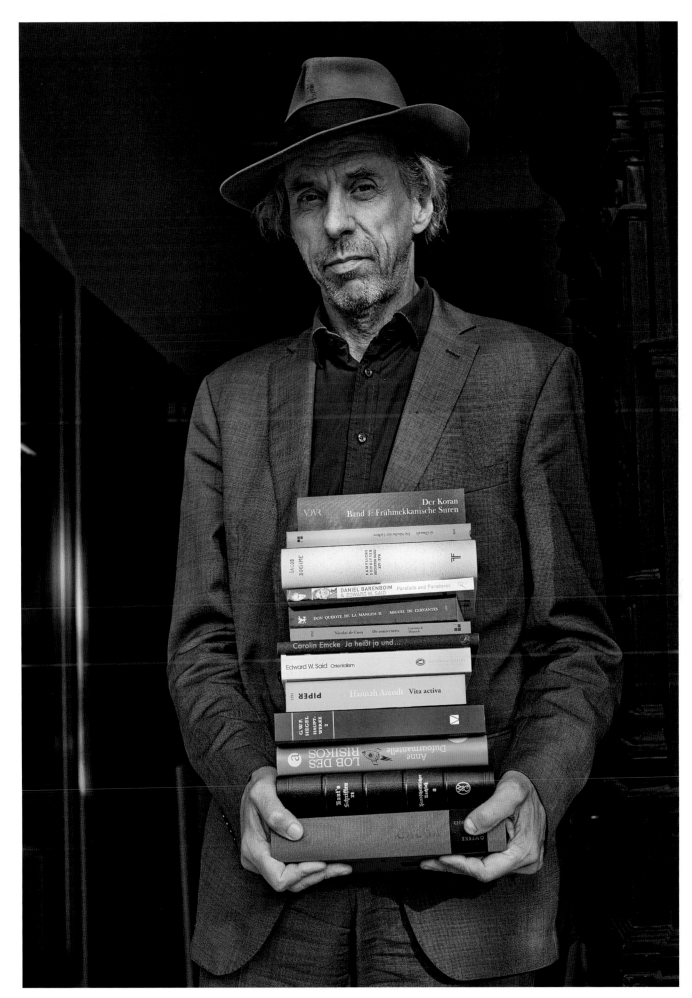

CLEMENS BELLUT — ARTES LIBERALES — HEIDELBERG

© Prestel Verlag, Munich · London · New York, 2020
A member of Verlagsgruppe Random House GmbH
Neumarkter Straße 28 · 81673 Munich

Front Cover: Boekhandel Dominicanen, Maastricht
Back Cover: Margaret Myers, Books Are Magic, Brooklyn
Page 3: phil, Vienna

Prestel Publishing Ltd.
16-18 Berners Street
London W1T 3LN

Prestel Publishing
900 Broadway, Suite 603
New York, NY 10003
www.prestel.com

Library of Congress Control Number is available; British Library Cataloguing-in-Publication
Data: a catalogue record for this book is available from the British Library.

Editorial direction: Curt Holtz
Editorial assistance: Josephine Fehrenz
Translation from German (pp. 156, 166, 170, 178, 222, 226): John Sykes
Copy-editing: Jonathan Fox
Design, layout and typesetting: Lars Harmsen, Melville Brand Design
Production: Corinna Pickart
Separations: Reproline Mediateam
Printing and binding: TBB, a.s., Banská Bystrica
Paper: Condat matt Périgord

Verlagsgruppe Random House FSC® N001967

Printed in Slovakia

ISBN 978-3-7913-8581-5